PRAISE FOR **HUBERT'S FREAKS**

"Gibson is a quirky, funny, and detailed writer who treats Langmuir's fascinating story as an unfolding mystery." — *CHICAGO SUN-TIMES*

"It's a credit to [Gibson's] narrative ability that he can turn a happy anecdote—struggling dealer stumbles on a fortune—into a novel-length tale of remarkable suspense." — *LOS ANGELES TIMES*

"*Hubert's Freaks* is a page-turner, charged with anecdotes about junk-shop hustlers and eccentric collectors. As it details Langmuir's quest for legitimacy in the fine-art world, it also offers redemption in surprising places, notably abandoned storage facilities, a mental-health ward, and the seedy past of Times Square."— *TIME OUT NEW YORK*, four stars

". . . strange and excellent . . . These tales are ably and meticulously told—and all true to boot. Mr. Gibson has a flare for the dramatic that elevates the book from straight history to propulsive page-turner." — *NEW YORK OBSERVER*

"Wonderfully uncategorizable . . . always intelligent . . ."
— *NEWSWEEK.COM*

"Gibson provides an account that blends a novelist's pacing with a historian's attention to detail . . . As we climb onboard the roller coaster ride that is Langmuir's life it is apparent that there will be no putting aside this interesting tale until you have reached the final page."
— *VANCOUVER COURIER*

"[T]errifically strange . . . a delightful read, by turns fascinating and suspenseful . . . The story Gibson mines here is as rich as New York cheesecake." — *OTTAWA CITIZEN*

"A consistently fascinating and intriguing read." — *LIBRARY JOURNAL*

"[F]ascinating . . . How the Arbus photographs are tied to Hubert's and what ultimately becomes of them are the central mysteries that will keep readers raptly engaged." — *BOOKLIST*

"Gibson's laser focus on Langmuir's shifting state of mind as he struggles to master his personal demons and navigate the pitfalls of his own obsession gives this story its heart and opens a window onto a lost part of the American soul." — *PUBLISHERS WEEKLY*

"[Gibson] brings together eccentric character studies, oddball action on old 42nd Street and complex art-world maneuvers to yield some classic Americana . . . [An] artfully developed tale of uncommon people and some photographs once lost." — *KIRKUS REVIEWS*

"A sideshow of singular stories masterfully intertwined. Meet the photographer, the ephemerist, and the carnival talker, 'they're all on the inside, they're on the inside . . .'"
— RICKY JAY, author of *Jay's Journal of Anomalies*

"*Hubert's Freaks* will fascinate those among us who are continually stimulated by the richness and variety of American subcultures. I devoured it." — LARRY MCMURTRY

"Greg Gibson has written a panoramic story that takes in sideshow culture, Diane Arbus, African-American social history, the image market as it ranges from foreclosure sales to Chelsea galleries, and much more. Its principal focus, however, is one man's life—his dreams and ambitions and delusions and dashed hopes—and that is what makes the book uncommonly moving and utterly engrossing."
— LUC SANTE, author of *Low Life*

HUBERT'S FREAKS

ALSO BY GREGORY GIBSON

Gone Boy: A Walkabout

*Demon of the Waters:
The True Story of the Mutiny
on the Whaleship Globe*

GREGORY GIBSON

HUBERT'S FREAKS

THE RARE-BOOK DEALER,
THE TIMES SQUARE TALKER,
AND THE LOST PHOTOS
OF DIANE ARBUS

MARINER BOOKS / Houghton Mifflin Harcourt

Boston New York

First Mariner Books edition 2009

www.hmhbooks.com

Library of Congress Cataloging-in-Publication Data
Gibson, Gregory, date
Hubert's freaks: the rare-book dealer, the Times Square talker,
and the lost photos of Diane Arbus/Gregory Gibson.—1st ed.
p. cm.
Includes bibliographical references.
1. People with disabilities—Portraits. 2. Abnormalities, Human, in art.
3. Arbus, Diane, 1923–1971. I. Arbus, Diane, 1923–1971. II. Title.
TR681.H35G523 2008
779'.2—dc22 2007029707
ISBN 978-0-15-101233-6
ISBN 978-0-15-603308-4 (pbk.)

Text set in Minion
Designed by April Ward

Printed in the United States of America

DOC 10 9 8 7 6 5 4 3 2 1

*The names of several individuals in this book
have been changed to protect their identity.*

To Joseph Mitchell and A. J. Liebling

Such discussions should not be scorned, for they lead us closer to the picture's habitat. But the issue of the picture itself must finally be met without words.

—**John Szarkowski**

CONTENTS

HUBERT'S FREAKS

THE MAN IN BLUE

ON JULY 26, 1971, while legendary photographer Diane Arbus was curled in a bathtub at the Westbeth apartments in New York City, slitting her wrists, Bob Langmuir was traveling out of his body, which was heaped in a roadside ditch in rural Vermont, struggling to maintain its own hold on life.

Back then Bob was twenty-one years old, at least outwardly typical of the sixties generation. He had a short, thin black beard, round black-rimmed glasses, and a sly, innocent moon face. He'd already worked as a seaman on a Danish steamer and as a cook on a Jamaican fishing boat. He'd tended animals in the zoo of a traveling circus, done a stint as a Fuller Brush man, and worked with his uncle cleaning sewers. But he was something more than your average rootless hippy. Bob had a restless, random, but enormously retentive quality of mind—ADHD plus flypaper. Had he been born a generation later, his teachers might have realized he "processed information differently," instead of throwing him out of class.

This particular day he and his sidekick, Bill Mooney, were driving down a mountain from Mad River Glen in a beat-up old box truck, the next size up from a van. It was a cool vehicle because the whole back of it was like a room. In those pre-seatbelt days you could stretch out in comfort. Which was what Bob was doing, in a folding lawn chair, while Bill drove. They were both hungover, listening to Cannonball Adderley's album "Mercy,

Mercy, Mercy." Bill was probably paying as much attention to the road as Bob.

Next thing Bob knew, Bill was screaming, "We're not gonna make it!" and the yellow sign warning of the hairpin turn was so big it seemed to fill the windshield. Then (had Diane already consumed her "last supper" of barbiturates?) the truck flipped over the guardrail and rolled into the gully below. Bob was ejected from the vehicle.

He didn't remember any of this until years later when he and his girlfriend were hitching on the Massachusetts Turnpike and got picked up by a man who was obviously drunk and driving at a high rate of speed, causing Bob to come down with the Terrors. While he was freaking out, he recovered the memory of being hurled from the box truck, in a remarkably flat trajectory just a few feet above the scrubby roadside terrain.

He landed headfirst in an opening in a heap of boulders. He was concussed and severely lacerated, but most of the shock of the landing had been taken by his shoulders. Both collarbones and several ribs were broken, a lung was punctured, a couple of vertebrae cracked, and he was stuck there like a cartoon character, head in that hole, legs kicking in the air.

Bill, who somehow escaped with only minor injuries, extracted him. They were out in the wilderness, miles from anywhere; Bob was in agony, certain he'd expire before anyone discovered them. As he was attempting to communicate this important fact to Bill, a man dressed entirely in blue emerged from the woods walking on crutches. The man retrieved a tire that had come off the wreck of the truck and placed Bob in it, easing his pain. The man then explained to Bob that he was recovering from a similar accident, and that Bob should calm down, try to relax, because his life was not in danger. If the blue man was a hallucination he was an unusual one, because Bill was staring at him, too.

Then Bill crawled back up to the road and stopped a passing car, which happened to be driven by a registered nurse who happened to be equipped with a radio and a trauma kit. She summoned a rescue team and climbed down the hill and gave Bob medical attention, the blue man having evaporated. And it was just at this moment, while he was waiting for the medevac crew to hack their way through the woods, that he started going in and out of his body—way out there, occasionally looking back and seeing himself sitting in that tire all messed up.

Thirty-two years later, after his headlong pursuit of the documentary remains of a Times Square freak show led him to the greatest discovery of his career, he fingered the nasty scar just forward of his jugular and remembered the accident at Mad River Glen and the episode of astral travel that accompanied it. He reckoned that was when he might have formed some kind of psychic connection with Diane Arbus, just on the verge of her own departure. What else would account for it? There were so many *coincidences*.

It was complicated. Bob was complicated.

AN AMERICAN PALINDROME

SUNDAY, MONDAY, AND CHARLIE

IN 1831 A YANKEE SEA CAPTAIN named Benjamin Morrell captured two cannibals in the South Pacific and brought them back to America. For the next few years he displayed them throughout the northeastern United States at places like New York City's American Museum. He wrote a book about his adventures, and his wife, who accompanied him on the voyage, wrote her own account, which verified his. A third narrative, written by a crewman named Keeler, substantiated both the Morrells' books.

The two savages, named Sunday and Monday in honor of the days on which they were captured, astonished American audiences. Captain Morrell wrote, "In the year 1830 they were . . . CANNIBALS! In the year 1832 they are civilized intelligent men." Morrell assured his readers that the two former cannibals would prove to be ideal ambassadors to their home islands, overflowing with breadfruit, coconut, and "many other valuables," when a trading expedition returned there. Stockholders of the proposed commercial venture, he said, would have a monopoly on the abundant profits because, "*I alone know where these islands are situated.*"

As it turned out, Morrell's book was ghostwritten by a hack friend of Edgar Allan Poe's named Samuel Woodworth; Mrs. Morrell's account was ghostwritten by another friend of Poe's; and most of Keeler's narrative was lifted verbatim from his captain's book. All three of these texts, though based loosely on fact,

were rife with exaggeration. Captain Morrell was simply trying to drum up interest in the remote Pacific and to promote himself as an expert navigator of those waters. He hoped to attract backers for a grand trading venture, or even for a government-sponsored expedition (to be led, of course, by himself). But the only person to make any real use of his ghostwritten saga was Edgar Allan Poe, who based *The Narrative of Arthur Gordon Pym* on it.

Morrell's extravagant claims didn't fool his fellow mariners. He became known as "the biggest liar in the Pacific," and he died at sea without ever realizing his grandiose schemes. Sunday and Monday, his faux cannibals, were probably just domesticated Pacific Islanders or African American impersonators, posing as savages to astonish white American rubes. They were among the earliest examples of such, and although they are long forgotten, they bear on the story of Bob Langmuir and Diane Arbus.

Arbus started photographing at Hubert's Museum, a freak show on West Forty-second Street, in the 1950s. At first she was more interested in the interiors of the nearby movie houses—her photos show half-lit faces and blurred bodies rising like dreams out of those huge, dimmed bowls—but Hubert's bizarre shabbiness ultimately proved a more fertile environment in which to pursue the images she was seeking. She recalled descending, "somewhat like Orpheus or Alice or Virgil, into the cellar, which was where Hubert's Museum was." That it occupied its own underworld only enhanced it.

Charlie Lucas, a black man from Chicago who worked as the "inside talker" and manager at Hubert's Museum, was Arbus's friend and collaborator during the years she photographed there. He was her link to the freaks and performance artists and, in a larger sense, to the culture and traditions of the freak show. He made the introductions for Arbus and in some cases set up photographic shoots with the performers.

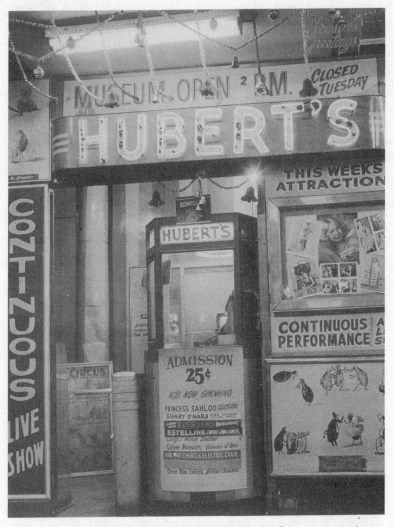

Hubert's ticket booth in the 1950s. Admission was raised to forty cents some time around 1960. Turnstile and stairs are to the left. An enlargement of Professor Heckler's Flea Circus flyer is on the lower right. *African American Photography Collection of Robert C. Langmuir*

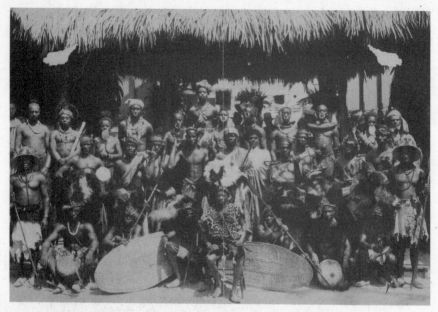

Charlie's "African Village." From a publicity brochure for Chicago's Century of Progress exhibition in 1933. Charlie has the "x" over his head, finger to his eye. He sees all. *African American Photography Collection of Robert C. Langmuir*

He'd been working circuses and sideshows in the U.S. and Canada since 1924, but he got his big break at the Chicago World's Fair in 1933. This event, commemorating the one hundredth anniversary of Chicago's incorporation as a city, was billed as the "Century of Progress." Splendid deco artifacts and architecture adorned the midway, along with a great deal of sideshow hokum, such as the Midget Village or the Infant Incubator Building, where crowds could gawk at real, live premature babies, attended by flocks of nurses.

Charlie Lucas presided at the Darkest Africa exhibit as, in his words, "African Chief of the Duck Bill Women." The core of his "tribe" was composed of fourteen authentic Ashantis who'd mi-

grated to Manhattan and been hired there, where the show had been conceived. The rest of the "natives" were recruited from Chicago pool halls, and the lot of them were decked out in leopard-skin sarongs and zebra-hide shields furnished by Brooks Costume Company, also of New York City. America was still in the grip of the Great Depression. There was no shortage of African American talent available for the impersonation of wild savages—an act that had lost none of its appeal since Morrell's day. Produced by white sideshow promoters, and occasionally enlivened by a few authentic Africans, the African Village became a staple of pre–World War II sideshow entertainment.

At the Century of Progress, Charlie was billed as WooFoo, the Immune Man. He had a bone supposedly clamped through his nose, dressed in ostrich feathers, and talked gibberish. Aside from his chiefly duties, he swallowed fire and climbed ladders of saw blades. In the tradition of blacks performing as savages, there hadn't been a great deal of progress since Sunday and Monday first took the stage a century before.

THE OLD ROMAN GARDENS

HUBERT'S MUSEUM HAD A RICH GENEALOGY in American popular culture. Though generally referred to as a freak show because of its performers, it was in fact a year-round, indoor sideshow, an offspring of the great "dime museums" of the nineteenth century. Dime museums descended from places like Peale's Museum in Philadelphia, or New York's American Museum, the venue in which Captain Morrell probably exhibited Sunday and Monday. These were quite unlike modern museums. The American Museum, for example, boasted thousands of natural and foreign curiosities, including live mud turtles, an iguana, the bed curtains belonging to Mary Queen of Scots, a pair of "Lilliputian singers" named Caroline and Edward Clarke, and lecturers to explain it all to the public.

P. T. Barnum purchased the American Museum in 1841, decades before he began his circus career, and carried the dime museum to its apotheosis. His magnificent five-storey edifice on lower Broadway featured an aquarium, a shooting gallery, wild animals, paintings, historical artifacts, and exotic curios from all over the world. Its Lecture Room scheduled daily dramatic performances, and, under the pretext of providing educational content, exhibited a continually renewed selection of human oddities such as Siamese twins, and midgets. In the 1860s Barnum capitalized on the evolution controversy by centering his Lecture Room entertainment around an exhibit known as What Is It? A supposed missing link, said to have been captured in Africa, the

creature was billed as a "unique specimen of BRUTE HUMANITY." In reality, "It" was William Henry Johnson, a black man from New Jersey.

As the nineteenth century progressed, the dime museum spun off more specialized forms of entertainment. Barnum's Lecture Room scheduled dramas like *Uncle Tom's Cabin* (with six acts, eight tableaux, thirty scenes, and a white woman in blackface playing Topsy). "Improving" works of this sort, leavened with intervals of music, farce, and comedy, eventually morphed into vaudeville. The natural history and art exhibits (Barnum had two floors devoted to paintings, stuffed animals, and preserved specimens) evolved into the highly focused institutions that we know today as museums. And, by the turn of the century, the exhibition of human anomalies found its own form in the sideshow—so called, originally, because such shows operated alongside circus and carnival midways.

In this type of entertainment, "born freaks" such as Siamese twins shared the stage with "made freaks"—who might have been shams like Sunday and Monday, or superannuated celebrities, or retired criminals, or weird normals like hunger artists or tattooed women. Often the freaks doubled as jugglers, fire eaters, dancers, or contortionists. These acts were supplemented by static exhibits such as mummified mermaids or pickled fetuses of two-headed babies (invariably rubber fakes, known in the trade as "pickled punks"). This grouping became the standard format of the sideshows, freak shows, or ten-in-ones (ten acts in one tent) that, until recently, enlivened fairs, circuses, and carnivals around the country. Sideshows even found permanent homes in Coney Island and New York City.

Hubert's Museum was such a place. From its opening in 1926, Hubert's offered additional value by grafting itself onto Professor Heckler's Flea Circus—an old sideshow act—so that it was

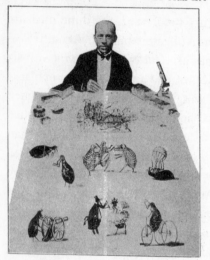

Illustration from a brochure advertising
Heckler's Flea Circus, circa 1940.
*African American Photography
Collection of Robert C. Langmuir*

alternately known as Hubert's Flea Circus. (The origins of the Hubert's name are obscure. Nobody called Hubert ever owned or managed the Times Square enterprise. A dime museum called Huber's operated down on Fourteenth Street at the turn of the century, but it had nothing to do with the latter-day Hubert's.) Even in the 1950s, when the flea concession was being run by Heckler's son Roy, Hubert's stayed true to the sideshow format. Born freaks like Sealo the Seal Boy worked alongside made freaks such as Jack Dracula, a heavily tattooed man. In addition to the standard magicians, fire eaters, and dancers, its resident "savage" was Congo the Jungle Creep, a black American of Haitian origin.

The building in which Hubert's was housed, at 228–232 West Forty-second Street, also had a deep history. Designed by McKim, Mead, and White, it was built in 1888 as a schoolhouse. In 1906 the school building was lavishly refurbished and reinvented as Murray's Roman Gardens. Murray's was one of the first theme restaurants in New York and the greatest of the lobster palaces, opulent eateries where bon vivants like Diamond Jim Brady would polish off their nightly three dozen oysters and

From left to right: Unknown lady, Sealo, Jenny (a fat lady), Andy Potato Chips, and Charlie Lucas at Hubert's. Charlie has his right hand on Sealo's flipper. Andy was the subject of one of Arbus's iconic photographs, *Russian midget friends in a living room, 100th street, NYC. 1963.* His costume here suggests he might just have finished his Maurice Chevalier impersonation.

African American Photography Collection of Robert C. Langmuir

half a dozen lobsters. It featured an enormous main dining room done up as the atrium of a grand Roman villa, decorated with vines, fountains, and frescoes.

Prohibition and changing fashions ultimately doomed the lobster palaces. As the neighborhood began its slide from legitimate theater toward burlesque and chop suey joints, Murray's Roman Gardens was leased by Max Schaffer, an impresario of amusement parlors. Schaffer installed Hubert's Dime Museum and Flea Circus, along with a shooting gallery, a game room, and a souvenir shop.

With its quirky ambience, Hubert's soon became a Roaring Twenties institution, attracting high-society slummers and what was left of the theater crowd. Over the next forty years its louche charm made it a favorite subject for sophisticated journalists like Joseph Mitchell, A. J. Liebling, and Tom Wolfe. Jack Johnson, the famous black prize fighter, did a celebrity act there from 1933 until his death in 1948. Bob Dylan wrote about visiting the place in his early New York days. Even Lenny Bruce had a routine about going to Hubert's as a boy to see the "Scientific Marvel," Albert Alberta, a half-man half-woman. Professor Heckler's trained fleas had an irresistibly wacky quality and often made the news on their own account. A publicist once tried to check Heckler's star performer into the Waldorf-Astoria. Another flea was shipped to Hollywood, where it was slated to appear in a Claudette Colbert movie. Sadly, it got lost in the mail.

The floors above Hubert's Dime Museum and Flea Circus, formerly fancy hotel suites, were converted to apartments. Stripper Gypsy Rose Lee, who lived there in the 1940s, recalled that the hallways still bore traces of the original Roman decorations. By the 1960s, in an irony that was lost on appalled community leaders, the upstairs of the old Roman Gardens had become a male brothel.

DEEYAN AND ALLAN

DIANE—EVERYONE PRONOUNCED IT DEEYAN, with the *ee* and the *an* slurred together, and the second syllable slightly more accented than the first—was born into a nouveau riche New York family in 1923. Her people, the Nemerovs, operated Russeks, a rather flashy department store specializing in furs. Her father was an energetic man with a gift for fashion and an apparent taste for philandering. Her mother, while patient and forbearing toward her husband's airs and affairs, was otherwise pampered and self-absorbed. Somehow they produced three children of considerable talent. Diane's brother, Howard Nemerov, was a poet who attained national prominence. Her sister became an artist. Diane herself was a challenge right from the outset—self-contained, moody, and deep. She seems to have kept her surface-dwelling parents continually off balance.

She was quick to reject their bourgeois values. "I was born way up the ladder of middle class respectability" she said, "and I've been clambering down as fast as I could ever since." Aside from her distaste for the hypocrisy on the higher rungs of the ladder, Arbus was convinced that the niceties of upper-middle-class existence somehow insulated her from real life. She was, as curator Sandra Phillips put it, "cosseted"—raised in a series of Upper East Side palaces, surrounded by maids and governesses. She wanted for nothing materially, but received little emotional

or intellectual support from her parents. She once told an interviewer, "I never suffered from adversity . . . I was confirmed in a sense of unreality." As she matured she attempted to penetrate this sense of unreality by seeking intensity of physical experience. In her quiet way, she was an accomplished risk-taker. She was also a deeply sensual person, and as critic Judith Thurman put it, "never . . . a sexual economizer."

Teachers at her posh private high school recognized her as a talented painter, a gifted writer, and a voracious reader with a philosophical cast of mind. But instead of attending college, she married immediately after graduating. Her husband, Allan Arbus, was twenty-three. Diane had met him five years before, when she was thirteen, and fell in love with him on the spot. He worked in the advertising department at her father's department store, had no money and little future, and was the vehicle by which she was able to repudiate her background.

He was also bright and opinionated, deeply in love with Diane, and a profound influence on her. She called him Swami. He called her Girl. In 1941, shortly after they married, he bought her a camera, a Graflex 2¼ × 3¼. She took lessons from the famed photographer Berenice Abbott and shared what she learned with Allan. They frequented Stieglitz's gallery, An American Place, and studied the work of the masters. They took their own photographs and used the bathroom in their small apartment as a darkroom. They'd both gone mad for photography.

Allan enlisted in the Army during WW II and learned the fine points of his craft in the photography division of the Signal Corps. When he returned to civilian life the young couple launched themselves in New York as professional photographers under the company name Diane & Allan Arbus. Their first account was with Russek's, the family business, but soon they were getting fashion work from *Vogue, Glamour, Harper's Bazaar,* and

Seventeen. They became friendly with rising stars in the field Richard Avedon and Irving Penn and were considered competent, if not innovative, professionals.

Allan was the technician, the man who took the shots and did the darkroom work. Diane was creative director and stylist, coming up with the concept of each shoot, and going to endless trouble to make sure every detail was perfect. She had an uncanny way of setting the models at ease, of making them feel that she was interested in who they were and what they had to say.

Both she and Allan eventually discovered that the pretense and fantasy of the fashion world did not suit them. They were not very good at hustling and, though they were received warmly in the advertising departments of the big magazines, they dreaded trolling for jobs. They had other, deeper interests. Allan wanted desperately to be an actor. Diane was interested in photographing on her own terms, rather than those dictated by the narrow world of high fashion. She'd been taking pictures incessantly since the first days of their marriage, and clearly had talent. To his credit, Allan recognized this and encouraged her. Even as they found success in the fashion world, the business wore them down. They longed to escape.

Diane was the first out, after fifteen years of paying her dues as commercial photographer, wife, and mother. In 1956 she removed herself from the Diane & Allan Arbus firm, though Allan continued to operate it under that name. She began to study with Lisette Model, a renowned photographer in her own right, and in a surprisingly short time Arbus emerged as a serious and dedicated artist. Allan reported, "It was an absolutely magical breakthrough. After three weeks she felt totally freed and able to photograph." Accounts of this momentous period differ in their particulars, but they all suggest that contact with Model inspired Arbus to tap into a vision she had been honing all her life.

With a new sense of purpose, Arbus began numbering her negatives and corresponding contact sheets. She also started keeping appointment books and notebooks in which she recorded meetings, events, ideas for projects, quotations from books that appealed to her, snatches of conversations, and lists of ideas to investigate. The few such pages that have been released for public view are teeming, associative, fertile, almost manic. A single column on one page of a vest pocket notebook lists "suburbs, bus trip, train trip, station, opera, séance, gypsies, tattoo, testimonial dinner, ballet class, church meeting, antique show, horse show, families, ship sailing, graduation, seventh ave?, subway rush hour, museums."

It was one thing to make lists, quite another to meet their demands. Doon, born in 1945, and Amy, nine years her junior, still needed mothering. Diane improvised child care and sought help and support from friends. She and the girls moved to their own apartment in 1959, but Allan continued to pay the bills and provide emotional support. (In what Elsa Dorfman has rightly identified as one of the central mysteries of Arbus's life, her wealthy parents do not seem to have given the struggling couple any money—at this critical time, or ever.)

Even after their separation, Allan continued to make the firm's darkroom facilities available to Diane, and to assist her in technical matters, about which she claimed to have little interest and less skill. In these early years Arbus used thirty-five-millimeter cameras and available light, and she cropped and enlarged her negatives to isolate certain images. This tended to produce a grainy, dreamlike quality with which she was infatuated. Gradually, under Model's tutelage, she opted for clarity and precision. Model helped her understand specificity, the very sort of value early postmodernists were espousing in poetry and literature. "It was my teacher,

Lisette Model, who finally made it clear to me that the more specific you are, the more general it'll be."

This shift in emphasis corresponded with Arbus's selection of working locations. In the beginning, when she was able to get out and shoot, she followed the tradition of street photographers such as Louis Faurer or William Klein, seeking her subject matter in New York's commercial venues and public places. She photographed in Central Park, Times Square, Coney Island, and in movie theaters and automats.

She began shooting at Hubert's Museum sometime in 1956. The fact that Lisette Model took pictures of Hubert's performers suggests she may have sent her student there. But owing to its eccentric charm, Hubert's had a following among connoisseurs of Manhattan's offbeat venues, any of whom could have brought the place to Arbus's attention. She also took photographs at Club 82, a nightclub for female impersonators in lower Manhattan. This location was even more off the beaten path than Hubert's and, more to Arbus's purpose, it was considered risqué, with an air of the forbidden.

These two venues had an important element in common. One could not simply walk in and start snapping pictures, as at the zoo or even in a movie theater. Photographs were, as a matter of policy, forbidden. Guests were not allowed in dressing rooms, and at Hubert's, at least, fraternization with the customers was prohibited. Arbus's work in these places required much more cooperation from her subjects. It demanded a higher level of planning, of patient cultivation.

WHAT MORE CAN YOU ASK FOR?

THERE WERE TEN THEATERS in the immediate vicinity of Hubert's Museum—grand old showplaces like the Liberty, the Harris, and the New Amsterdam. By the 1960s they'd all grown shabby from neglect. Legitimate stage productions had long since departed, relegating these places to serve as "grind houses," cut-rate joints showing second- and third-run films twenty hours a day. Each theater had its specialty—westerns, war movies, crime, horror— and all the theaters served as trysting places and shelters where, for a modest admission fee, indigents could get off the street and catch a nap. Violent crime had begun its alarming rise in the neighborhood, and pornography was just gaining a foothold. Hot dogs and Orange Julius (an ideal mixer for methadone) had replaced the chop suey joints of the 1930s. Pizza cooks twirled huge discs of dough behind windows overlooking the street, hoping to lure customers in for a fifteen-cent slice. Closet-sized retail spaces bulged with souvenirs, jokes and tricks, cheap luggage, soft-core smut, evil-looking knives, and cut-rate imported electronic gear, including the latest marvel, transistor radios. Homosexuals converged at the Eighth Avenue end of the block, and the IRT subway arcade at the Seventh Avenue end—locals called it "the hole"—teemed with scary loiterers, runaways, and greaser mobs in their tight leather jackets and black continental pants. Chicken hawks prowled the street for young boys. Pimps, whores, hustlers of both sexes, punks, perverts, and addicts mixed with

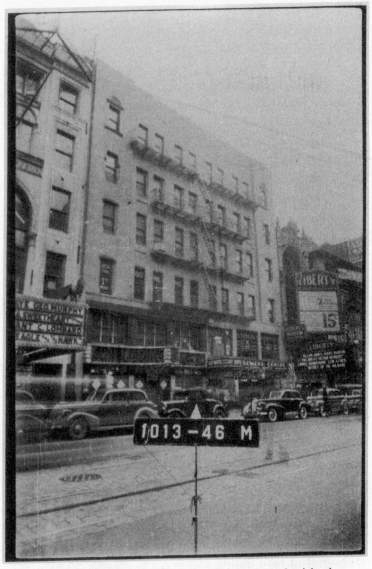

An old street scene, taken as part of a city survey during Hubert's heyday. The Hubert's sign is on the right, next to the Liberty Theater marquee.

New York Department of Records/Municipal Archives

the throng. On each side of the block was a patrolman whose primary job was to keep the loiterers moving.

By this time, Hubert's had been relegated to the basement, and the street level area, with its huge plate-glass windows, was given over to a souvenir shop, an amusement arcade, and a shooting gallery. Skeeball and pinball predominated. The place was a chaos of flashing lights, rifle cracks, and pinball clunks. You could buy a plastic replica of the Statue of Liberty, beat the cowboy to the draw, or have a picture of you and your girl taken in one of the curtained instant photo booths.

The back wall of this space was plastered with lurid posters advertising Hubert's and beckoning you downstairs. When you entered the basement level, you first passed a vacant space on your right, covered over with circus banners, forming an improvised tent. Under this tent was a beach chair on which Charlie Lucas would nap when things were slow, or take delicate sips from his daily pint of Christian Brothers brandy or Gordon's gin. As the inside talker, Charlie was a combination pitchman and master of ceremonies. His job was to gather the crowd, build their anticipation, and guide them into the "blowoff"—sideshow slang for an exhibit that customers had to pay extra to enter. If he wasn't napping or sipping, Charlie would be working the room, wearing his ivy-league sports jacket, narrow tie, and perfectly improbable fez, talking wondrous nonsense until there were enough of you to lead into one of the two acts that charged extra.

At the first stage on your right you might see DeWise Purdon, the crack marksman who would extinguish candles and split playing cards in half with his rifle. Purdon had no hands. He used a protruding stump of flesh to pull the trigger. He and his wife, a white couple, were special friends of Charlie Lucas and his wife, who were black. The four of them often dined together after work. In the tumult of Times Square, the mixture of races

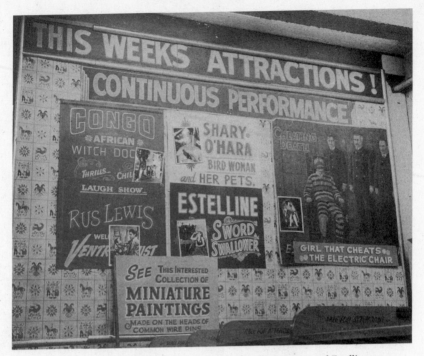

The lower part of the back wall at Hubert's, mid-1950s. Congo and Estelline are already featured attractions. A row of Skee Ball machines occupies the right foreground. *African American Photography Collection of Robert C. Langmuir*

seemed not to matter, or perhaps was overshadowed by the sight of a man with stumps moving fork to mouth.

Further down the right-hand wall was a large stage for featured acts. Here you might see Congo the Jungle Creep, the black Haitian man whose act spoofed the traditional savage shtick. He wore a fright wig, black tights, and garlands of animal skins and totemic gewgaws. He was a born street performer, who swallowed lit cigarettes and regurgitated them, still smoking, grunted "ugga mugga," and generally gave the crowd a satisfying few minutes of wild, improvised shenanigans. Or you might see Jack Dracula,

who was as gifted a performer, in his own way, as Congo. Jack, who stood six foot five, and was decked out in a rhinestone cape and jeweled hood, would glide slowly onto the stage, as if he were floating. His mysterious entrance froze visitors in their tracks. He'd slide the cape from his shoulders, revealing a body covered with 350 tattoos—"twenty seven of which," he'd intone, removing the hood with a flourish, "are on my FACE!" Jack Dracula, if you were *that* interested, and if Charlie needed him to stall so that the crowd could build, would show you his tattoo gear, even let you feel the vibrating needle against your skin.

Then Charlie would take up a position in front of the flea circus, a partitioned space the next stop down, and deliver what was known in the trade as "an opening." This was an exhortation aimed at exciting the crowd sufficiently to get them to part with another quarter to go inside and watch the fleas do their tricks. A contemporary account gives a sample of Charlie's patter. (Charmingly, in what we can only hope was a gin-induced error, flea numbah three has been omitted entirely.)

"NUMBAH one!" continues the Talker, raising his voice suddenly, "*will* kick a football. Numbah TWO! Will juggle a ball that is three times his size while lying on *his* back. Num-BAH four! Will operate a miniature merry-*go*-round that is no bigger than this silver dollar I hold here." (He bounces it on the bally-box with a loud metallic clink.) "NUM-bah five will run the famous chariot *race*, and the flea which hops the fastest *will* win. NUM-bah SIX! *and* the feature of this show today is the *dancing* fleas! Little lady fleas dressed in hoopskirts and costumes of silks and lace, rhinestone jewelry and each little gown tucked into the waists of these infinitest-timial

Estelline Pike, the sword swallower.
African American Photography Collection of Robert C. Langmuir

creatures. And the fee to *see* all this is only *twenty*-five cents and you pay me right here. Step this way, ladies and gentlemen, to see Professor *Heckler* and his *Trained* FLEA CIRCUS!"

The "tip"—those customers willing to pay the extra fee— would then be let into the room, whose walls were lined with mounted butterflies (collected by Roy Heckler himself) and old newspaper clippings about the flea circus. The center of attention was a high table covered with a white desk blotter. Here, under the glare of rickety lamps, Heckler would put his fleas through their paces, narrating in a sing-song drawl that had been polished over thousands of performances. If it was meal time for fleas you'd get to watch him feed his charges, inverting a tumbler full of them onto his forearm and letting them graze while he calmly smoked a cigar.

Then to another stage, on which would appear Stanley Berent who, because his hands grew out of his shoulders, performed as Sealo the Seal Boy. (When nature called, Sealo undid his zipper with a cup hook attached to the end of a dowel. Bobby Reynolds, a kid who hung around Hubert's studying sideshow arts instead of going to school, once hid Sealo's stick—with predictable results.) Or you might see Lydia Suarez the contortionist, or Estelline Pike the sword swallower, her pleasant, cheerful, southern accent offset by the terrible *schlupping* sound the sword made as it came back up her throat.

There was a dressing room in the back corner, and toilets and vending machines at the far end of the room. Charlie, in his aggrandized talker parlance, referred to these as the "men's smoker" and "ladies powder room." His pitch extolled the virtues of Hubert's concessions: "We have a cigarette machine, a Coca-Cola machine that will give you four different types or variety of

drinks I should say. We have a candy machine. What more can you ask for?"

Charlie had to keep the talent rotating so that there would always be fresh acts for the people. Hubert's was the only freak show that was open year-round, and the only such show in New York City. Hence there were plenty of acts at Charlie's disposal. Presto and Dingo were magicians and fire dancers. Jean Carroll and Lorette were tattooed ladies. William Durks, perhaps the most grotesque of the born freaks, had a face split right up the middle, ending in an empty socket where the top of his nose should have been—into which Durks, a man with no little sense of humor, painted a third eye. He was married to Mildred, the Alligator Skin Girl. Tiny Tim worked Hubert's as Larry Love, the Human Canary. He wore his hair short back then, and was a fanatical baseball fan. Eddie Carmel, the Jewish Giant, was the World's Tallest Cowboy during his Hubert's gigs. Andrew Ratoucheff, the Russian midget, worked as Andy Potato Chips. There were many others. They all knew each other, and to some extent they depended on one another. Jack would occasionally cook kielbasa for Sealo when they were on the road. Andy might loan Charlie a few bucks. News of job openings was regularly exchanged. Their relationships were collegial, professional. They considered themselves performers, not freaks.

After you got to the end of the right-hand wall, you'd cross over to a partitioned space containing the second blowoff. The crowd would have to pay another quarter for admission, so it would have to be something sexy or grotesque. At Hubert's it was Charlie's very attractive wife doing a seductive dance with a live python slithering around her. Her name was Virginia. In those days she was billed as Princess Sahloo, though she also performed under the pseudo-African names Princess Wago and Woogie.

Woogie and her snake at an outdoor venue on the road somewhere in New England or Canada in the 1940s. *African American Photography Collection of Robert C. Langmuir*

Everyone called her Woogie. She had a lovely smile and a direct, oddly wholesome way with the customers. If you were lucky, you'd get to touch the snake when the dance was over. Then two or three girls, usually Puerto Ricans or blacks, would do another dance, and the music would stop.

Next to the blowoff was a stage fronted by coin machines that would guess your weight or vend comic books or let you fire a pistol at a target or look at paintings on the head of a pin. There was a "blade box" onstage, one of those contraptions they stuck swords into and never killed the girl. Also the electric chair, in which a performer or a brave spectator would sit, unharmed, while the current lit a fluorescent tube in his hand. Or Harold Smith would be playing his musical glasses. He was courtly and grave, a natural-born mortician type, and he filled in as Charlie Lucas's assistant manager, working nights or when Charlie was out sick.

Past some relics from the Collyer brothers' mansion (they were a couple of eccentric millionaire pack rats who died in the squalor of their hoarded objects), up the L-shaped staircase, through the racket of the arcade, and you were back on Forty-second Street. You'd be entranced or repelled or—if you were a certain kind of sophisticate—bemused by the palpable aura of failure barely averted, of a weariness just this side of desperation, of the tatty, threadbare courage of an institution that had long outlived its time.

EARLY BOB

BOB LANGMUIR, AN INCURABLE ROMANTIC, occasionally saw his life as a long series of bizarre adventures linked by extraordinary coincidences. This was probably truer than he knew; as the perpetual cutting edge of his own biography, Bob himself was a bizarre adventure. But there were later times when he could sense something deeper than coincidence—something fated, inexorable—in his connection with Charlie Lucas and Diane Arbus.

Bob's first great mentor and friend was a man named Paul Grillo. Bob and Paul met in 1965, when Bob was a sophomore at Springfield High in suburban Philadelphia, and Paul, then in his early twenties, was a fledgling teacher at Cardinal O'Hara, the nearby Catholic school from which Bob had recently been expelled. Paul, a mustachioed, pipe-smoking intellectual, held a weekend salon for "youthful seekers" at his West Philadelphia apartment. Where others might have seen dyslexia and behavioral problems, Paul saw in Bob a healthy sense of mischief, a zest for life, and an innovative, powerful intellect, albeit with very stringent requirements—baseball, music, girls—as to what was worthy of its attention. He also saw something he described as a persistent "thread of curiosity." Beneath Bob's chaotic affect, Paul detected the makings of a scholar. At that time he was probably the only one in the world who would have made such a diagnosis, but events proved him correct.

Like thousands of young people, Paul and Bob shared a deep

interest in folk music, especially the blues. Part of this was love of the music, plain and simple, but it was also a rejection of the hypocrisy, conformity, and empty materialism that seemed to be infecting society. The music of downtrodden negroes had intensity and honesty—qualities sorely lacking in white America of the 1950s and early '60s. However it is characteristic of Bob that he was not content to spend hours mooning over vinyl compilations of scratchy old blues tunes.

He was the oldest of six children, all born within nine years. His father, a time-motion engineer at the Lennox china plant, was sufficiently well-off to hire a woman to help his harried wife with children and chores. As it happened, the suburban Philadelphia neighborhood in which they lived was close to a well-established community of black people who, generations before, had worked as domestics for prosperous Quakers. So Bob got raised by a large black lady who lived just down the street. Her name was Thelma McDaniels, and she had a growly voice like Big Mama Thornton's.

Bob adored her, followed her everywhere. He learned important things about the world from her, and he absorbed the cadences and particulars of middle-class black American life. As a result, black people never seemed alien or threatening to him. They reminded him of Thelma and of the security he had felt at her side. Throughout his life he'd unconsciously use ebonic turns of phrase—"I be getting some of that"—because talking like that made him feel comfortable, happy. By the time he fell in with Paul, he felt like his own species of white negro, as different from Norman Mailer's alienated intellectual as he could be, but of the same strange genus nonetheless.

Bob knew that the truly authentic blues was on 78-rpm records, but he also knew that they were collector's items; none of the regular record shops stocked such things. So one day in 1966

Young Bob enthralled at a circus exhibit in 1956. He says this was "the seed, the very moment, of my fascination with collecting and history." *African American Photography Collection of Robert C. Langmuir*

he took the bus to Media, the courthouse town a few miles away, and paid a visit to People's TV, Tire & Record Store. He'd had his eye on the place for years. People's was an ancient emporium of low-end goods, frequented almost exclusively by blacks. Bob supposed that if there were still some old race records around, they'd be in a place like this. Trying not to seem too eager, he went in and asked if they had any 78s. Bob was led down a dark flight of stairs—it seemed to him like going down a rabbit hole—into a

bonanza. It was the first of many rabbit holes for him, the first of many such finds.

Down there, on long metal racks, were hundreds of vintage 78s, immaculate in their original sleeves and cardboard mailing boxes. Bluebird, Savoy, Flair, Gotham, Blue Note, Swing, Chess—all the great labels, for sale at "fitty cent" apiece (the price spat out like a challenge by the counterman when Bob emerged with an innocent grin and an armful of records). He bought what he could afford and took them home, where he organized and shelved them as Paul had taught him, and listened attentively. The less interesting ones he took to school and sold to fellow blues fanatics for a dollar apiece. Then he realized he could take that money and buy more records, then sell them, and use the proceeds to buy still more, keeping the best ones for himself and selling the rest. He worked People's TV, Tire & Record until he'd cleaned them out. That was the start of it. The pleasures of collecting, he discovered, paled beside the thrill of *dealing*. He was sixteen years old.

Books were Paul's other interest, and eventually Paul introduced Bob to Sam Kleinman, owner of Schuylkill Book and Curio, a wondrous junk heap and treasure room, full of dark corners, surprising discoveries, and more rabbit holes than Bob could have thought possible. Kleinman was hardly the kind of picturesque old bird you'd imagine, perched in front of a mountain of dusty tomes. He had the muscular, solid build of a retired athlete, a gray brush cut, wire-rimmed glasses, and he never, ever, *ever* stopped talking. His scorn for Philadelphia's high-end antiquarian booksellers was matched only by his love for the books themselves. There was an aspect of madness to his chatter, but plenty of meaningful content as well. He was brimming with marvelous tales of treasures snatched at flea markets, of first editions rescued from junk bins, of snooty, upper-crust booksellers bearded in their dens.

None of this came out at first. Some imagined affront nearly got Bob thrown out of the place on his initial visit, and he was allowed only gradually to work his way into the old man's confidence. He had to study. He had to read. He had to listen to an ungodly amount of Kleinman's jawing about city politics, about the neighborhood, about the nasty, short, and brutish lives of his rivals. But once he got going in the right vein, Kleinman had an endless store of itchily fascinating tales about books and authors—about Lord Byron sleeping with his sister, Thorsten Veblen letting his dirty dishes pile up in a huge sink and then hosing them down all at once, Dylan Thomas drinking so much his brain exploded, Mary Lamb murdering her mother with a carving knife at dinner and then sitting down with her brother to write children's books.

Kleinman was far too self-absorbed to think of mentoring Bob the way Paul had, but he did at least discern Bob's natural interests and began telling him stories about the great modern illustrators—men like Rockwell Kent, Lynd Ward, Maxfield Parrish, and their English predecessors, chiefly the Pre-Raphaelites, and back as far as the brilliant and eccentric William Blake. The first book Bob ever purchased for himself came from the shelves of Kleinman's shop. It was a biography of Edward Burne-Jones. Bob got so excited about the Pre-Raphaelites that he started wearing capes.

By the time he graduated from Springfield High in 1968, nothing cum laude, Bob had been captured by old books, and by the risks and thrills of dealing. He was ready for life as an antiquarian book dealer, he just didn't know it yet.

He had other things on his mind, so he commenced a three-year ramble that included stints in the merchant marine and a brief tour as a road man in Muddy Waters's band, and which culminated in the accident at Mad River Glen in the summer of 1971.

Bob in the early 1970s, just back from
a stint in Russia and the merchant
marine, still looking for his land legs.
Photo by James Gowen

Then a short bout with higher education, and the resultant desperate escape to Alaska, where the first of his mysterious depressions ensued, perhaps related to his accident, and where he was rescued by a man named, he swears, Robert Johnson.

After each of his adventures he'd return to Paul's to regale the Grillo family with tales from the great wide world. Paul's wife loved him. Their daughters considered him an uncle. The Grillos, he felt, were the family he never had. For Paul, there was a different kind of payback. Bob's natural exuberance lifted his spirits. "I laughed harder when I was with him."

Bob filed a lawsuit against Bill Mooney's insurance company and was eventually awarded a $35,000 settlement, which funded a tour of Europe that led to the resolution of Bob's single most important question: He was twenty-five years old. Should he continue his rambling ways or settle down and start a life?

In relating the event, Bob places himself on the bank of the Bosporus, the strait that divides Europe and Asia. It's a Byronic moment, and we can assume that he'd found a lofty perch on which to stand, overlooking the timeless waters, wrapped in his cape. Far to the east was India, the land that called to him, a place where his spiritual quest might be fulfilled. To the west was

home—everything familiar, comfortable, and safe. At that moment, in a life-altering flash of insight, he realized he was just about fed up with being on the road, sleeping in the rough, getting rousted by pickpockets, petty thieves, and lowlifes, not to mention cops and hulking peasants. India, for all its spiritual promise, would be more of the same. Paradoxically, home seemed like the place where something new might happen.

So he turned around and headed west, spent a summer in Ireland, and wound up in a basement apartment in London's seedy Earl's Court neighborhood, working for an Indian housepainter and buying books and Pre-Raphaelite wardrobe items in that city's abundant flea markets and junk shops. "I was trying to live my life like a character in a book," he said. In Paul Grillo's estimation, he gave it a good run. "Back then, everybody wanted to live like Kerouac. Bob actually *did* it."

By 1976, however, Earl's Court and London housepainting were getting stale. Having decided to take up the book business in earnest, Bob moved his collection back to the States, rented an apartment in Media, Pennsylvania (just a few blocks from the scene of his first triumph at People's TV), and bought an old VW camper that he drove around day and night looking for books at yard sales, flea markets, thrift shops, and antique stores.

It was a frenetic period for him. He didn't really understand the way the business worked and was trying to force himself into it by sheer energy. Finally, a savvy old bookseller hipped him to the fact that just as banks were where the money was, bookstores were where he'd find the books. The game for a book scout like Bob (and that's what he was, a man without a retail shop, going around scouting for valuable books) was *knowledge*. So Bob began to get serious about educating himself as a book scout. Employing the methodology he'd learned at Paul Grillo's side, he studied his fa-

vorite illustrators in depth. He also read about photography and, because it fascinated him, American history and literature.

Bob cut an exotic figure back then, as he tore through the greater Philadelphia area in his velour cape, like some Godfather of Book, prowling, clowning, making people chuckle and shake their heads, but always curious, always aware, always ready for the next rabbit hole to open. The recession of the early 1970s had gotten people acutely aware of the value of collectables. They were ransacking their change jars for silver coins and pillaging their attics for treasures. Floods of antiques and books hit the market in a chain of transactions that began with auctions, estate sales, or "house calls" made by predatory dealers. Bob remembers those years as a sort of golden age for him, full of great finds and limitless prospects.

LIFE IN THE COLONIES

IN 1960 DIANE ARBUS had the first of several lengthy conversations with Joseph Mitchell, a *New Yorker* writer and one of the great delineators of the city's characters and eccentrics. "She asked me how I found the kind of people I wrote about and I told her by being persistent—by hanging around." This was not exactly news to Arbus, but it confirmed her approach. Mitchell went on, "I told her about Professor Heckler at the flea circus, who was a good friend of mine. Did she know him? I asked. Indeed she did—she had been spending a lot of time at the flea circus." This was when she would have befriended Charlie Lucas and his wife, Woogie.

She was developing a methodology that would separate her from many of the innovators of the fifties and sixties. Typically the work of photographers such as Robert Frank or Gary Winogrand was based on a candid, improvisational approach to the subject. A photograph might be taken, seemingly at random, on a crowded street or from the window of a moving automobile. But Arbus's work at Hubert's and Club 82 necessitated a different method. She was, to use Susan Sontag's dismissive term, "colonizing" territories on the fringes of society. (Bruce Davidson, a friend and colleague of Arbus's, was working along similar lines, spending extended time with a Brooklyn gang. A few of his pictures from that project were actually taken at Hubert's, one of the gang's favorite destinations.) As she had during her career in fash-

ion photography, Arbus deployed her personal skills to establish working relationships with particular "models" from these subcultures. She collaborated with them to produce images that were as carefully conceived as any high-fashion shoot. This gave her work—regardless of whether you loved it or detested it—an enormous emotional charge.

At about this time she began a fruitful association with the editors of *Esquire*. The venerable magazine for men was in the process of reinventing itself as an edgier and hipper publication. The editors hired talented writers such as Tom Wolfe, Gay Talese, and Norman Mailer, whose work was coming to define the highly personal, inventive style known as New Journalism. This type of writing, as well as its frequent choice of oddball subject matter, meshed with Arbus's developing aesthetic. Her first major freelance magazine job was a photo essay in the July 1960 issue of *Esquire*. It had the ambitious title "The Vertical Journey: Six Movements of a Moment within the Heart of the City." It featured Congo the Jungle Creep and Andy Potato Chips—both Hubert's performers. This was followed by a similar spread in the November 1961 issue of *Harper's Bazaar* entitled "The Full Circle," which featured five eccentrics. One of them, the tattooed man who called himself Jack Dracula, Arbus had met at Hubert's Museum.

It was an auspicious beginning—two portfolio spreads in major magazines within a year—but these grandiose assignments did not continue. As curator Thomas Southall says, "In 1962 and 1963, the magazines Arbus had been working for began to discover that her real strength lay in portraiture." She was sent out to photograph artists, writers, and celebrities—everyone from Bennett Cerf to Mae West. Between 1960 and her death in 1971 she published over 250 photos in magazines like *Harper's Bazaar*, *Esquire*, the *New York Times*, *Holiday*, and even *Sports*

Illustrated and the *Saturday Evening Post.* Few featured her writing at any length, and fewer still showcased her work in the portfolio format, as had "Vertical Journey" and "Full Circle."

The magazine work may not have been entirely to Arbus's liking, but she knew she could not continue to rely on support from Allan, who was moving more and more into his new life as an actor. She used her intelligence and personal charm to talk editors into assignments that interested her, and she was able to maintain an unusual degree of autonomy in how they were shot. She was also adept at coordinating her working life with her development as an artist.

Hubert's Museum continued to be a fertile source for Arbus, resulting in relationships with performers who would become the subjects of her most famous images. Arbus's in-depth association with this world had another beneficial effect. According to curator Elisabeth Sussman, each subculture she explored turned out to be, "not only a territory unto itself, but a key to deciphering the rules of another, apparently unconnected, subculture." She was mining the vein that had opened at Hubert's, and the tunnels branched and deepened.

BOB: THE MIDDLE YEARS

IN THE MID-1970S BOB hooked up with a strange, compulsive little rat of a man who drank sour milk, pissed in jugs, and slept in piles of his books. Over the years this fellow had accumulated tens of thousands of volumes, some of them quite valuable. Toward the end of his life, when his building was condemned, Bob was there to help him dispose of his stock, and to help himself to some of the more interesting items, offered in lieu of payment. The man had a sheet of rare airmail stamps in mint condition, and Bob says he was given one.

Bob sold that stamp, which even then would have been worth hundreds of dollars, for thirty-five dollars. He says he took it to a sharp old stamp dealer, and the man bullied and browbeat him until he found himself unable to say no to the offer, even though he knew the stamp was worth a lot more. He took the money and ran out of the shop just to escape the torture of having to argue. Then, at home, he fell into a depression. Hated himself for being such a patsy. Resented the stamp man for being so greedy and dishonest. It was an awful spell, and Bob spent weeks fighting his way clear of it.

Mistakes were inevitable. Sooner or later, any dealer would pay too dearly or sell too cheaply. Most quickly learned that it was of primary importance not to dwell on errors of the past, but to learn from them and forge ahead.

Bob sometimes found himself unable to achieve this perspective. Perhaps he lacked the self-esteem to present his opinions with sufficient force. Perhaps he was, at heart, too gentle to relish the rough give-and-take of haggling. Perhaps, by the time he discovered, bought, and paid for the thing, he had no more energy left to devote to the selling of it. Whatever occasioned such episodes, it left him with a bitter, gnawing sense of failure and self-recrimination that negated the fun of owning that precious object.

There were variations on the theme. One day he was out at a country auction with Bill Mooney and he saw a lovely painting of a girl in a white dress signed, "Rockwell Kent. 1934." Bob had never seen the painting in any reference books on Kent. But he knew Kent's style and he was certain this one was genuine. He made Mooney stay there with him until the painting came up for sale. The bidding started at fifty dollars and quickly rose to nine hundred, Bob topping every advance. Mooney was beside himself. Nine hundred dollars, for those two guys in those days, was an enormous amount of money. He kept tugging Bob's sleeve, begging him to put his hand down, begging him to stop. Which Bob eventually did, but only after the painting had been knocked down to him at $950. He paid for it with what was left of the insurance money, getting down to the bottom of *that* barrel. Bill thought he was nuts.

Bob took the painting back to his apartment in Media and hung it on the wall. He loved it. But then the devil began whispering in his ear. The painting was so beautiful that it was too beautiful for him. It was too valuable, too fine. He didn't deserve it. It began to make him uncomfortable. He took it to a gallery in Philadelphia and they promptly sold it on consignment. Bob got $2,250. But instead of being happy he dwelled on the fact that the buyer had paid five grand for it. He probably could have sold

it himself for even more. He felt like a fool. He'd never even wanted to sell the painting in the first place!

After a few years of selling his wares out of a booth in an antique mall west of Philly, Bob fell in with John Hellebrand, a tall, saturnine fellow about his own age who was also an aspiring book dealer. The two were perfectly complementary: short and tall, joyous and grave, self-doubting and assured. Bob was all action and Hellebrand was all intellect. Bob had traveled more, had scouted a broader range, but John had cultivated a different level of the book world. He introduced Bob to the auction rooms— Freeman's in Philadelphia, and Swann's, Christie's, and Sotheby's in New York. This exposure to higher-end material opened Bob's eyes to the true potential of his trade. Books *did* sell for thousands and even tens of thousands of dollars. It was just a matter of knowing which ones—Bob got right on that end of it—and of knowing where to sell them—which was more naturally John's province.

For a while the friendship thrived. Bob would scout up great material and bring it back to John, who'd give the thumbs up or thumbs down—not always correctly, in Bob's opinion. Sometimes he felt demeaned by his friend's remarks. In his own insecurity, he wondered if Hellebrand was disrespecting him, or only using him to scout up interesting books. On the other hand, Hellebrand and his wife were feeding him; they hooked him up with a whole new crowd, and even let him crash on their couch. Besides, John could be funny, and he truly was smart. The two spent many hours brainstorming about the trade, swapping information, trying to figure exactly where they fit in the grand scheme of things.

Which was ultimately the issue over which they split. John wanted to use Bob's knowledge and energy, and Bob wanted to use John's money and social connections. As long as it was

informal give and take, the arrangement worked to their mutual satisfaction. But when Bob suggested an official business partnership, John gave him the cold shoulder.

That was okay. It was time to split, anyway. One of the people he'd gotten to know through John was a lady named Mrs. Dickinson who ran a bookshop called Book Mark on Rittenhouse Square West in the heart of Philadelphia's ritzy downtown district. Bob began selling her his finds, and then he started working there. When Mrs. D. had to take her ailing husband to Florida for the winter, Bob assumed full responsibility for running the place. This gave him a different status in the book world, elevating him, in the eyes of established dealers at McManus or Allen's or Baldwin's, from a scout to a colleague. People were starting to notice him now. He was getting a reputation as a smart young fella. Somehow the capes got left behind.

During that winter, when Mrs. Dickinson was in Florida, a couple of her friends approached Bob. They thought the business was ripe for buying, and they wanted to buy it at an advantageous price. So they tried to enlist him, knowing he had Mrs. Dickinson's sympathy and trust, as their straw buyer. Bob politely declined. Then, when Mrs. D. returned, he informed her of the plan her "friends" had hatched in her absence. The old lady was aghast. She had, in fact, been planning to sell the business—but never to those traitors! She expressed her appreciation of Bob's loyalty then and there by offering to sell Book Mark to him for five thousand dollars cash. Without even thinking, Bob said yes. Mrs. Dickinson wrote out a contract on the back of a matchbook. Bob borrowed some of the money from his mother. For the rest, he took Valerie Francis on as a partner in business and in life. That episode is worthy of its own chapter in this account, though in the hearts of its principals it undoubtedly deserves an entire book.

SIMOOM IN THE SAHARA

VALERIE FRANCIS IS A HANDSOME, dark-haired woman whose naturally pensive expression is equally likely to erupt in raucous delight or molten rage. She's heavier now, but she was a dancer in her youth, and she still carries herself in a dancer's square-shouldered way. She's also agoraphobic, and though the affliction is always with her, she says its severity "comes and goes." She lives in a narrow, three-storey building about one hundred yards down a tunnel-like back alley from the Book Mark building, which she owns with Bob, so she and Zoe, her Jack Russell terrier, can get to and from their daily work without venturing into public spaces.

Back in 1977 she was going out with a fellow who was a big fan of the novelist John Cheever. Valerie thought it would be nice to make him a present of a first edition of one of Cheever's books, so she called around town and wound up putting in a request at Book Mark, whose clerk had sounded friendly and encouraging over the phone. The clerk, of course, was Bob, serving his apprenticeship under Mrs. Dickinson. During his telephone interview with Ms. Francis, he realized he had a passing acquaintance with her boyfriend, a black man, and he made the understandable but incorrect assumption that Valerie Francis was black, too. This, combined with her husky telephone voice and obvious intelligence, made her interesting to Bob.

Eventually Bob found a Cheever that filled the bill and called

Ms. Francis. She said that while he'd been looking for the book, she'd broken up with her boyfriend, but since he'd been good enough to find it for her she'd stop by and pick it up, anyway. When she got to Book Mark, she found that Bob had been called away on an urgent book buy. But he'd left a long, flirtatious note with the book, addressed to "Lady Day." She telephoned him when he returned and asked him if it was store policy to harass female customers. He was hooked.

A portrait of Valerie in the old Book Mark shop, painted by her husband, Larry Francis. The wall behind Val conveys some of the shop's offbeat charm. *Collection of Robert C. Langmuir*

They continued communicating by telephone and increasingly intimate notes for a month or more, intensely aware that they'd hit upon a loony, antiquated way to commence a relationship—one that was romantic and platonic, but also, in its continually deferred gratification, hugely erotic. Part of the reason for the deferral was Valerie's uncertainty. How would Bob, the man of the world, the book adventurer, react when he found out she was agoraphobic? Finally she couldn't stand it. "I've had enough," she thought. "We must be in love, even though we've never met." They arranged a rendezvous.

Valerie was headed home on the appointed day to ready herself for the big meeting when she saw him, waiting on the land-

ing of her apartment. Her first conscious thought on beholding Bob, a short, scholarly-looking guy, was, "He's not my type. Not my type at all!" But that hardly mattered. Valerie was determined not to be deterred from her great love. And Bob's attentions were relentless, irresistible.

Her agoraphobia seemed to be a nonissue at first. Bob insisted on moving in with her right away, and began taking her every day to Mrs. Dickinson's shop with him. She quickly fell in love with the place, the dusty slant of sunlight through the big front window, the smell of old books, the murmur of browsers. Despite her fear of crowds she was terrific with people one-on-one, and the cozy surround of musty old tomes made her feel protected, secure. After a few months she quit her regular job as a retail jeweler and went to work as Bob's assistant. And when Mrs. Dickinson, betrayed by her socialite friends, offered the shop to Bob, Valerie came up with another five thousand dollars to capitalize the fledging enterprise.

Bob stocked Book Mark by frequenting all the country auctions, flea markets, antique stores, and bookshops that he'd cultivated during his days with Hellebrand. Soon his shelves were filled with Americana, art and architecture, photography, local history, color-plate books, and other serious nonfiction subjects calculated to appeal to Philadelphia's cultivated collectors. Customers began drifting in, attracted more by the young couple's intelligence and charm than by the books they offered. With disturbing frequency, well-tailored ladies and gentlemen would enter, poke around, and announce, "What a charming place! I'll have to come back when I've got more time."

The fledgling entrepreneurs began to realize there wasn't enough time in the world to wait until those phonies dropped any money at Book Mark. Consequently their checkbook ran on

empty, and they were constantly having to sell Bob's finds on the cheap to raise cash. This drew swarms of more established dealers, and it fed Bob's paranoid suspicion that he was being used by his colleagues. When Sotheby's auction gallery called from New York and told him that *Simoom in the Sahara* had sold for three thousand dollars, it was a godsend.

Simoom in the Sahara was an early nineteenth-century genre landscape by a French painter of no great distinction who had supposedly accompanied Napoleon to Egypt. It featured Arabs in white robes, horses, camels, and lots of dust, *simoom* being a native term for a dust storm. Bob had taken it, six months before, to an appraisal day held in Philadelphia by Sotheby's. These appraisal days were popular events back in the 1970s, forerunners of *Antiques Roadshow* and excellent advertising for the firms that sponsored them. Sotheby's art expert, a soft-spoken gentleman not much older than Bob, said the painting might be worth a few thousand. Afraid that the art expert might change his mind, Bob drove up to Sotheby's the very next Monday and consigned the painting to auction. The actual sale of *Simoom* was just another in a long series of stopgap funding measures that kept Book Mark afloat in those early days. However the story behind its purchase and deacquisition contained a lesson that stayed with Bob for the rest of his career.

He'd been running WE BUY OLD BOOKS classified ads in several local papers in the Philadelphia area. One day a young man called in response to the ad and asked if Bob bought paintings as well as books. Bob, recalling the Rockwell Kent caper, said he did indeed buy paintings. The young man replied that he and his uncle worked cleaning out houses in Chester, and that they'd come upon some real old paintings in fancy frames. Bob drove down to Chester, a tough waterfront town south of Philadelphia, and found the address, a funky row house along the edge of I-95.

The kid, slender and black, about eighteen years old, was sitting on the covered porch in front of the row house with three paintings. The two bigger ones were three hundred dollars each. Bob bought the smaller one, *Simoom*, for $150, which was all he could afford. The kid called several times after that, but Bob was broke, and never bought another painting from him. He carried *Simoom* to the shop, where it hung, charmingly, for months until it went up to New York.

Long after the three-thousand-dollar windfall had been spent, Bob saw an article in the papers about the kid who'd sold him the painting. There'd been reports of gunfire in a penthouse apartment in downtown Philadelphia. When the cops responded, they found Bob's vendor ensconced in a luxury suite, appointed with a gun, $14,000 cash, a wounded visitor, and dozens of packing crates loaded with paintings destined for major auction houses in New York. The young man had obviously stepped up his business plan after his encounter with Bob. Police speculated that the source of these paintings had been the Deshong Mansion, the derelict estate of a deceased Chester millionaire. The kid had been cleaning house all right, pilfering the Deshong Mansion for a year or more and sending the spoils to auction in New York. Because the Deshong estate was in disarray it was impossible to say exactly how much had been stolen, or to place any legal claim on the goods that had already been fenced. Bob's profit on *Simoom* was in the clear, which was good news. More interesting to him (in an abstract way, at least) was the image of a prestigious New York auction gallery blithely accepting four hundred thousand dollars' worth of European paintings from an eighteen-year-old ghetto kid—"More paintings for us, Sir? Very well, just back your truck into our loading dock on Seventy-second Street."

No charges were pressed in the shooting, but the kid got three years' hard time for interstate transportation of stolen property.

After he paid his debt to society, the IRS decided he owed half a million dollars' worth of taxes and penalties on his ill-gotten gains. They garnished his salary down to ninety dollars a week. He wound up living with his mother and being treated for chronic depression. Sotheby's, according to the article, "was not accused of any wrongdoing."

DIANE AND JOHN

MONEY WAS ALWAYS A PROBLEM. The going page rate for magazine work was only $150, and Arbus's annual income during the eleven years of her working career averaged only about $4,000. In 1962, hoping to relieve the financial pressure and make more time for her own projects, she applied for a Guggenheim Fellowship. She was encouraged and assisted in this endeavor by Robert Frank, Walker Evans, Lee Friedlander, and Lisette Model. Each of these colleagues had already won a Guggenheim, and their support was crucial in establishing Diane's credentials.

In the course of the application process she submitted a portfolio of her photographs to John Szarkowski, the recently hired head of the photography department at New York's Museum of Modern Art. The photographs were accompanied by a letter from Arbus citing the sponsorship of Evans and company, and stating in a typically forthright but graceful manner that "each of them has suggested I show you my work because your recommendation, if you could give it, would be so significant."

This was a critical moment in her career. There were hundreds of photographers roaming the city, taking pictures for artistic rather than commercial reasons. Some had their work published in magazines, a few might have sold prints to patrons or admirers or hung them in public at venues like Helen Gee's Limelight coffeehouse (galleries specializing in photographs did not yet exist), but few received grants to pursue their work, or

the support of well-known institutions like MoMA, whose photography department had become the great clearinghouse for the work of contemporary American photographers. Szarkowski's approval would indeed be significant because, aside from helping her win a grant, it would be a major step toward validating her work as art and insuring a broader audience for her photographs.

As it happened, this was also a critical moment in John Szarkowski's career.

He was thirty-seven years old, just two years younger than Arbus, and was a working photographer himself. He had been chosen by Edward Steichen, the outgoing chief of MoMA's photography department, to be his successor. Szarkowski, an unassuming midwesterner, thought he'd stay at the museum for three years, six at the most. But he brought with him his own strong ideas about photography, developed on the job and in academia. These ideas were to have a profound effect not only on his own career but on the world of photography as well. Near the end of what turned out to be a thirty-year tenure at MoMA, *U.S. News and World Report* said, "Szarkowski's thinking, whether Americans know it or not, has become our thinking about photography."

Steichen had grounded MoMA's photography department in the aesthetic of magazines, which both editorially and in their advertising pages used the photograph as a means to demonstrate a larger idea. Szarkowski developed a revisionist view. In the catalog of one of his first exhibitions he announced, "Photography was unmasked, and shown not to be a faithful witness but an interpreter. The subject would now tend to become not the reason for the picture, but its pretext; the picture's first function was to reveal the *photographer*." Szarkowski reversed Steichen's direction by emphasizing any photographer's potential as an artist, and photography itself as an art.

Although he elaborated on the implications of this concept throughout his career, Szarkowski was anything but an ideologue. He employed his vast erudition and enormous energy in a continual process of discovery of photography as it emerged from the present. He was a prolific and talented writer, inherently decent enough not to go on at length about things he didn't like, and possessed of the rare good sense to know when to shut up. He used these skills to promote the artists who exemplified his continually evolving views of what photography was all about.

In Diane Arbus, Szarkowski saw a person whose energy and purpose equaled his, and whose artistic agenda squared, in its own unique way, with his ideas about photography. If she hadn't come along, he would've invented her, or found her somewhere else.

At their first meeting in 1962, Szarkowski was drawn to her on a personal level, but had mixed feelings about her photographs. "I didn't really like them but they were very forceful." He was more impressed by the profound seriousness of Arbus and her work. He characterized her as "somebody who was just enormously ambitious, really ambitious. Not in any cheap way. In the most serious way. Someone who was going to stand for no minor successes . . . There's something untouchable about that kind of ambition." Szarkowski's workload prevented him from meeting Arbus before the submission of her Guggenheim application, but that hardly mattered. In April 1963 she received a grant from the Guggenheim Foundation for "photographic studies of American rites, manners and customs."

Through persistent application of her "untouchable" ambition and with the help of a network of serious artists like Lisette Model, Walker Evans, Robert Frank, and John Szarkowski, Arbus began opening the cultural channels through which her work would be received as art rather than mere magazine journalism.

In 1964 Szarkowski acquired six Arbus photographs (along with an additional one she donated) for MoMA's collection. This was her first museum sale ever. The next year two of the photographs in this lot were included in a MoMA show entitled Recent Acquisitions.

Diane cited Recent Acquisitions, along with some of the images that had resulted from magazine assignments, as evidence of work accomplished when she applied for a renewal of her Guggenheim grant in 1965. She wrote, "The Fellowship enabled me to go far enough to find the way to go further. I have learned to get past the door, from the outside to the inside. One milieu leads to another." In a literal sense, she might have been talking about the process by which her work at Hubert's and her friendship with Charlie Lucas led her to the circuses and sideshows that provided subjects for her later work. Her Guggenheim was renewed in 1966 for $7,500.

Hubert's Museum was by that time a thing of the past. The flea maestro, Roy Heckler, had gone into retirement, and Charlie, Woogie, and the rest of the performers, supplanted in Times Square by X-rated movies and electronic games, were no longer financially viable as a form of entertainment. The live acts shut down at the end of 1965, though the place remained open as a forlorn arcade long enough for Joe Buck to walk past its backlit sign in the 1969 movie Midnight Cowboy.

In February 1967 a momentous show called New Documents opened at MoMA. Szarkowski intended it as a demonstration that documentary photography had broken away from the dignified sociological presentation exemplified by giants like Evans and Dorothea Lange. Two of the photographers chosen for this show, Gary Winogrand and Lee Friedlander, made Szarkowski's point in a witty, deep, and occasionally uproarious selection of work that shared the largest of the exhibition's two rooms. But

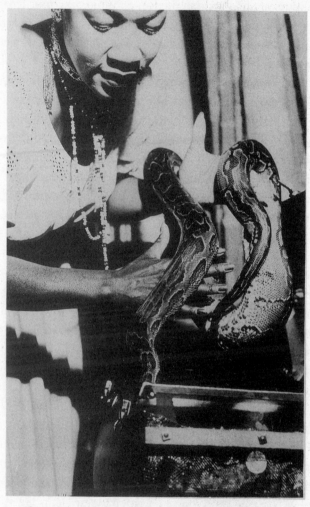

This is a pitch card that Woogie used when she performed as
Princess Sahloo. Performers autographed these photo postcards
and sold them to raise money and promote themselves.
African American Photography Collection of Robert C. Langmuir

Arbus's thirty-two photographs, presented by themselves in the second room, had a visceral edge, an unnerving psychological component that no one had encountered before. Reactions ranged from excoriation to exaltation. One thing, however, was certain: Diane Arbus had broken new ground.

Typically, she'd been ambivalent about getting involved in New Documents in the first place. As the show began to come together, Szarkowski had to use his charm and enthusiasm to rally her to the task of selecting images. Ultimately, Andy Potato Chips and two denizens of Club 82 made their appearances, accompanied by nudists, transvestite whores, the arresting images of a young man in hair curlers, and a handsome young woman with a cigar. At Szarkowski's urging she printed several in a large 16 × 20-inch format, which only enhanced their shock value. The physical labor involved in getting all this material exhibition-ready must have been tremendous. Further complicating matters was the fact that sometime in the summer of 1966 Arbus had come down with hepatitis. There can be little doubt that the disease affected her energy level. It also seems to have exacerbated her tendency toward depression.

Still, her enthusiasm gained momentum as the opening of the show approached. She made postcard-size prints of some of the images and sent these out as invitations to friends (today these ephemeral items are worth tens of thousands of dollars apiece). She sent Szarkowski a typed list, several pages long, of people to be invited on her behalf. Mr. and Mrs. Leonard Bernstein were included, as were Gloria Vanderbilt, Frank Stella, and Anthony Perkins. "Charlie and Woogie Lucas, 232 West 116," were also on the guest list, three lines below the Bernsteins. Next to their names Diane wrote in green ink, "She is a snake charmer."

JAN, MEG, ERNIE, AND MOM

OTHER LESSONS AWAITED BOB as he struggled to make Book Mark a thriving concern. He went to an auction one day and paid twelve dollars for a collection of photos and books from the estate of an old man who, by the auctioneer's description, had been in the magazine business in the 1930s. As Bob soon learned, the "old man" was Dr. Mehemed Fehmy Agha, art director for the Condé Nast chain and an early innovator in the way magazines used photography.

Dr. Agha's collection included valuable books on photography, issues of the rare periodical *Camera Work,* and an expandable manila folder crammed with two hundred 8 × 10 photos taken by people like Steichen, Horst, Beaton, and Sheeler. Bob began to suspect that he'd made another big score. His suspicion was reinforced when the two stocky Middle Eastern types who'd attended the Agha auction, and who were under the impression that Bob had made a presale agreement with them, followed him back to his shop and demanded to be cut in on the lot. For some reason, one of them was armed with a carpenter's hammer, which he waved vigorously in Bob's face until Valerie came in and scared them off.

After a few days a local photo dealer, smelling blood in the water, drifted into the shop and convinced Bob to let him dispose of the Agha property. He did pretty well on Bob's twelve-dollar investment, grossing thousands, which they split. But it

didn't take long for that old sulfurous whiff of self-doubt to rise up again in Bob. He began to realize that being stuck in the retail shop made him a sitting duck for predators like that photography dealer, who'd simply wholesaled the goods—something Bob could have done just as well by himself.

He'd screwed the deal up and cost Valerie and himself a lot of money. Depression set in again. Fearing exploitation by other dealers, Bob became more reclusive, evasive. His colleagues began to realize that he was a hard man to get along with. Even worse, Valerie was beginning to realize the same thing.

Hoping to escape other booksellers, Bob fell in with Carl Palmer, the wastrel son of a wealthy businessman, who introduced Bob to his Main Line crowd of auction-room habitués and dilettante antiquers. Valerie had no use for Carl, whom she rightly saw as a mere dabbler, forcing himself between her and Bob. Carl didn't like Valerie, either. She was too loud, too Jewish (though he was Jewish himself). He found a more acceptable girlfriend for Bob who, to Valerie's mortification, was open-minded enough to at least try to see if Carl's taste in women might be better than his own.

Valerie sulked, left the shop, took a job she hated, and went to great lengths to share her misery with Bob, who stormed and moped and even hinted darkly at suicide. But it is generally true that once you've fallen in love some part of you is always there. The new girlfriend soon disappeared, as did Carl Palmer. Valerie started coming into the shop on Saturdays, the biggest retail day, because Bob was hopeless with customers, and she took up the bookkeeping again. They tried to avoid each other at the shop, and they were cold and formal when circumstances forced them together, but they'd begun to recover a relationship that stood an excellent chance of enduring.

Then Bob met Jan.

It was a golden October in 1982, a day so crisp and sere that even a disgruntled lover couldn't help but take heart. Bob was scouting an auction out in Lancaster County, at a dignified old stone house that sat up on a hill, its white-pillared porch looking down over rolling gardens, statuary, and a reflecting pool, around which were lotted rugs, paintings, furniture, various "smalls" such as china or flatware, and tables heaped with estate jewelry, books, and family papers.

In this idyllic setting, while inspecting the definitive thirty-nine-volume set of *Ruskin's Works* in full black morocco with raised bands, red labels, and gilt inner dentelles, Bob, to his complete surprise, espied something even tastier. Two classy-looking women, about twenty yards away from him, were doing the same thing he was—examining the goods with serious, professional eyes. One was tall and long-necked, not unattractive. The other was perhaps six inches shorter than he, with dark hair neatly trimmed, framing an oval face, round cheeks, and winningly pursed lips (occasioned, at that moment, by her deep study of a piece of Delftware). She was tidily gotten up in a flowing dress with a gingham apron pressed against her shapely breasts and hips.

In the instant Bob first beheld her, he saw his future. He saw a life lived graciously with this impeccable, cultured pearl, in a milieu of art, antiques, and fine books. He saw travel to the great cities of Europe and Asia. He saw salon evenings, vastly more brilliant than any he'd had in Paul Grillo's living room, overseen by this intelligent beauty, with himself in the background (always in the background!) basking in the radiance of it all. An erotic rush pulsed through him, followed by a mad, dizzying tumble out of space and time into the abyss of—could it really be true love again? Or was it his own fantasy, his own need, projected onto a fellow being who in some mysterious way had sent out the

message that she was receptive? Perhaps it was both. Perhaps always is.

Bob ran his usual full-court press, outbidding the women on a vellum-bound limited edition children's book, illustrated and signed by Arthur Rackham, and using that as an excuse to chat them up. It turned out they were sisters. They lived together with their mother in a renovated farmhouse they called Merrie Green. The long-necked one was Meg. The shorter one was Jan. She was thirty-four years old. She had a masters degree in fine arts, and she ran a little antiques business out of the front room at Mom's house, sharing a bedroom with Meg upstairs. Unattached! Or so he thought.

There was a book fair in Lancaster the next Friday evening, and Bob met the sisters, accompanied by their mother, there. He took the ladies out to dinner after the fair and quickly discovered that an inordinately tight bond existed between the two sisters, their brother, Ernie, and Mom, a charismatic woman who, in Bob's opinion, assumed it was her matronly duty to manage the lives of her offspring, and who regarded him, right from the outset, as a hindrance to this mission. She and her husband had parted company years earlier, and the husband, who'd gotten rich running a string of Manpower Inc. franchises, had given her the operation in Lancaster. She spent its profits turning a broken-down farm into the Victorian family fantasy known as Merrie Green.

It didn't take long for Bob and Jan to discover how many interests they shared. They both liked books, art, and antiques, and they were both crazy about animals, especially birds and cats. Bob was desperate to escape his psychological miseries and the debacle with Valerie, and Jan needed just as desperately to find a life beyond the confines of Merrie Green. Neither of them was getting any younger. With so much in common, it was no won-

der they fell in love. Despite the apparent disapproval of Ernie, Meg, and Mom, they were married in June 1984.

Valerie, whose relationship with Bob had by that time progressed to the point that she was again genuinely interested in his well being, was convinced that his new kin—despite their strange relational baggage—would provide Bob with the sense of family and stability he had always craved.

MISS McRAE

UNFORTUNATELY, VALERIE WAS WRONG. Bob and Jan ran into trouble after four months of married life.

Jan felt trapped in their teeny Lancaster newlywed apartment. She had no friends in the neighborhood, so she spent a lot of time with Mom and Meg at Merrie Green. Bob resented that, and a lot more besides. There was none of the hoped-for male bonding with his brother-in-law over weekend TV sports. The newlyweds, as a couple, were rarely invited to Merrie Green or on any family outings. Bob would commute home from a hard day in Philadelphia and Jan would be gone. He'd call Merrie Green, but of course they'd all be out somewhere. He felt that he was being systematically excluded from the family. Why was he even bothering to support Jan if she was, in effect, continuing to live with her mother?

The unhappy couple sought counseling. It was decided that they needed more room and a fresh start, so they bought half of a cute little duplex just down from the old silk mill in Lancaster and tried again. Jan began working at Manpower, but she wasn't earning much. The financial burden of their new mortgage threatened to add to their marital difficulties.

However Mrs. Dickinson's quaint idea of opening a shop on Rittenhouse Square turned out to have been brilliant. Once Valerie and Bob sloughed off the last of the old lady's socialite friends, serious professionals and dedicated collectors began

coming in. The downtown location lent an air of legitimacy to the operation, which was reinforced by the interesting material Bob was able to find and by the clever way Valerie managed the ambiance. Financing the house in Lancaster, and its continual redecoration and improvement, turned out to be fairly painless. More important, Valerie and Bob, always excellent business partners, were becoming friends again.

Meanwhile, Miss McRae got old and died. Miss McRae was a chain-smoking, mole-covered crone who happened to own quite a bit of Philadelphia real estate, including a string of buildings on Rittenhouse Square West. She was Book Mark's (and Valerie's) landlady. The lease had been included in Mrs. Dickinson's deal with Bob, and when it expired Miss McRae graciously renewed it at the old rate. She had a boyfriend named Mr. Greer who, although he looked like Elmer Fudd, had schooled her sufficiently in the ways of love that she conceived a deep empathy, in her eccentric, disfigured heart, for Valerie and Bob. After her death it turned out that she'd done her young friends the kindness of securing them first refusal on the Book Mark building and on the building a few doors down in which Valerie lived. It was an offer Valerie and Bob had to take. The question was, how would they finance it?

They didn't have to look far for an answer. Just at this time, the Franklin Institute, one of Philadelphia's oldest and most respected historical establishments, resolved to reinvent themselves as a more open and accessible Franklin Institute Science Museum. As part of their master plan, they determined to send their little-used collection of antiquarian books and periodicals to auction.

This played right into Bob's hands. He contacted everyone who might be interested in such material—all his new, high-end customers, as well as institutions like Winterthur, Princeton, and

the Bronfman-funded Canadian Centre for Architecture. Many expressed interest in specific items. Some sent librarians to Philadelphia to be wined and dined by Bob, who took advance orders. When the books were auctioned off, Bob bought about a third of them. He wound up making a handsome profit on his purchases, most of which he'd presold.

The periodicals, scheduled to be auctioned in another sale, were even rarer—things like Belgian textile catalogs from the 1850s with fabric swatches, or German instrument-makers' directories, or illustrated trade catalogs on obscure technologies from the eighteenth and nineteenth centuries. A big-time English dealer hired Bob—on commission—to purchase the periodicals and ship them back to London. Bob was happy to do so, outbidding several local dealers and institutions in the process, then shipping the goods out by air at a huge cost. He made another killing on that deal. The Englishman, as it developed, failed to turn a profit, having overpaid in order to dominate the auction.

The one melancholy aspect of the whole caper was that a splendid research library had been dismantled. Sure, it was dusty and underutilized, but it was a world-class collection of reference materials. After the first round of books had been sold, a few local politicians woke up and protested. Bob recalls that the city council allotted something close to $200,000 for the purchase of the remains of the library. But all the city's allocation accomplished was to make the Englishman pay more. He lost his shirt, Philly lost the pamphlets, and Bob got the down payment for the Book Mark building.

THE FINAL ACT

NOTWITHSTANDING ARBUS'S MISGIVINGS, New Documents was an important event. Gary Winogrand said that the show "meant everything" to her. She sent one of her handmade postcards of *Identical Twins, Roselle, NJ,* to a friend, telling him that her work seemed "just much more beautiful than I had ever seen it at home." The show was noted in trade journals and specialist periodicals such as *Arts,* whose reviewer referred to the "great humanity of Diane Arbus's art." It also caught the attention of mass media outlets. Jacob Deschin, the stalwart *New York Times* camera editor, was a bit put off, noting that "she seems to respond to the grotesque in life." But the review was illustrated with one of Arbus's photos. *Newsweek* attributed to her "the sharp, crystal-clear, generous vision of a poet," and paired her with Louise Nevelson in chatty articles that shared the Art section for March 20, 1967. Over the next year, a somewhat abbreviated version of New Documents toured the U.S. Inevitably, reviews of the controversial show—whether they appeared in Detroit or Minneapolis, Houston or Atlanta, were illustrated with *Two Transvestites* or *Twins,* or one of Arbus's other signature images. New Documents put her and her work squarely before the public.

Eventually, though, the excitement began to wear her down. The exhibition was scheduled to run until the first week in May, but Arbus left town at the end of March to use some of her Guggenheim money photographing in Florida. "The show was

splendid but too many calls and letters and people thinking I am an expert or incredibly loveable. I need to be forlorn and anonymous in order to be truly happy." "Forlorn" was never far away, though its actuality may have been more troubling than the gamine image she suggests. Anonymity was beginning to be more difficult.

Her newfound notoriety impeded her ability to get work from the usual sources. Over the next few years she did a few projects for London's *Sunday Times Magazine* and a British magazine called *Nova*. She visited the hippy scene in Haight-Ashbury, whose latter-day "freaks" bored her; covered the antiwar movement for *Esquire;* and created a small firestorm by publishing a nude, stoned-out portrait of Warhol star Viva in *New York Magazine*. But by the end of the decade, her *Magazine* work had diminished considerably. Thomas Southall, the expert on this aspect of Arbus's career, suggests, "Arbus's style had become well known . . . it certainly did not help her to have the public, potential sitters, and editors increasingly associate her work with controversial subjects."

In 1968 she was diagnosed again with hepatitis. The debilitating side effects of this disease may have been exacerbated by the finalization of her divorce from Allan. In 1969 he moved to the West Coast, remarried, and pursued his acting career full time. (He is best remembered for his role as Major Sidney Freedman, the psychiatrist in the long-running TV series MASH.) He and Diane remained on good terms, but she found herself profoundly affected by the change. By all accounts, the severity of her depressions increased. She wrote a friend, "I am literally *scared* of getting depressed . . . And it is so goddamn chemical." Still, she was able to work through the melancholy and lethargy to produce some of her greatest photographs. *Albino Sword Swallower at a Carnival, Jewish Giant at Home with His Parents in the*

Bronx, and *Mexican Dwarf in His Hotel Room* all date from this period.

Celebrity had other unexpected consequences. She complained to Allan, "I feel paranoid and besieged . . . Partly it is the goddam honors and people wanting to see me . . . and museums wanting prints for no money." Even worse, she had a sense that her signature techniques were being stolen from her. "Everyone is turning to Rolleis and . . . printing with borders." She experimented with other cameras and resolved to abandon the Rolleiflex's square format.

Toward the end of 1969 she began photographing seriously at what she referred to as "the retarded school." This was actually Vineland State School, one of several institutions for the mentally retarded in New Jersey at which she'd been given permission to take pictures of the inmates. These places were the last territory she would "colonize" the way she'd worked at Hubert's—spending time, establishing connections, securing permissions, and producing an extended body of work. Her pictures of retarded adults were a departure in terms of style and subject matter, and may have been a reaction to her sense of being besieged by imitators. John Szarkowski later spoke of her need to "get out from under all these people she felt she was carrying on her back."

Szarkowski, always supportive, hired Diane to research and edit an exhibition of news photography at MoMA. She applied for grants and taught for a semester at the Rhode Island School of Design. With the help of her lover, collaborator, and mentor, Marvin Israel, she designed and marketed a limited edition portfolio of her work that she called *Box of Ten Photographs.* An edition of fifty was planned, but the technical difficulties, both with the innovative Plexiglas box and with the production of so many large prints, were immense. Finally she managed to print a few

full sets, complete with annotations and plastic container, which she sold for a thousand dollars each. She taught a photography class in her apartment building and continued to work on developing magazine assignments and on selling prints to museums, but her exhaustion and the difficulty of her life had taken their toll. On July 26, 1971, she climbed into the bathtub, overdosed on barbiturates, and slit her wrists.

She was forty-eight years old when she died. Her daughter Amy was at summer school. Doon was in Paris. Allan was out West making a movie. Marvin Israel was at Richard Avedon's house on Fire Island. And Bob Langmuir was in that box truck with Bill Mooney, coming 'round the mountain at Mad River Glen.

The text in *Diane Arbus Revelations* (the encyclopedic tome issued in conjunction with Arbus's most recent retrospective) characterizes her final act as "neither inevitable nor spontaneous, neither perplexing nor intelligible," urging us to regard her suicide in the same way we are to consider her photographs—"in the eloquence of . . . silence."

BLACK HISTORY

IN THE DECADE AFTER THE FRANKLIN INSTITUTE sale, even as Book Mark flourished, Bob's personal difficulties increased. He'd discover a book or a pamphlet for which there was no recent record, or no record at all. His instincts would tell him it was a terrific piece, and usually his instincts would be correct. But the moment he sold it, he'd be overwhelmed by the feeling that he'd sold it too cheaply. His brain would teem in that particularly anxious, uncomfortable ADD way—What *was* that piece worth? Who could truly know? There was only one answer. The fact that someone bought the item proved, in the most perverse way, that he *had* sold it too cheaply. Otherwise they wouldn't have bought it. Then he'd hate himself. He'd get into that blues mentality in which the people who bought from him disrespected him for being so easy. So he'd try to be hard the next time, to protect himself more, and buyers would think he was acting like a jerk, which would make him paranoid. How come nobody liked him? That would make him bitter. They were all phonies, anyway. He became treacherous. Driven to that desperate, alienated state in which unforgivable things seem unremarkable, he mistreated people, but only, he told himself, because they'd have mistreated him if he'd waited around for it. And, as if to balance his transgressions, there were the inevitable, seemingly inexplicable, affronts. Why were people so mean to him? His pathology stalked him like a tiger in the jungle.

Bob's disenchantment was contagious. Valerie began to unravel, too. The death of her father was a big blow, sapping her of the energy that made her so successful at retail. By 1995 they were both fed up with the ancient and honorable tradition of maintaining a charming antiquarian bookshop, run by odd but fascinating people. They just didn't have it in them anymore to be someone else's eccentric. They took to hiding in the room above the store, wallowing in their dysfunction, compulsively watching the O.J. trial (at the time, they both thought O.J. was innocent). If a customer rang the doorbell begging admittance to the shop, Valerie would tell Bob, "You get it." Bob would reply, "No, you." If some particularly intriguing testimony was being offered, the door would never get answered.

That was when Bob resolved to remove himself once and for all from the antiquarian book trade. Recalling his beloved black nanny, Thelma McDaniels, and his early adventures at People's TV, he decided to throw Book Mark's resources and his own considerable talent into the acquisition and sale of ephemeral material pertaining to African American history and culture. He was certain this change in his area of specialization would lead him away from his regular rounds, away from the phonies, liars, deadbeats, and backstabbers who had been his colleagues in the book world. He hoped it would be the ticket back to his own personal Eden.

The artifacts of black Americana were more visual than literary, and Bob began purchasing photographs, posters, broadsheets, newspapers, and magazines having to do with African American religion, music, sports, and other forms of entertainment, as well as with black popular culture and daily life. This sort of material was still relatively common and inexpensive, and by buying on the cheap and selling a small part of his finds, he was able to keep paying his bills, and to keep acquiring new

material, which he'd catalog and organize. When he sold a substantial archive of black history material to Emory University, his new path was clear. It was furtive, it was dark, but it worked for him.

By the time the millennium rolled around, Bob and Valerie had found out about eBay, a venue that liberated Valerie from having people in her face, and Bob, at least momentarily, from the awful feeling that he was selling his goods too cheaply. They set themselves up with a fast computer with lots of RAM, a DSL connection, a printer, a scanner, and an eighty-dollar-an-hour geek to hook it all up for them.

Thus it was that in the midst of their mutual burnout they stumbled onto a new and highly successful business model. Bob would go out and buy his African American photographs and ephemera and give some of the items to Valerie to flog on eBay. Then he'd sort and assemble the rest into larger subject collections, or send the best items up to New York for auction at Swann's. He became the leading consignor to Swann's annual black history auction, contributing as much as 60 percent of the lots offered. This was a hell of a lot more efficient than schmoozing retail customers or getting picked over by opportunistic dealers.

However, it was far from an ideal situation. The sad truth was that getting out of antiquarian books and into African American ephemera had provided only temporary relief. Bob still felt he was running around too much, drinking too much, not paying sufficient attention to his inner needs. He wanted to change his way of living, to stop hustling, to become more spiritual. He fantasized about moving to Mexico, about getting out, somehow.

Jan decided they needed a change. She found a place on a one-acre parcel of land along the Conestoga River outside Lancaster, a beautiful old stone house situated on top of a rise that

sloped a quarter mile down to the river, not steep enough to be a cliff, but sufficient to give a dramatic sense of the way the land fell off, the river taking its sweet, pokey time below. They hired a gang of Mennonites to come in and clear the locust trees and sycamores, and the gorge filled with yellow sunlight, darting birds, and river mist.

But trouble between them heated up again, this time regarding the disposition of their old house on Janet Avenue. Bob had little wish to get back into the manic business mode in order to keep up with their now substantial mortgage. He wanted to sell the old place and use the proceeds to pay down the debt on the new house. Jan was adamantly against it. Real estate, she insisted, was a good investment. Bob assented grudgingly, adding that resentment to his growing list. She rented the old place to her hairdresser at a rate that was less than the monthly financing, tax, and insurance costs, and he wound up deeper in the fray than ever— scouting antique shops, flea markets, and ephemera shows up and down the East Coast.

It was at one of these shows that Bob first encountered a tall, slender, immaculately dressed dude, with the lilting, British-tinged accent and refined manners of an upper-class postcolonial African man. He said his name was Amos Chikaodili Okeke, but that everybody called him Okie. He was from Nigeria, descended from Nigerian royalty. This, in itself, didn't particularly impress Bob, who had never met a Nigerian not of royal descent, and who assumed they simply had a different standard for assigning royalty. He picked through Okie's stock and, seeing some potential there, told Okie that he was a dealer in African Americana. Okie told Bob that African Americana was his specialty. "Everyone wants to buy my stuff," he confided, and suddenly Bob wanted to buy his stuff, too, just to discover what was really there, to see if Okie might be standing at the mouth of a rabbit hole.

THE COLLECTORS

BOB HAD BEEN A COLLECTOR all his life. His first experience as a dealer—reselling those blues records from People's TV—had begun as a collecting foray. He'd made his living for decades by satisfying the needs of collectors, and he himself was the proud owner of a collection of thousands of photographs documenting twentieth-century African American culture. The primacy of his collector's retentive instincts may even have been the reason for the difficulties he experienced pricing and selling his wares. But he was as unable as the next man to explain why he or anyone collected things, except that the activity provided a sense of security and satisfaction.

What he could talk about with more certainty was the process. First you got interested in something and then you acquired some of it and you discovered how satisfying acquisition and ownership could be. Since even the most casual collector was an informed consumer, your activities inevitably led in the direction of scholarship. Collecting might also develop a social dimension because people who collected the same things shared immediate, and sometimes deep, bonds. But, because every collector was personally invested in his collection, pride, competitiveness, and secrecy were important parts of the game. This investiture of pride and scholarship had another dimension. Almost any good collection was worth more than the sum of its parts, and most collections tended to accrue monetary value

over time. At the highest levels of collecting there was enormous prestige as well as great value. A collection could denote a person's social standing. Frick and Huntington and men of their ilk were memorialized as much by their collections as by their millions.

Imagine those captains of industry plundering Europe for paintings, sculpture, and objects of virtu with which to appoint their lives. Imagine Berenson advising them, Duveen greasing the wheels of commerce. Imagine the next generation of great men, advised and assisted by a whole corps of professional Berensons and Duveens—a specialized class of dealers, appraisers, curators, and conservators that arose to satisfy the collecting impulses of the wealthy. Now imagine a time when supplies of the best material—the old masters, for example—ran short, as inevitably they must have. The rich folks still needed things to acquire, and the people who made their living selling art still needed goods to sell. Could it have been an accident that works of the impressionists entered the market? And when the greatest impressionist paintings had been sold, or had escalated in value beyond the reach of all but the richest few, could the luminists, or the abstract expressionists have been far behind?

This is a simplistic rendition, but it illustrates the trend. The market for collectable objects, whether high art or low kitsch, is constantly moving downward in search of new product. At its entry level, the product is undervalued—a Van Gogh sells for a pittance in 1907. At the other end of the process, Van Gogh becomes virtually unobtainable, but a Jasper Johns can still be had. With the democratization of wealth in America that followed the Second World War, there were thousands of little Fricks running around, snatching up objects of virtu, appointing their lives with Rauschenbergs, memorializing themselves with works of the New York school.

Gradually, over the course of the twentieth century, by some mysterious and complex process of institutional and public consensus, abetted by the efforts of people like Alfred Stieglitz and John Szarkowski, certain works of photography came to be included in the class of art objects. It was then only a matter of time before the collector's market found them. Critic Peter Bunnell describes the process in economic terms, beginning with "the capitalist concept of the art work as a singularly rare object, with a measure of its importance provided by the extent of its economic value." He continues, "The first country to truly exploit this notion of capitalist enterprise with regard to art photography was the United States . . . the development of the private gallery, of organized marketing activity replete with regular exhibitions and published criticism, was an American contribution."

Bunnell rightly credits Stieglitz and his 291 Gallery with pioneering the movement. But after 1912 the gallery showed no photography at all, and Stieglitz took typically stubborn pride in operating in an unbusinesslike manner. (His Intimate Gallery announcement of 1925 stated, "No effort will be made to sell anything to anyone.") It was half a century later that photography entered the marketplace in any meaningful fashion—and even then at the lowest level.

Many innovations fed into the birth of the market. Once the technology developed sufficiently that a photographic image could be printed simultaneously on a page with text, magazines and newspapers began relying on photography for commercial purposes. Journals specializing in fashion photography came into their own around the time of the First World War. The 1920s saw the invention and mass production of rugged and portable thirty-five-millimeter cameras that allowed new levels of freedom and access. Improvements in photoengraving techniques and the introduction of high-speed rotary presses made the mass

dissemination of inexpensive, high-quality images possible. This fostered the rise of photojournalism in the 1930s. During WW II, picture news magazines like *Life* became dominant. (In terms of American photography, the war had a couple of interesting side effects. Many professional photographers—Allan Arbus, Richard Avedon, and Lee Friedlander come immediately to mind—received their training during the war, and others, such as André Kertész and Lisette Model, were displaced by the war from Europe to America.)

In the 1950s pictorial magazines featuring fashion or current affairs, and rich in photographic advertisements, reached their golden age. They were well funded and adroitly edited, and could choose from the work of a group of highly skilled professionals who drew their sustenance from magazine assignments. Some of these photographers were able to produce commercial images that had a creative edge, or to juggle personal work with lucrative magazine assignments. Others accepted commercial work only grudgingly in order to support their artistic endeavors. Together these men and women produced an unprecedented quantity of work that was intellectually accessible, readily available, still comparatively inexpensive, and potentially investment worthy. To put it bluntly, there was plenty of product around, and once it had been ordained as art, it began to find a market among collectors.

In 1969 Lee Witkin opened the first successful gallery in New York dedicated to photography. He carried the work of the great nineteenth- and twentieth-century photographers at prices ranging from twenty-five to two hundred dollars, and was soon emulated by dealers like Harry Lunn in Washington, D.C., or by operations like Tennyson Schad's Light Gallery in Manhattan, the first to specialize in the work of contemporary photographers. These people were selling photographs to institutions, but they were also patronized by a generation of visually literate young

professionals who had grown up in a world informed by picture magazines and TV.

The "published criticism" required by Bunnell, works such as Sontag's *On Photography* or Roland Barthes's influential *Camera Lucida*, helped legitimize the product by giving it a philosophical underpinning. Critics like Andy Grundberg and Hilton Kramer reviewed photography for newspapers and periodicals. Universities began adding courses in photography to their curricula, thereby providing jobs for underpaid photographers as well as educating future collectors. Gallery owners, intent on honing their "organized marketing activity," began to develop more businesslike methods, keeping photographers on retainer or purchasing work in bulk and reselling it at hefty profit margins.

Auction galleries always had their place in the trade. By the midseventies, Christie's and Sotheby's were holding dedicated photography sales each spring and fall. Public auctions gave the appearance, at least, of representing fair market value (whereas prices and deals in private sales might be juggled for any number of reasons). Auction results were public information, and they helped legitimize and abet the growth of the photography market.

The record for the sale at auction of a single image by a twentieth-century photographer climbed steadily and always made for exciting news. In 1983 Charles Sheeler's $6\frac{1}{4} \times 9\frac{1}{2}$-inch silver print *Wheels* sold for $67,000. Photography soared along with everything else in the art boom of the late 1980s, and when the crash came at the end of the decade, photographs held up better, in terms of value, than paintings or antiques. In 1989 Edward Weston's *Shell* sold for $115,500, only to be beaten in 1991 by his former girlfriend Tina Modotti's *Roses, Mexico,* which sold for $165,000. Stieglitz's photo of Georgia O'Keeffe in *Hands with Thimble* sold for $398,500 in 1993. Then, in 1999, the London

auction of the photography collection of André Jammes, which had been estimated at $2–3 million, brought in excess of $10 million. This was an unprecedented leap, and although the works being offered were primarily nineteenth-century photographs, the excitement spread quickly through the rest of the photography world.

A specialist newsletter called the *Photograph Collector* began keeping systematic track of values. They assembled a "market basket" of twenty-five representative images—from nineteenth-century masterpieces to such modern works as Ansel Adams's *Moonrise, Hernandez, New Mexico* and Lange's *Migrant Mother.* Beginning with the results of the 1975 season, they recorded the auction sales of each of these images and compiled them into an average index value. For comparison purposes, these results were pegged against the Dow Jones industrial average. The starting point for both the Dow and the Photograph Collector's Comparative Auction Index was 815, which was where the stock market stood in the fall of 1975.

By October 2002, just as Bob began courting Okie, the Dow was at 8,494. The Photograph Collector's Index was at 24,940. To put it another way, the Dow had appreciated 1,042 percent since 1975. The photography market, as represented by those twenty-five images, had appreciated 3,060 percent in the same time period.

OUT OF AFRICA

WHETHER OR NOT OKIE'S FAMILY in Nigeria was descended from royalty, they possessed sufficient wealth to send him, in 1990, to Los Angeles to study theater. Somehow, though, despite his good looks and charming manner, his career on the stage never materialized. Okie wangled himself a job as a script reader for a small-time producer.

One day the producer was in desperate need of an obscure reference book, without which he would be unable to complete a project. On his own initiative Okie began looking for the book. In the course of calls to publishers and local bookshops he stumbled upon a specialist dealer in Northern California who was able to supply the book for two hundred dollars. Okie took it to his boss, who was ecstatic. He asked Okie how much it had cost, and Okie, off the top of his head, replied, "Six hundred dollars." The man gave him the money and one hundred dollars extra for his trouble.

Thinking he'd discovered a golden goose, Okie quit the script-reading job and set up a book-search service. Hundreds of requests poured in, not one of which Okie was able to fill. That was how he learned that rare books are called rare because they're nearly impossible to find. Not only that, but everybody was looking for the same precious few. He shut down the book-search service before it ever turned a dime.

But he'd learned something. Publishers, it developed, were eager to supply nonrare books. In fact, after a few cash-with-orders, they were happy to send books on invoice. Even better, they were lackadaisical about making collections. Thirty days could easily stretch out to sixty, ninety, and beyond. Okie would send partial payment, a few returns, and another bigger order. Books began arriving by the case, purchased mostly on credit, at deep wholesale discounts. He'd peddle these to the dozens of new and used bookstores in Greater Los Angeles at his cost plus just a fraction, and order more on credit. His apartment got so full of books that he was forced to open a little bookstore adjacent to a coffee shop along L.A.'s Golden Mile. Angelenos loved his taste, and his business proved a great success. The only problem was that it took work. Too much work.

He was so distracted by this problem that when a man came into his shop with three boxes of old books at fifty dollars per carton, Okie peeled off a buck and a half just to get rid of him. As soon as the man left, Okie assumed he'd been hustled. But the books were his now, so he blew dust off the dustjackets and looked through them, recognizing the names Hemingway and Fitzgerald and suddenly getting a good feeling about the man-nered twenties designs that graced their covers. On a hunch, he called in a high-end rare-book dealer from down the block. The dealer scanned the boxes, paid three thousand dollars for a half-dozen books, and left Okie standing there in an altered state. If that guy had paid him three grand, what was *he* going to sell them for? What were they *really* worth?

Just as Bob might have done, Okie got disgusted with himself. In a reckless attempt to make up for his mistakes, and fired by his latest epiphany—that old books were where the real money was—he started taking more chances on expensive antique books. Somehow, though, few of Okie's rare-book deals panned

out. He did not share Bob's penchant for research or his gift for discovery, and he never seemed to be left with anything but debts, to which he paid as little attention as he did to the invoices from the publishers who'd sold him those glossy art books. Unfortunately for him, antiquarian booksellers were much more diligent than glossy art-book publishers about collecting overdue accounts.

Okie fled L.A. for New York, where he quickly discovered that the rare-book scene was even more competitive than it had been in Los Angeles. There were more book scouts working the second-hand shops, flea markets, and book sales, and they all seemed more knowledgeable than he. After a difficult period of experimentation, he found a venue that better suited his talents.

It is the nature of urban life that people are sometimes forced to put their goods in storage. Thus companies like Security Self Storage or Spectrum Storage or Tuck-It-Away arose, offering secure, dry storage cubicles for a nominal sum each month. If the customer died or went bankrupt or skipped town, the company would make a good-faith effort to locate him or his heirs. If, after a certain length of time, no claimant turned up to pay the accumulated storage fees and recover the property, the company had the right to advertise in the classified sections of the New York newspapers that the goods were going up for sale at what is known as a "self-storage lien sale" or "warehouseman's lien sale."

Lien sales were held to free up space and recover unpaid storage costs, and were strictly regulated by New York State abandoned-property laws. Since they weren't necessarily a source of profit, advertising was minimal. Purchasing abandoned property at warehouseman's lien sales tended to be a cultish activity, known to only a few small-time scouts and pickers. Not many of them had a great deal of capital, and a quick turnaround was essential. Goods purchased at a Thursday sale might appear at the Chelsea fleas by Sunday. Stories abounded of Rolex watches and

mink coats amongst the schlock, but usually it was just junk, occasionally saleable junk, and—on rare occasions—valuable junk.

It was perfect for someone like Okie. He could sleep late and, over coffee, scan the classified section of the *New York Times* or the *New York Post* for legal notices advertising warehouse auctions or warehouseman's lien sales. If anything seemed promising he'd bestir himself on the appointed day to a warehouse in Brooklyn or the Bronx, where the property would be heaped in a tumble or sold off by the cubicle. With his sharp eye and quick mind, Okie developed the ability to scan a room and figure what the odds were that there'd be anything for him. He always looked first for documents, manuscript items, photographs, and pamphlets, mostly because they were lighter than refrigerators, but also because the other dealers didn't seem to appreciate this material as much as he did (even if they were capable of reading it). Okie became something of a specialist in trunks and suitcases, since this was where documents, photos, and manuscript items were usually stored, and in posters and prints, which were frequently sold off with the paper goods. Because of the active and ready market for ephemera, particularly when it related to African American history or culture, Okie was able to escape the buy-it-on-Thursday-sell-it-on-Sunday cycle. He was canny about pricing and selling his wares so as to maximize profit, and he soon began to accumulate both goods and capital.

On July 14, 2002, he spotted a small ad in the classified section of the Sunday *New York Times* for a warehouseman's lien sale by order of Auer's Moving & Rigging, to be held at their warehouse in the Bronx. In minuscule type, the add offered "lr dr & br furn. Ant. hand operator printing press. Antique trunks, paintings, books, etc." Except for the printing press, it could have been any household lot. But "antique trunks" held some promise, and Auer's was a reputable company that stored art for the big New

York auction houses and galleries. There might just be something out of the ordinary.

At ten thirty A.M. on Friday, July 19, Okie arrived at the auction site and found plenty out of the ordinary. The items had been removed from their storage unit and were spread out for display. The viewing area was festooned with African shields, leopard-skin costumes, spears, shrunken heads, stage magic tricks in their own crates, photos of exotic-looking performers, and posters advertising their acts. There were, as advertised, two old trunks. One contained more costumes and artifacts; the other one was full of photos, documents, notebooks, pamphlets, and handbills. Apparently all these items were the remains of some kind of circus. The printing press was nowhere in sight.

When the bidding began, Okie discovered that several dealers had already made a treaty among themselves. By pooling their resources, they were able to buy most of the obviously interesting shields, spears, and costumes, leaving the unallied bottom-feeders shut out entirely. Happily for Okie, the trunk of papers was more or less ignored by the ring of dealers, who were scarfing up the shrunken heads. He bought it, along with several related lots of photographs and posters.

It may seem obvious that Okie's haul of papers, photos, and documents would have told the story behind that odd and exotic collection of pseudo-African sideshow artifacts. That story might have been as interesting—and perhaps as valuable—as the artifacts themselves. But Okie would have had to do research to tease the story out of the archive at his disposal, and although he was intellectually capable of such an investigation, he had no interest in the job. All he knew was that this lot had some money to earn back before it started showing a profit. So he stripped out items that seemed, roughly, to duplicate others and set about selling these first.

This methodology suited his purposes well enough, but in terms of maximizing his return, it was the worst approach he could have taken. The value of the whole archive would have been much greater if kept intact, so that one photograph could illuminate another document, which would shed light on the shrunken heads. Okie's marketing scheme was laying waste to that integrity.

But it was what it was. Long after the leopard skins and spears had disappeared at the Chelsea flea markets, Okie was still cherry-picking and pricing his lot of sideshow paper. When he set up at an ephemera show, he'd never put more than a few items from this archive out at a time, so that if they were priced too low he'd be able to raise the prices on similar items at later shows. And he took his time piecing them out, judging the response, keeping his eye peeled for similar items in other dealers' booths and the prices they were bringing. His research was done entirely on the market side, and it proceeded deliberately. Despite the power that accrued from having the goods, Okie didn't like selling them; in his heart of hearts he wished he could keep everything he ever found. This honest, uncomplicated greed for the material may have been tainted by a lurking suspicion, nourished by his own misadventures, that it had sold too cheaply—that he'd been hustled once again.

FEEDING THE RAT

BOB CALLED AND CALLED, but months went by without a peep from the Nigerian prince. Then in April 2003, Bob attended a black memorabilia show in Gaithersburg, Maryland. As usual, the goods on display ranged from flea market junk to items of real historical significance. There were imported African paintings made from banana leaves; overstock clothing; reproductions of historical posters; genuine signed photographs of jazz greats like Billie Holiday or Count Basie; an inscribed first edition of Booker T. Washington's *Up from Slavery;* letters from colored soldiers in the Civil War; enough posters, lobby cards, and programs to trace the history of popular music in Harlem; and an unopened Wheaties box with a smiling Michael Jordan on the front, sealed in a plastic baggie to keep the Wheaties fresh. It pleased Bob that in this world of black stuff, the porters—those men for hire who wheeled the goods in and out of the show at its beginning and end—were white.

He was even more pleased to discover, tucked in among these various vendors, Okie, dressed that day in clothes whose ebony tones perfectly complemented his skin—leather pants, handsome cardigan sweater with chrome button loops, matching jersey, cashmere scarf, and, in the same aubergine range, gumsoled leather sneakerlike shoes that laced up the sides. The ensemble was completed by tortoiseshell glasses, a five-day growth of light gray beard, and a beret atop his shapely head. The look was either

Werewolves of Gaithersburg or a mannequin jailbreak, and Bob, who maintained his own unique-but-tasteful sense of style (despite having abandoned the pre-Raphaelite capes), regarded Okie's getup with no little admiration.

He noted that Okie had acquired new material and immediately intuited the gist of what Okie did not comprehend. Where Okie saw only a mass of saleable ephemera, Bob saw a potentially coherent archive, perhaps of a black sideshow, since many of the performers pictured were African Americans. There were programs from circuses and carnivals, illustrated pitch cards, and photos of black fire eaters, dancers, and "savages." Bob paid a hefty price for a large hand-colored photo of a black man and a black woman dressed in African costumes, and used the occasion to make it clear to Okie that he was a real buyer, a serious collector, in for the long haul. Okie gave him a gentle smile and a perfectly mannered nod and told him not to worry, he knew Bob was serious. The items he was selling here were only the duplicates from a much larger collection of black circus material he'd recently acquired. Bob pressed Okie for a chance to see the rest of the material, and Okie, to his surprise, consented.

This time, with the goods so close he could smell them, Bob kept Okie in his sights, calling and leaving messages until he got an answer, then nailing him down as to exactly when the black circus collection would be available for inspection, preliminary to an immediate purchase of the entire lot. Of course, Okie could have let his messages go unanswered, or been as elusive as before. Bob was under no illusions about that.

A possible explanation for Okie's change of heart presented itself when Bob bumped into an old acquaintance named Mo, who dealt in rock-and-roll memorabilia. Bob mentioned that he was trying to buy a bunch of black circus material from a dealer named Okie, and Mo averred he had "got took" by Okie on some

bad rock posters. They were excellent knockoffs. Apparently the forger had gotten old paper from somewhere and used computer-enhanced newspaper ads to replicate vintage flyers. He didn't get sloppy until the very end, Mo said—something about the ink. He didn't know if Okie was doing the work himself, but in his opinion, Okie was no innocent middleman.

Bob was hard put to believe that forgery and felony were part of the stylish Nigerian's résumé. Suspecting there was more to the story than Mo wanted to tell, he called a colleague named Wyatt at Swann's Auction Galleries. This guy, who was a specialist in African Americana, had cataloged a lot of Bob's best material for Swann's black history auctions. Lately he and Bob had been co-operating on some of the cataloguing chores. Bob wasn't getting paid for this work, but it was to his advantage to have his material correctly described, and it lightened Wyatt's workload a bit.

Wyatt told him that Okie had multiple—perhaps as many as a dozen—eBay identities (usually a sign of bad dealing), but that he didn't see the Nigerian as a calculating felon. He characterized Okie as being more amoral and inept than immoral. Okie's expulsion from Swann's auctions was a case in point. On several occasions Okie had placed winning bids on material and failed to pick up the goods. It became apparent that he was purchasing an item, then trying to sell it over the phone in order to pay for it. When he bounced a check, Swann's banned him from their rooms. But Wyatt had spoken with Okie and was convinced that he'd bounced the check fully believing he'd be able to make it good before Swann tried to cash it. Furthermore, there were several instances—one involving a collection of Marcus Garvey papers—where Okie had somehow gotten his hands on a po-tentially important archive and destroyed its integrity (and most of its commercial value) by selling it off in dribs and drabs. Okie was an intelligent scout with a good eye, but he had no idea how

to process or sell an archive, or even how to find and maintain a customer. It was all random, hand to mouth. Okie would get a collection and then wait until creditors were at the door before he'd start trying to sell it.

Hardly a resounding endorsement, but Bob didn't care. He was simply trying to purchase a potentially interesting lot from a man who previously had given signs of being reluctant to part with it. What he'd heard from Wyatt and Mo suggested to Bob that Okie was in hot water, or knew he soon would be, and that he was therefore trying to accumulate a war chest, which made the reports good news rather than bad. Okie was a motivated seller. Bob found driving instructions to Okie's house on Map-Quest, checked his bank balance, cleared his schedule for the end of April, and made ready to depart.

Not that there was a great deal to clear from his schedule except loneliness, frustration, and discouragement. Other than his ongoing eBay auctions and some future consignments for Swann, business was slow. Over the past few years he'd managed to ignore, insult, or otherwise alienate most of his colleagues in the book trade and, with the exception of a few black-history specialists, nobody was calling to offer him goods anymore. Old friends and colleagues like Matty Needle seemed to have dropped off the face of the earth. He imagined them slipping into decrepitude. In his troubled state, it never occurred to him that he might call Matty, just to see how he was getting on, or that Matty (who was, in fact, in fine fettle) wasn't calling Bob because Bob was acting like a jerk, being all mysterious and not calling. Bob could not, for the life of him, escape the cloud that hung over his head.

Some of the misery was organic, a result of his own depressive episodes, but much of the cloud was generated by his increasingly dysfunctional relationship with Jan. She seemed to be drawing further into herself, possibly mirroring his own troubled state.

He wound up spending less time at home and more evenings on the second floor of the shop in Philadelphia. Like a hypersensitive adolescent barricaded in his room, he'd read, or listen to music, or arrange and research his black-history collection, which by now had grown to considerable size. For all his kinetic energy he was an inveterate daydreamer, especially in his depressed condition. He could spend hours in Oblomovian reveries of his childhood, or on elaborate fantasies of cataloging the several aspects of his collection and writing books about black music and black religion, and then, on the strength of his scholarly renown, selling the subcollections to big institutions and getting enough money to travel, to live in leisure, to wander his own city like the flaneur he was at heart, to philosophize, to dream. He was not at all ashamed of dreaming. It seemed like civilized behavior to him.

These intervals of melancholic lassitude were punctuated by an insistent, energizing desire to get out on the road. Rock climbers refer to this sort of recurring itch as a need to "feed the rat." Most booksellers of the traveling sort experience similar periodical pangs. They'd loll around the office for weeks at a stretch, and then suddenly it would be time to feed the rat—to go out there where the books came from, where the adventure and the novelty were. In the old days Matty Needle and Bob used to prowl the East Coast like a couple of German submarines.

That, anyhow, was the way Bob recalled it, once he was back in his van and driving up to check out Okie's black-circus collection. The road and its prospect of rabbit holes cheered him, and he commenced the freewheeling, associative mode of attention that was his delight and great strength. This state of being was invariably accompanied by the nervous, jive-ass, yet somehow innately gracious persona that contributed to Bob's excellence as a scout. He'd see through your pockets and remove from them what he needed, and you'd be chuckling, shaking your head.

THE BUY

THIS TIME THE TRIP was going to be a little scary, which made it even better. Okie was black and he lived in Brooklyn. Although Bob had no intimate experience of the place, he had Philly ghetto visions of grim tenements and street-corner crack. When he exited the Brooklyn-Queens Expressway onto dingy, crowded streets (whose "grim tenements" even then were selling to Manhattan yuppies for a million apiece), it seemed those fears would be realized. But soon the mean streets were behind him, and his MapQuest directions led to a sprawling yellow-brick apartment building on a wide street in the north central part of Brooklyn. The neighborhood had a faded dignity redolent of maiden aunts and retired department-store managers. Okie met him at the door, hospitable and house proud, in a tan cowl-necked sweater, gray slacks, and red slippers, with black half-glasses perched on the bridge of his nose, looking more like a novelist than an ephemera dealer.

High ceilings, gleaming urethaned floors. The hallway was lined with paintings and prints carefully sequenced and perfectly lighted. Bob saw a possibly genuine signed Bearden print and recognized Jacob Lawrence's bright flat shapes in an unsigned painting. There was a gentility to the visual aspect of this place that appealed to him.

The living room was at the front of the apartment, over-

looking the street. It had capacious glass-fronted specimen cases at either end and shelves in the middle of the front wall, between the two tall windows. Bob scanned the titles and saw that they were well chosen academic and antiquarian tomes—none of those flossy coffee-table books that people often accessorized with. He had no corresponding knowledge of African tribal art, but his instincts told him the masks, drums, bells, and bones in the cases had been intelligently selected.

"Some are real," Okie told him, "but some are museum-quality reproductions of priceless objects."

"Man, this is wonderful. Is any of it for sale?"

Okie laughed his lilting laugh, shaking his head and waggling his long graceful forefinger at the coffee table. "No, no. These are what I have for sale." Arrayed on the low table were several hundred items—photographs, documents, and notebooks. The black circus lot. Bob sat on the couch and got down to business. Okie pulled up a chair.

Bob's first question—always the first question, but the big question in light of the testimonials offered by Wyatt and Mo—was about provenance. Where had the stuff come from? Okie assured him everything was legit. He explained to Bob about Auer's Moving & Rigging, and about warehouseman's lien sales.

Upon his initial sorting through the pile, Bob identified pitch cards of bearded ladies, midgets, tattooed people, and other freaks, born and made—all collectable and of more or less known values. Beyond these, the collection soared away into the exotic and bizarre. There were a few anthropological photographic studies of African natives and a couple of small notebooks, on the order of pocket diaries or address books, that seemed promising. They were sure to contain some kind of information about their owners. There were some equally interesting letters, a number of

performers' contracts and other financial documents, some penny postcards bearing crudely scrawled messages, a number of photos of blacks gotten up as "savages" in the old trope—dancing, climbing ladders of swords, eating fire, posing with drums and spears, or assembled in "native villages." And there were several larger photographs, printed on 11 × 14-inch paper.

With a click of recognition, as if he'd met them at a party a few weeks before, Bob identified the man and woman who appeared in several of the photos. They were the same couple pictured in the hand-colored photograph that he'd bought from Okie in Gaithersburg. The man, handsome and muscular, had been photographed in various stages of maturity, between twenty and fifty years of age. He appeared in savage getup as a younger man, but in the later pictures he wore a sports jacket and tie. The earlier pictures were from outdoor sideshows, probably staged at several different venues.

Bob quickly confirmed his suspicion, formed way back in Gaithersburg. These photos and documents constituted a coherent archive, or part of one, anyway, rather than a miscellaneous collection. And they pertained to a sideshow rather than a circus. The visual and documentary evidence was irrefutable. There was, for example, the moody nighttime photograph of the banner line of a deserted sideshow, or the image of a doctor and a nurse attending a two-headed baby in a jar, just the sort of hokey exhibit that would have turned up in an outdoor ten-in-one.

One of the 11 × 14 prints was of the sports-jacketed man. It was a strange image only in that he was wearing an unusual piece of headgear, a turban or fez of some kind. The other two big prints were the most arresting. One showed a tall, scary fellow in dark glasses, standing on a platform stage with his arms folded over his chest. The vantage point was from below, enhancing his looming menace. When Bob looked closely he saw that there were

no hands at the ends of the arms. The guy was a freak of some kind or other, and had just finished, or was about to start his act—whatever weirdness that entailed. But the handless man was nothing on the weird scale compared to the other photo, which was difficult to read at first and then snapped shockingly into the image of a snake, coiled on a newspaper, devouring a white mouse.

When it came time to start putting a deal together, Okie dropped the hospitality and assumed a retentive, sulky, high-handed mien. If Bob picked up a photo Okie would snatch it from him, saying it needed further study, or that he couldn't possibly part with that one, or that Bob couldn't afford it, anyway.

Bob kept his cool, but after numerous repetitions of the "couldn't afford it" taunt, he put his foot down. He reminded Okie that he was here to purchase this lot of circus stuff for good money, as they had agreed weeks before. If Okie was going to play games, to contradict their original agreement, there could be no deal. (A complete bluff. There was no way Bob was going to leave without getting this archive.) Okie settled down, and the two men began, chunk by chunk, to sort through the collection and to haggle about the value of each piece.

This was when Bob began to count, though he was not aware that he was counting. It was a deep, subliminal reckoning, reminiscent of the way his revered bluesmen had that particular form so profoundly in their bones that they could commence a vocal line stunningly off the beat—enabling a rich vocabulary of musical gesture, from pathos to sarcasm—and still finish on the dime. So Bob, who knew how much money he'd brought, and who had also formed pretty quickly an idea of how much he wanted to pay for this collection, began his counting. The purpose of the tally was to track the average of known values against the remaining items whose value was unknown. If he sensed that

he was ahead in the tally—that the total would come out less than he was willing to pay for the lot—he'd concede to Okie's price for an item. If he felt he was behind, he'd bargain harder. When he finally saw that everything was on course, he gave in more graciously to Okie and gained some good will. This was of utmost importance. Already he was in love with this archive, and he was certain that the wily, retentive Nigerian was holding some of it back. Bob wanted it all.

Okie was counting, too. He was counting, in his imagination, stacks of twenty-dollar bills, and the higher the imaginary stacks got, the more he was able to sever his emotional ties to the black circus lot. He was also calculating what he'd already earned from this lot plus what Bob was likely to pay him, against what he spent for it at the warehouseman's lien sale. He soon saw that this bunch of stuff would earn him a healthy multiple on his investment. He felt good about it, and he felt good about himself. Bob clinched the deal by offering the last five hundred in cash, and the two men bounded around the corner to an ATM machine.

His hospitable feelings restored, Okie responded candidly to Bob's gentle prodding. He said he realized that Bob had paid a steep price for this lot. But Bob had shown good will, and Okie was prepared to reward him by selling him a circus trunk that had also come with the lot, which still had some papers remaining in it. The trunk, however, was in another storage facility, and retrieving it at this moment would not be convenient.

This was fine with Bob, who was just realizing that the travel and the haggling had exhausted him. He knew Okie had more of this sideshow stuff, and he wanted to wait till he was fresh to take another crack at it.

In fact, Bob's problems were approaching critical mass, and

he was in a fragile state. The depressions were increasing in frequency and severity; his social life was nonexistent, his finances were shaky, and his marriage was foundering. But he still had his instincts. If anything, having been honed by a career of adversity, they were better than ever.

THE FINER SORT

BACK IN PHILLY, BOB SPREAD HIS HAUL across his long worktable. His immediate object was to organize the archive, to catalog it, to gain what is referred to as "intellectual control" over its contents. But organization was preliminary to his true purpose, which was to get this heap of paper to tell its human story.

He shuffled and sorted for several days. Piles of outdoor shots, piles of indoor shots, pitch cards, piles of typewritten paper, piles of handwritten paper, printed forms, photos of freaks, freaks outdoors, black freaks. Black faces. African-American "Africans" in their hokey costumes, slouch-hatted whites looking on. Sort again into piles of black and white, of freak and nonfreak. Re-sort by estimated date or location. By subject.

Bob swam happily in the swarm of images, occasionally allowing himself to be snagged by a particularly arresting one—the photo, say, of the five humongous white girls in tutus, labeled "Alice Murphy and her Rosebuds—2000 lb. of Fun." Or the picture whose caption read, "The Prince, The Duke, and Chief Woo-Foo and entire Tribesmen assembled at DARKEST AFRICA on their arrival at A CENTURY OF PROGRESS"—fifty muscular black men grouped under a thatched roof, bare from the waist up, all abs and pecs, many of them with prominent white rings in their noses, holding spears, clubs, or drums, dressed in animal skins, facing the camera with studied ferocity, except for one dude on the left

who appeared to be nodding out. Someone had made an *X* on the image of one of the fiercest characters and had written at the top of the photo, "R. C. Lucas," an odd name for a tribesman.

He was the man in the color photo that Bob had first purchased from Okie, and whose archive this almost certainly was. He appeared variously in photo captions and supporting documents as Charlie, Butch, Woof, Prince Woofoo, or Woo Foo, the Immune Man (another picture from the Century of Progress that labeled him immune showed him in his animal skin, standing on a bed of nails, regarding the camera with a jaunty expression). His wife, or partner, was Princess Wago, Woogie, or Sahloo. She had her own act, dancing with pythons, but the two also appeared in skimpy African garb performing something billed in publicity photos as "The Dance of Love." It looked pretty good to Bob. They were young, attractive people, and the theme was clearly calculated to play on the white man's fantasies of raw black passion that animated the "African savage" shtick in the first place.

The midway photos and the other outdoor "African village" shots seemed, from the clothing and other clues, to have been taken in the 1930s and the 1940s. This material comprised only a small part of the collection. The rest, including pitch cards, publicity shots, tax forms, performer contracts, personal correspondence, and two address books, dated from the 1950s and early '60s. They centered around Charlie and his female partner, and an institution identified in the archive as "Hubert's Museum, Inc." Charlie's full name turned out to be Richard Charles Lucas—thus the "R. C. Lucas" identification in the African village photo. He'd performed with, and then married, Virginia Bostock, aka Woogie. Sometime in the 1950s, Charlie and Woogie quit their life on the road. They settled in New York and found steady work at Hubert's. In short order Charlie rose up from his

PRINCESS SAHLOO AND WAGO · DANCE OF LOVE

A publicity photo for Charlie and Woogie's "Dance of Love," from the late 1940s.
African American Photography Collection of Robert C. Langmuir

```
                                              WI 7-9393

                    R. C. LUCAS
                    HUBERT'S MUSEUM

    228 WEST 42ND ST.        FRI. - SAT. - SUN. - 2 TO 12 P.M.
    NEW YORK 36, N. Y.       MON. TUES. WED. - 2 TO 11 P.M.
```

Charlie's business card from his days at Hubert's in the 1950s and 1960s. Adding
the time it took to open and close down, he was putting in sixty hours or more
a week. *African American Photography Collection of Robert C. Langmuir*

bed of nails, put on a sports jacket, turban, and tie, and began
managing the place.

Bob did a finer sort through the photos, trying to get a visual
fix on what this Hubert's place must have been like. Utilizing
clues afforded by background and costume, he isolated more
photographs that had probably been taken at Hubert's, and from
these he began to construct in his imagination the interior of the
place. He did this reflexively, because he needed a setting for the
story he was sure the documents would tell.

He then returned to the documents in earnest. The business
papers included performers' contracts that gave Bob a feel for the
economics of the business. Shary O'Hara, for example, was hired
on November 13, 1957, to work until November 18, for sixty dol-
lars. Her act consisted of "entertainment with talking birds."
There were a few of Charlie's tax returns, showing what he and
Woogie made at Hubert's. In 1953 they'd filed jointly. Charlie had
made $2,745.29, and Woogie had made $2,860.00, for a total of
$5,605.29.

There were letters from performers asking for gigs and typewritten replies, signed by Charlie. There were letters and postcards from some of the same people, but of a more personal nature, addressed to Charlie and Woogie. Many of these had to do with money loaned to Charlie. Finally, there were the two date books, from 1963 and 1964. Charlie had entered addresses in the backs of these, but he'd also used them as daily journals, entering, in his semiliterate and ungrammatical scrawl, brief memoranda, notes to himself, and philosophical reflections.

Charlie lecturing next to the Electric Chair, an illusion in which the current lit a fluorescent bulb in the participant's hand. In a postcard written to her daughter in 1960, Arbus said, "Pa sat in the electric chair with great aplomb."
African American Photography Collection of Robert C. Langmuir

Bob, who sensed that he was on the edge of something truly interesting, went through these more carefully.

They were difficult to penetrate. Charlie was a sloppy writer and a worse speller, and the subject matter was obscure. He knew Charlie's personal notes made the entire archive a significant find, but he had no idea how significant until, one afternoon, at the back of the 1964 date book, he saw a name he recognized. The entry read, "Diane Arbus, 131½ Charles St. WA 4–4608." Quickly

he scanned the 1963 book and found, toward the back, the same name and address. Underneath this entry was written "morn's 8–10 eves 6–8." Arbus visiting hours?

He recalled the mood of Arbus photos he'd seen and compared that mood with the prints in the Hubert's lot—the brooding sideshow exterior, the weird guy with no hands looming up on the stage, the snake eating the white rat. He concluded that some of the photos, especially the 11 × 14s, had a vintage Arbus feel to them. It was by no means too great a leap from Charlie's address books to those photographs, particularly that eerie snake.

Diane Arbus, he suddenly realized, had been working with Charlie Lucas. Working him. Using Hubert's to find her subjects. She'd taken those pictures. Those were *her* photographs.

The mother of all rabbit holes opened before Bob's eyes, and he dove in.

FLYING FUR

IN A BETTER WORLD, or even in a more dignified, less distraught time, it might have been possible to accord Diane Arbus's suicide the eloquence of silence. But those were the days of Kent State and the Attica Prison riots. America was mired in Vietnam, struggling to come to terms with the moral demands of the civil rights movement, on the edge of the abyss of Nixon's lies. Social mores were being challenged by the pill and the women's movement, and the galloping pace of technological and societal change was producing unintended consequences. Popular culture was in the ascendant, suddenly worthy of the serious attentions of intellectuals. Even the Top 40 had become an important venue—a sort of cloud chamber in which American musical traditions collided and mutated.

Bob Langmuir, in the course of his musical education, could dig how Bob Dylan's wry comment on the rolling stone theme had been initiated by a Delta bluesman, memorialized by an English rock band, taken up by a popular magazine, and answered with a vengeance by the Temptations' ghetto-sodden "Papa Was a Rollin' Stone." The interesting thing is that virtually the entire nation was listening along with him. In Arbus's famous photograph *Jack Dracula, the Marked Man*, the French words "Regardez les Cours des Submarines" are just visible, tattooed like a necklace around Jack's throat. This wasn't a quote from a surrealist

poem. It was an homage to Murray the K, a trendsetting deejay on 1010 WINS New York, the AM radio station to which Jack, and nearly every other New Yorker under thirty, listened. "Submarine race watching" was all about parking with your girl at Jones Beach or wherever, and in the photograph of the Marked Man it had already become an aspect of the "rites, manners and customs" Diane Arbus sought to record. It should not be surprising, therefore, that when she died, popular culture quickly marked out a place for her—a sordid, fascinating corner of Valhalla inhabited by Marilyn Monroe, Janis Joplin, Judy Garland, and Sylvia Plath. In a few more years Anne Sexton would join their number—brilliant women laid low, as the public imagining had it, by their demons. (In 1972 *Time* magazine would pronounce Arbus, "as much a cult figure as Plath.")

Arbus's death notice appeared on the obituary page of the *New York Times*, but only the basic facts were given. Richard Avedon flew to Paris to fetch Doon, and a small, sparsely attended memorial service was held in Manhattan. A few weeks after Arbus's death, the *Times* published a thoughtful and generally favorable article entitled, "Diane Arbus: The Subject Was Freaks." This was one of the first postmortem pieces to link Arbus's manner of death with that single aspect of her subject matter, and to state the context in which her work would henceforth be considered by the public. "Inevitably," the reporter said, "these pictures raise the question of what freaks are and how they differ from the rest of us."

Arbus's friends and supporters wasted little time finding appropriate ways to memorialize her. John Szarkowski organized a retrospective show at MoMA that opened in November 1972 and ran through February 1973. It was the most successful exhibition since the Family of Man exhibition seventeen years earlier.

Hundreds of thousands of people flocked to the museum to see the work of this dark, suicided genius, and to draw for themselves the line between freakishness and normalcy.

To accompany the show, Doon Arbus and Marvin Israel produced a book entitled *Diane Arbus*. The eighty photographs published in that work (in which images of normals outnumber those of freaks) established the canon of Arbus's most important pictures. They conveyed a teetering, dangerous balance in which outlaws and perverts were introduced in the formal, forthright conventions of portraiture, and absurd nudists sat in their living rooms with the casual assurance of visitors from a parallel dimension. Something about Arbus's vision, some deep, primordial authority of those images—those *people*—struck a chord in the popular imagination that no other photographer, before or since, has equaled. *Diane Arbus* became one of the bestselling art books of all time. Sales revenues kept its publisher, the financially challenged Aperture Foundation, afloat for years. Royalties put Doon and the Arbus estate on a solid footing.

This was about more than Arbus becoming a face on a T-shirt. New York's Museum of Modern Art had enormous cultural weight, and the Arbus retrospective received serious critical attention. It did not hurt that Arbus's work was easy to write about—whether in positive or negative terms. This got her a lot of "ink" and accelerated her growing notoriety. Hilton Kramer, the *Times'* esteemed art critic, wrote a notice of the Arbus retrospective that spoke of her work in the context of "photographic art." He elaborated on this placement and its reasons in a long review in the *New York Times Magazine*. "From fashion to freaks: This, briefly stated, is the course traced in the meteoric career of one of the most remarkable photographic artists of the last decade ... who suddenly, by a daring leap into a territory formerly regarded as forbidden, altered the terms of the art she

practiced." It must have been gratifying to Szarkowski, not only to see her work praised, but to have it accepted unquestioningly as high art. Much had been accomplished since 1962.

Then, in the fall of 1973, Susan Sontag published a piece on Arbus and on Walker Evans in the *New York Review of Books.* Sontag had already established herself as a formidable critic with essays like "Notes on Camp." She was sexy, dangerously intelligent, and, in the words of her eulogist in the *New Yorker,* "the most famous and influential young critic of the sixties and seventies, a central figure in the . . . absorption of pop culture into high culture." Picking up the theme that had already been forwarded by the *New York Times,* Sontag called her essay "Freak Show." She followed it in subsequent months with essays on related topics and then reworked them all into a book called *On Photography.*

Her prose was brilliant in places and her observations about photography were smart in a stiff-necked sort of way. "Needing to have reality confirmed and experience enhanced by photographs is an aesthetic consumerism to which everyone is now addicted. Industrial societies turn their citizens into image-junkies."

After about thirty pages she commenced a discussion of the work of Diane Arbus, contrasting the 1955 Family of Man exhibit with the 1972 Arbus retrospective. "Family," she said, was an "up." The Arbus show, "a down," which "lined up assorted monsters . . . most of them ugly" who did "not invite viewers to identify with them." Arbus's work portrayed people who were "pathetic, pitiable as well as repulsive." At the same time Sontag was unable to accept the assurance with which many of these subjects inhabited their own skins. "Do they see themselves, the viewer wonders, like *that*? Do they know how grotesque they are? It seems as if they don't." She portrayed Arbus as an aristocratic voyeur exploiting her freakish subjects for an audience of urban

sophisticates who prided themselves on their hardness. Her comments were marked by a moral stridency not unusual in Sontag's writing. "Arbus's work is a good instance of a leading tendency of high art in capitalist countries: to suppress . . . moral and sensory squeamishness."

Throughout, Sontag treated her personal responses to Arbus's photographs as if those *reactions* were the photographs themselves. She developed her own picture of Arbus's pictures and then instructed her readers to judge the *auteur* on the basis of the critic's secondary, derived image. For a writer who made her reputation by penning "Against Interpretation," it was a surprising approach.

Worse still was Sontag's spiteful tone, which seemed to have been especially reserved for Arbus. After writing wonderfully about the possibility that a photographer might be an armed version of Baudelaire's flaneur, "reconnoitering, stalking, cruising the urban inferno, the voyeuristic stroller who discovers the city as a landscape of voluptuous extremes," she turned down an alley to participate in a snide ad hominem mugging, criticizing photographers who happen to be "locked into an extremely private obsession (like the thing Lewis Carroll had going for little girls or Diane Arbus for the Halloween crowd)." It was just plain nasty, trapping Arbus inside those parentheses with a man who had a "thing" for "little girls." How could Sontag, who was so often courageous, intelligent, and right, be so wrong about Arbus?

At this remove it seems likely that Sontag considered Arbus a rival for ascendancy in the hip and glamorous zone that marked the intersection of pop culture and high culture. Sontag, just coming into her best days, was seeking to consolidate her power. Arbus, ten years older, solidly established and infuriatingly dead, battled back from beyond the grave. "The fact of her suicide," Sontag complained, as if it conferred an unfair advantage on her

adversary, "seems to guarantee that her work is sincere, not voyeuristic."

Like any turf war, this one was provincial. The forbidden territories colonized by Arbus may have tunneled into the American psyche in some profound way, but for the most part they never extended more than a bus ride beyond Manhattan. Sontag's attack was initially played out in the New York press, and it mattered primarily to New York intellectuals. However, once Sontag's essay escaped into book form its effects were more widespread.

On Photography got good reviews and became a bestseller. In that broader national arena its moral underpinnings faded quickly. What stuck with the public were freaks and suicide. Sontag's Arbus was troubling, notorious, and that made her an object of fascination. In some perverse way that Sontag could never have intended, her attack only helped draw attention to her rival.

DOWN THE RABBIT HOLE

CONSIDERING BOB'S FRAGILE EMOTIONAL STATE, it may not have been the best of times for such a journey. But his deal with Okie had perked him up considerably. Besides, if he really had discovered Arbus photos, they'd be worth tens of thousands or maybe more. The money would buy him time to sort himself out. So he undertook the descent.

He began with a period of intensive research into Diane Arbus's life and career, which led, via innumerable Googles, to the Web site of New York's Metropolitan Museum, where he found contact information for their curator of photography. A few e-mails and a JPEG of one of the photos caught the curator's interest sufficiently that, in July 2003, Bob was invited to bring his treasures to the Met.

The curator, a man named Jeff Rosenheim, had his doubts about Bob's attribution of the freak show photos. He was a scholar and he was keeping an open mind. The Hubert's provenance was interesting, certainly, and the images were intriguing. But he wasn't prepared to say they were Diane Arbus's work merely on the basis of what he had seen. He told Bob, "You'll have to sell me on them." The process, he continued, by which photographs came to be acknowledged as Arbus photographs was clear-cut. Likely candidates were submitted to the Arbus estate for authentication. Without this authentication, Bob's find was just a collection of sideshow photos—interesting, but of no

particular value or significance. As matters stood now, there just wasn't sufficient evidence to interest the estate in undertaking the authentication process.

Surprisingly, this rather equivocal interview inspired Bob. Rosenheim had spoken with excitement about the Revelations show that would open in San Francisco in the fall of 2003. It was to be an unparalleled gathering of Arbus's work and sources. The world was about to see new aspects of a great artist, he said, and interest had never been more intense.

This was music to Bob's ears. If the photographs were what he thought they were, there couldn't be a better time to bring them to market. And now he had a clear map of how to proceed. Once he marshaled sufficient evidence, he would present it to the estate. Doon Arbus would match his prints with their corresponding negatives. Then, no matter what Rosenheim or anyone else thought of them, his pictures would be what he knew they were. He'd sell them for a lot of money at the height of the boom, and use the proceeds to take some time off.

Bob was on the hunt now, just like Diane with that camera strapped in front of her, and he wasn't about to be deterred. He was convinced he had the goods, he just needed more proof that these photos were hers. It might be in the archive, in those notebooks and papers of Charlie's. Or it might be somewhere out there, waiting to be discovered, in the parts of the archive that Okie had spread to the winds. It might even be back in Brooklyn, in the rest of the Hubert's stash Okie had promised him. He commenced a deeper study of the documentary remains of Charlie Lucas, and that was when unexpected things started happening.

Sorting through letters, postcards, contracts, tax forms, and legal documents, he found a sheet of paper on which Charlie had scrawled a brief autobiography. The details were sparsely stated, but poignant. They told the story of a sensitive man who'd been

beaten down in the course of a difficult life (a story Bob felt eminently qualified to understand). Charlie seemed to have trouble with whiskey, debt, and guilt. His full name, as Bob already knew, was Richard Charles Lucas. But it wasn't until this closer examination of the papers that he realized Charlie's initials, R. C. L., were the same as his own—Robert Cole Langmuir. To compound this coincidence, there was another: The date of Charlie's birth, August 15, was the same as Bob's own birthday. The match seemed pedestrian at first, but as he dove deeper into the material, it resonated.

Diane Arbus's personal entry in Charlie's 1963 date book. Note the distinctive printing and her "hours."
African American Photography Collection of Robert C. Langmuir

On one of his sweeps through Charlie's date books, he looked again at Diane Arbus's address in the 1963 book and realized that it had been written in a different hand from all the other entries. It was printed in capitals, spidery and angular, quite unlike Charlie's rolling scrawl. What else could it be but Arbus's own writing, preserved over all these years? He was amazed that he hadn't noticed it before. The distinctive penmanship did not appear anywhere else in the archive, nor was there any other reference to Arbus. But Bob was certain that somewhere, in some book or on

some Web site, there must be a sample of Arbus's printing, and that when he found it, it would coincide with the writing in the back of the date book. Would that be sufficient to command the attention of the estate?

Then another coincidence. One of the things about an old bookstore, and one of the reasons Valerie and Bob had burned out, was that such places attracted all manner of offbeat characters. Usually they were just lonely people with too much time on their hands who held shopkeepers hostage with their boring stories. Occasionally, however, someone interesting turned up. Such a strange soul was Jack, a giant of a man with a gray crew-cut and huge arms and shoulders, which he displayed by wearing loop T-shirts. The reason for the T-shirts was that his arms and shoulders—in fact every visible inch of his skin, including his face—were covered with tattoos. They'd gotten blurred and runny over the years, so that he looked like some kind of bluish green alien, but that didn't seem to bother him. Quite the contrary; he acted like an alien, too. When he first appeared at Book Mark in the early 1990s, Jack delivered long soliloquies on hitherto undiscovered aspects of history and philosophy. As he grew more comfortable, he took to performing full-length arias from his favorite operas, some of which had never been heard before, on this planet at least. Never smelled of liquor, claimed he didn't drink, was loud and obstreperous, but rarely overstayed his welcome.

He was memorable all right, and as Bob continued his research that summer, he began to suspect that Jack had been the model for Arbus's *Jack Dracula, the Marked Man*. This striking photo of a heavily tattooed man confidently reposing in tall grass called to mind some complex archetype of freak-as-lion. The *Marked Man* of the photo had aviator's goggles tattooed around his eyes, and Bob was fairly certain that his Jack was marked with

the same goggle tattoos. However Jack had stopped coming
around when the store closed, and Bob hadn't seen him for quite
a while. He made inquiries in the parks and on the street corners,
but nobody else had seen him, either.

Then one evening as Bob was driving dejectedly back to Lan-
caster for another round with Jan, he saw Jack on the street. In a
motorized wheelchair. He nearly got rear-ended jamming his ve-
hicle to the curb in rush-hour traffic, and he leaped onto the side-
walk, hailing the surprised occupant of the wheelchair who said
that, hell yes, he was Jack Dracula. He'd just been out of circula-
tion for a spell. He was having his leg amputated on accounta the
diabetes. Lost a lot of good tattoos with it, too.

It is difficult to do justice to the effect this encounter had on
Bob, on his excitement about his discovery, and on his sense of a
formerly immutable reality that had unexpectedly become fluid,
capricious. Standing there sweating on Twenty-second Street, he
had the damnedest feeling. He e-mailed Jeff Rosenheim about it
the next day. Said that it seemed as if Arbus's photos were com-
ing to life.

Jack Dracula was Bob's Queequeg, and Bob made a concerted
effort to decipher him. He took Jack back to the shop and showed
him the Hubert's photos. Jack identified the scary guy with no
hands as DeWise Purdon. His act was that he was a crack shot
with a rifle. When Bob asked him how Purdon fired the gun, Jack
replied, "With his stumps." Jack had a way of talking to you as if
you were stupid, which, Bob decided, was probably the way he ac-
tually felt about people. For a washed-up freak in a wheelchair, he
had an imperious, regal bearing.

The two men visited several times on the sunny concrete
plaza outside Jack's apartment building. Bob asked him about
Diane Arbus. She had indeed been at Hubert's when Jack was
there. In his version of events, Charlie, a racist drunk, was Arbus's

tool in enlisting the cooperation of other freaks for her photographic sessions. He didn't know if Charlie and Diane had a thing going, wouldn't even speculate, but he thought it possible that Arbus was paying Charlie for access to the performers. This was an assertion Bob instinctively doubted. It seemed to him to say more about Jack than about Charlie and Diane—especially when Jack revealed his businesslike consciousness about exploiting freakdom as a financial asset. He said he'd never wanted to be photographed by Diane because she expected him to work for free, and he had no interest in getting photographed and not getting paid. But Charlie had forced him into it by threatening to fire him if he didn't play along. Soon after his first introduction to Diane, Jack fought with Charlie and quit Hubert's. He moved to New London to work in a tattoo parlor near the submarine base. Diane found him there and took the famous picture of him in the grass alongside a road in New London (rather than in Central Park, as all the experts claimed). Jack never explained why, if he didn't want her taking pictures of him, he'd cooperated with her on this occasion, except to express his surprise that she'd been persistent enough to follow him all the way to Connecticut.

In any event, she'd come back when the pictures were ready, and had given him copies, even bought him lunch. He remembered he was in a restaurant near where he worked, with his girl, and Arbus came in, wearing a trench coat tied tight around her waist, to give him the pictures. His girl got jealous, and Jack told her, "What? You think I'd be interested in that bag of bones?" Once he went to visit Diane Arbus in New York, called her up, and asked her if he could come over. She said, sure, but when he got there she didn't say anything to him, so he left. She was an odd duck. He wished he still had those pictures, though. They got lost in one of his moves, or somebody stole them. They'd be worth a fortune now.

As for that stuff she wrote about him—the famous photo of Jack in the grass had originally appeared (with Arbus's accompanying text) in the 1961 article in *Harper's Bazaar*—it was all fiction. In the article she claimed Jack was "living in seclusion," and that she had sworn not to reveal his whereabouts. To which Jack replied, "I was operating a tattoo parlor in New London. I needed the publicity. Why would I want her to keep my whereabouts secret?" She wrote, "One afternoon I sat with him while he put a small new rose on his thigh." "Baloney," said Jack. He didn't even have a rose tattoo. Same with Arbus's claim that "his pet bird is called Murderer"—"I never owned a pet bird." In regard to that nonsense she wrote about his wish to sell his soul to the devil so he could fly and "blast some people out of existence," Jack replied, simply, "Why would I say that? I've been a Christian since I was born." It was all hot air, fabricated by Arbus to enhance her photo. Or, thought Bob, it might have been a biography of the character in the photo who, by virtue of her art, had ceased to be Jack. *The Marked Man*, as he appeared in the Arbus photo, was handsome, strange, feral. The Jack who sat in the wheelchair was a bloated storyteller, whose memories might have been as blurred as the ink under his skin. Even so, Jack's version of events added something to what people knew about Arbus and her world. Too bad, Bob mused, that he couldn't sell Jack with the rest of the archive. Jack'd probably dig it—if he got a big enough cut.

Thus passed the summer of 2003. When Bob looked up from his researches, it was the end of August—time for a summer paper show up in Hartford, Connecticut, and time to stop at Okie's for a second go-round with the Hubert's archive.

This time Okie was all business. He handed Bob a thick manila envelope of 11 × 14 photos that, he said, constituted the rest of the lot Bob had bought last April. Bob glanced at the cor-

ners of the photos and set them aside, feigning disinterest. He then paid too much for more material from Hubert's and some other photos of black performers. When all this business had been transacted, Bob asked about Charlie's trunk, promised by Okie on his last visit. Okie said it was in a storage facility down by the docks, and that they'd have to drive there. Bob suggested they take separate cars, since he'd be heading north to Hartford when they were finished dealing.

In the car, while waiting for Okie's Mercedes SUV to wheel around the corner, Bob slid the nineteen photos out of their manila envelope and glanced through them. Arbusesque, no doubt. Dancing girls, Charlie, a powerful photo of three Puerto Rican women that echoed one of her great images. Strong stuff. Stuck in among them he found a yellowing sheet of paper on which a note had been penciled in that unmistakable, spiky capital-letter printing, the same hand in which her address was printed in Charlie's date book: "Pictures enclosed for you, Suzie and Dingo. (Went to Amusements of America Carnival in Hagerstown, MD saw my first geek.) Diane."

An irrefutable link between Arbus and the photographs Bob now owned.

Bingo!

THE GRIND

THE ARBUS EXHIBIT OPENED in San Francisco on October 25, 2003. It was accompanied by a massive 352-page catalog called *Diane Arbus Revelations*. As Jeff Rosenheim had suggested (he was a contributing editor), this publication was a splendid resource. Along with full-page prints of dozens of Arbus's best-known images, *Diane Arbus Revelations* provided a beautiful nuts-and-bolts chronology, with samples of Arbus's writings (her printing, too—a dead match with his Hubert's note, natch), and many hitherto unpublished photos. The book made it clear that Diane's years at Hubert's Dime Museum had been a formative part of her career.

Certainly the freaks appealed to her. She counted performers like Susie the Elephant Skin Girl among her friends, and she was fascinated with the ritualized goof of an act like that of Congo the Jungle Creep, so bad it was good. At the same time, she was completely serious in her study of this archaic form of American entertainment. In her 1962 application for a Guggenheim Fellowship, she listed sideshows as one of her subjects, and mentioned Hubert's Dime Museum and Flea Circus among her working locations.

Diane Arbus Revelations published a 1956 photo of the entrance to Hubert's, showing the upstairs penny arcade and the Hubert's ticket booth, bright lights and skeeball, posters advertising

Susie the Elephant Skin Girl, Lydia Suarez the contortionist, and Princess Sahloo (aka Woogie). Behind it all, off to the left, was the stairway leading down to that strange world.

There was a sweet bit of text in the 1960 section of the Arbus chronology, making it clear that Charlie Lucas had sent her from Hubert's to that sideshow in Maryland, whence she'd written the note that Bob had found among the nineteen photos.

The book also printed Arbus's photo of Woogie dancing with one of her snakes, along with a substantial chunk of a letter from Diane to her lover and confidant, Marvin Israel:

> Woogie left me alone with the rat and snake . . . Being alone with them was like a sort of reversal of what happened in Eden, with the snake succumbing to its own temptation. The rat was mostly white with a pink eye and its legs were splayed wide apart in complete abandon while the snake was very knowing and the enormity of its mouth was a little like a smile.

That *had* to be the photo Bob now owned.

It was all fitting so beautifully, right up to and including the group portrait on page 177 of the Hubert's gang as the place was closing in November 1965—Congo at his creepish best; stoical Woogie; a weary, pensive Charlie hugging the midget Andy Potato Chips. The nostalgia was palpable in the air of that odd, linoleum-floored repository of freakdom. Those people knew it was all up for them. Congo stared at the camera like an African mask.

This printed information dovetailed with the two date books from 1963 and 1964 that Bob obtained in his first Okie buy. They were vest-pocket booklets, with room for only the briefest journal

entries under each date. Charlie seemed to be sick a lot, prima-
rily from alcohol, and many of these entries related to his drink-
ing. "Today was my day of[f] I was drunk fell very Bad." Or, "I
Hap to stop if can." He seemed to have a good relationship with
his wife, Woogie, who also appeared in the date books as Wiggie,
Wago, and Sahloo. He valued her counsel enough to record it:
"Wiggie said the Museum cost too much money to run . . . I am
the Head. All I have is food and drink." Their lives were hard. "To
day Christmas eve Very cold—in hotel no steam heat." There
were notes of money borrowed, money owed. He was fascinated
with Woogie's snakes, which he called "rittle" (i.e., rattle) snakes,
but which, according to a receipt from a pet shop, were actually
ball pythons. He recorded how much they ate, when they had ba-
bies, and even when he dreamed about them. Charlie's dreams
were frequently recorded, and they were wild—"My bad luck
night—some spuck try to kill" (Some spook—white person—
tried to kill me?)—and enigmatic—"Mennes [Dreams] A man
drink—colored—Wiggie Big Boss—Max No See 5 white cats—
Thar was gaveing to me—"

Further research revealed Max to be Max Schaffer, the guy
who actually owned Hubert's. He was Charlie and Woogie's "Big
Boss." But "5 white cats"? Bob meditated for a while on racial is-
sues, which were uniformly present in Charlie's writings, but
ultimately it was the enumeration of the white cats that got
his attention. As he went back through the two date books he
saw that many of the entries contained numbers, often three-
digit numbers, some circled. It struck him, finally, that it
wasn't about numbers, it was about "the numbers," the unsanc-
tioned but highly organized daily street lottery. As well as being
a booze hound, Charlie Lucas was an inveterate gambler. Thus,
May 20, "Dream of the no was 257." And on the twenty-first, "it
cam 252."

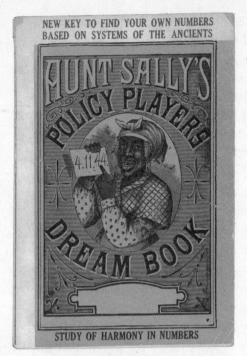

NEW KEY TO FIND YOUR OWN NUMBERS
BASED ON SYSTEMS OF THE ANCIENTS

AUNT SALLY'S
POLICY PLAYERS

4.11.44

DREAM BOOK

STUDY OF HARMONY IN NUMBERS

A book like this would have been Charlie's
source for converting his dreams into the
numbers that might win him a fortune.
Author's collection

Bob knew there was a long-standing belief that dreams, correctly interpreted, could provide winning numbers. Guidebooks to this sort of interpretation had been written and marketed in the black community. Charlie, in keeping with this belief, was meticulous about recording his dreams. While some had sexual content ("i dream that I was with a white girl—three white men came and just looked at us. 368 392 996 the 3 white men said not a word. I just looked at THEM"), almost all these dream entries were supported by, and referenced to, other entries tallying Charlie's more mundane triumphs and concerns. Obviously the man was looking for a pattern, some way to use his dreams to predict winning numbers and to guide his conduct. He was a philosopher of sorts, or maybe an alchemist, seeking to transmute the dross of daily life into gold.

The second Okie haul provided significant additions. There were the nineteen new photos, the Arbus note to Charlie, and there was also Charlie and Woogie's circus trunk, obtained almost as an afterthought from Okie's storage space. It was filled

with tax forms, pay stubs, contracts, and IOUs, as well as letters, postcards, and photographs that appeared to document Charlie's life on the road.

At the end of September, a third and final meeting with Okie yielded a notebook with more of Charlie's writings, and Okie's fervent assurance that they had reached the bottom of the barrel. This time Bob believed him.

The notebook had been given by Woogie to Charlie on Christmas 1948. She used their pet names for each other in her inscription, which was pasted inside the book. "Dec. 25 1948. To Butch on Xmas morn. I hope you have a clean shirt (smile). Very poor. But it is Christmas So Merry Christmas. Wiggie." Inside its leather covers was a three-ring binder, the kind that snapped open so you could insert and remove sheets of paper. Charlie had done just that over the years. Somewhere, at least as early as 1950, he'd acquired a typewriter. And on these loose-leaf sheets, he'd practiced his typing by keeping a journal. The record ran from 1950 to 1967. It consisted of more than sixty pages of single-spaced typewritten notes, plus dozens of scraps of paper with manuscript entries. These new autobiographical documents were much more detailed than the entries in Charlie's date books.

Charlie practiced writing business letters:

Dear I should much like to have the privilege of discussing with secretary a matters relating. It would be of great assistance to me obtan frist hanf in formation . . .

Such exercises were followed by lists of useful phrases like, "in clouse you will find our contracts," and, "what.s the matter don't you have enough." Then individual words, "Entranced" and "Transpertoion." Then he put the words together into phrases of his own devising.

Next voice you hear.
 space cadets are
after that vacum occupied are going
to gace up as easily as a miser, with his money
sewed to his undershirt. they have been in office
so long fresh air makes them sick.

you have seen both in the all american in
chicago ill. choice of shaking.

the business of 1952 is getting the old.
it doesn't make slightest diff in the dawn's dump light.

scram early have a ttended history.

Charlie's pained, penetrating, lunatic poem grabbed Bob and
shook him. In "the dawn's dump light," Bob could hear Charlie
freaking out.
Then,

No—1. So you dream a number. How do you figure
them out? A man gave me 50 Dallars, Oct 23 1951 the
number that day 509

Twenty-two entries, 1951–1955, recording dreams and daily
numbers. Trying to puzzle out a system, ending in failure:

May 26, 1955. When I think of my safe today I almost
fainted with horro, if you ask what is roung I Could not
say . . . I play numbers each day. I wim sum times But
nothing big. My tips most of the time Ok, My woman is
the best and or with me 100 per Cents and all of this,

sumthing is stell rong, We or good in our on way we try
had to do the right thing by all, but out davil and mon-
strous . . . I am not a man that is likeable but I have tried
all of my life to be nice

This cycle repeated several times throughout Charlie's writ-
ings, as he sought the key that would yield the number that would
liberate him. His winnings were small and infrequent, yet his be-
lief in a payoff never wavered. Perhaps the minuscule odds af-
forded by the numbers seemed better than whatever chance daily
toil provided. In the end, however, it was always the same:

May 12, 1959. From may 6–may 11 was very sick from
wine & whiskey, I have no money, my loan 1000. I work
very hard & jus don make no headway . . . God I hope
that I can save 1000 and get out of Huberts museum.

This was important material. How many dream journals of
black, urban, midtwentieth-century males were there? Bob began
to feel like a latter-day Sir Arthur Evans—except that instead of
cracking Linear A in Crete, he was in Philadelphia translating
Ebonics B into Langmuirian. He understood now that, as a soci-
ological document, the Charlie papers might be as significant as
the Arbus photos.

The circus trunk yielded one final artifact, more immediate
in its evocation of Charlie than even the journals had been.
Nestled in among the papers and documents was a seven-inch
reel-to-reel tape recording, fifty-two minutes long, of Charlie giv-
ing his Hubert's pitch. In sideshow parlance it was called a "grind
tape." It had been made by Charlie Lucas (as Charlie himself tells
us) on February 12, 1965, and it was meant to be played contin-
uously through loudspeakers in the arcade upstairs, directing

people to the back corner of the room where the stairway led down to Hubert's Museum.

Whatever the grind tape's original function, it now serves as a time machine, carrying its listeners across a gap of half a century. We hear a genuine inside talker plying his trade at a freak show in Times Square. His laughter, his growl, his breathing are so present that it seems there should be some imaginative algorithm by which we could deduce the room, the sideshow, and the rest of Charlie's life from the sound of his voice.

It begins in the middle of Charlie's exhortation, "... in the rear, where the show is going on right now. Hurry along, hurry along, hurry along! Come on in! You are just in time. There is no waiting. There is no delay. This is a continued show ..." With his sharp, slightly nasal timbre, he sounds very much like Lord Buckley, the influential hipster comedian of the 1950s. He employs a studied, high-class diction—the sort of speech you might hear in a *Thin Man* movie—in which terminal consonants are clipped, vowels slightly elongated and Rs flattened. "Way back he-ah, in the Rea-ah. Hurraay along." Overall, it's a classic example of the puffed-up rhetoric and diction of the talker or "professor" (they were never called "barkers" except by rubes).

The music backing these introductory sections begins in a startling manner with an outer-space sound that resolves into a jazz tune, which turns out to be a slow blues performed by an ensemble consisting of piano, bass, alto, trumpet, tenor, and vibraphone. Charlie plays this same track, in part or in its entirety, each time he repeats his introductory spiel. The tape recorder's fidelity is low, but eventually the gluey, outer-space noise becomes recognizable as a man humming over a bowed bass—the signature sound of bassist Slam Stewart.

After a brief piano intro, each of the instruments, beginning with the bowed bass, takes twelve bars, and the piece ends with an

all-out chorus. Simplicity itself. The only unresolved aspect of the performance is that the trumpet and the alto are playing in a different language than the other instruments. They keep tempo, hold the form, but there's something discordant about their solos. The alto has a certain audacious fluidity that suggests Charlie Parker, and it thus becomes possible to trace the performance, via the Parker discography, to June 6, 1945. The tune was called "Slam Slam Blues," and the group was headed by vibraphonist Red Norvo. Along with Slam Stewart on bass were Dizzy Gillespie on trumpet, Bird on alto sax, Flip Phillips on tenor, and Teddy Wilson on piano. Jazz buffs consider it a notable session because it combines four masters of swing with the two enfants terribles—Charlie Parker and Gillespie—of bebop.

Charlie voices the "hurry along" portion over the music. Then he lifts the needle and commences a longer "lecture." There are six of these lectures on the grind tape, and they give us additional information about Hubert's—that it had been in business for forty-one years, that its anniversary was January 17, that it never closed, even for holidays, that the admission was now fifty cents, that the blade box, Congo the Jungle Creep, Presto the magician, Harold Smith the musical glasses player, Estelline Pike the sword swallower, and the Electric Chair constituted the six live acts at that time.

In one extended lecture, Charlie slides underneath his talker's persona and dredges up material sufficiently funky that we can imagine he has been nipping at a pint of Gordon's all the while, and that the bottle is nearly empty.

This year, 1965, is the year of snakes. When I said the year of snakes, you have to be kind to your wife, be kind to your girlfriend is because snakes have always proven through life that you can be murdered by your girlfriend,

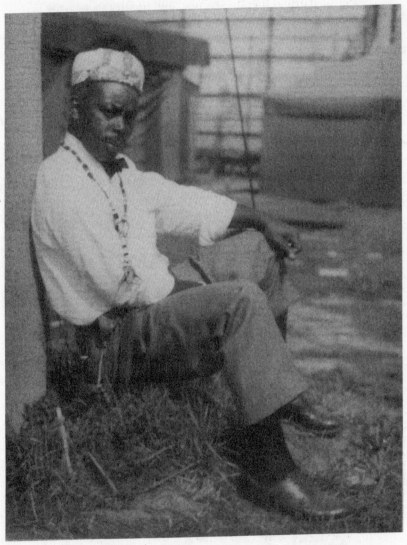

Pensive Charlie, pre-Hubert's, during his traveling days in the 1940s.
African American Photography Collection of Robert C. Langmuir

by your wife. So this way if you get into a heated argument, or you get ugly, and you want to kind of make it possible, just make sure that you leave everything friendly home so when you go back, you can sleep peaceful. Because if not, you might not be able to wake up. That is just kind of a tip, you know. Then when you come into Hubert's Museum, you will see what I mean by, this is the year of snakes, and this is the year that ladies is a little ugly. May I remind you, keep that in mind.

Deep, weird themes, these snakes, homicides, and ladies, delivered in Charlie's hypnotic rap; the lore and dream-stuff of a Harlem conjure man. *Want to learn more? Hurry along!* Slam Stewart resumes his unearthly crooning.

How did Charlie come by his copy of "Slam Slam Blues"? Did he own other jazz records? Was he a jazz buff? A hipster? It's a little like standing at the portal of that time machine without a key—the easy, weary "Slam Slam Blues," the giants performing it, and the mind of the talker, all leaking through from the past.

A CRACK IN THE MYSTICAL VESSEL

THE HUNDREDS OF PAGES OF CHARLIE'S MUSINGS were so rich, so personal, so informative, and Bob applied himself to them with such ardor, that he eventually developed a strong sense of identification with their author. He could *hear* Charlie's voice. He could see the mirror image of himself in Charlie's active mind, his deep-seated (and well-covered) sweetness of temper, his optimism, his alcoholism, his hypochondria, his paranoia, his brute endurance. Soon the coincidence of their shared birth dates and initials revealed its true meaning: Bob came to believe that Charlie was his psychic twin.

With this connection in mind, he returned to the study of Diane. Being a visual learner, Bob concentrated more on Arbus's images, and only picked up occasional lines of text from the reference books and Web sites he perused. Floating down a page, from photograph to photograph, his eye might light on a sentence or a paragraph and pause there, almost for a rest, while the words flowed into his mind. If they seemed significant, he'd parse and store them, and recall the text when he needed it, integrating the words with what the pictures were telling him.

Thus it was that in the difficult autumn of 2003, another Diane emerged. Glossing a page, he saw that the great photographer Walker Evans had called her a huntress. That seemed an odd word for such a pretty wisp of a thing, but a smart word, too, a play on the goddess Diana. A huntress, he decided, she must have

been. Who else would make her way backstage at a transvestite club? Or wind up in a cheap hotel room with a naked dwarf? Those were *not* places where petite Jewish mothers of two daughters went, unless they resolutely put themselves there. And she wouldn't be putting herself there unless she was looking very hard for something in particular. She was sexy all right, but Bob doubted it was about sexual kicks. It was the images she was hunting. Pictures she was "taking" back to the world from those risky places. Except that the risk was just a by-product, not a motivation—of what sort of weirdness?

Well, it wasn't really about weird, was it? He intuited something vastly more profound in those photos than kinky voyeurism. It seemed miraculous to him, for example, that he could feel more tender regard flowing between the two doll-faced, delicate she-males in *Two Female Impersonators Backstage, N.Y.C., 1961*— the one with his hand ever so gently on the other's self-clutching arm—than he personally had been party to in many a moon. Or that *Mexican Dwarf in his Hotel Room, N.Y.C., 1970* could so absolutely knock him for a loop. Towel thrown over the dwarf's lower body (what was a *towel* doing there?), left arm cocked against the night table on which sat the opened pint of hooch, the jaunty tilt of the hat (sole item of clothing on the little guy), each contributing flawlessly to the grotesquerie of the stumpy fingers, freakishly shortened torso, and those three toes just peeping out from under the towel at the bottom of the frame. How was it that the man's face could convey such patience, such a kindness toward Bob? It was a balm to him as he stood there at the worktable, in his own existential pain, repelled by the naked hotel-room dwarf and pulled back in by that calm face, those serene, forgiving eyes, and the wide, gracious mouth, until the man himself became lovely, allowing Bob to feel lovely for a moment at least.

It occurred to him that Diane hadn't gotten her tiny white self there and then just accidentally snapped those pictures. They represented a conspiracy between the shims and the photographer. Between dwarf and Diane. The huntress was implicated in those images, and their effect on Bob's psyche implicated him as well, as if the photographs were machines that took this energy from its source and sent it to Bob. What would the camera be then? The boundary? The valve?

That was something nobody seemed to get about the camera—how, when that was there, out in front of you, it was like your shield and your passkey all at once. You were drawn by it; you were on its mission; you were protected by it. And when you were in that state, nothing deterred you. Bob understood that about her. He'd felt it himself, even without a camera, when he was on the hunt, the way he was when he'd been going after this sideshow archive. When you were on that kind of a mission you could do anything. But Bob was equally able to imagine Diane Arbus as her daughters' loving mom, the human being overwhelmed by this other thing, the power she carried, as signified by the camera—as if the artist she was *consumed* her.

He could feel her presence so strongly. He'd touch the scar just forward of his jugular and recall his accident all those years ago in Vermont, the very day that Diane Arbus departed this life. He'd wonder—were they in some kind of communication?

Now inextricably bonded with both Charlie and Diane, Bob probed deeper into the meaning of their relationship. Somehow Diane's photos wound up in Charlie's possession. How was she using Hubert's? How did she use her experiences there?

As the photos in the archive attested, she spent more time photographing Charlie, his wife, and other black and Puerto Rican normals than she did the true freaks who worked at Hubert's. In fact, this notorious photographer of freaks didn't seem

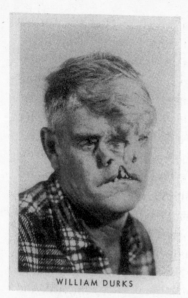

WILLIAM DURKS

Bill Durks's pitch card. It was a photo postcard, like Sahloo's, to be sold to horrified spectators for a dime. *African American Photography Collection of Robert C. Langmuir*

particularly interested in photographing the most freakish. For example, William Durks was at Hubert's while she photographed there. His pitch cards revealed a truly hideous facial deformity. There was only one, fairly tame, Arbus photograph of him in the archive. On the other hand, someone like Eddie Carmel, the subject of her famous 1970 photograph *Jewish Giant at Home with his Parents in the Bronx,* seemed less a freak than a vivid occasion for the representation of the prodigious, unruly effect of any boy child in any family—the mother's awed but fond gaze, the father's distant, faint disapproval. Bob knew that Diane first met Eddie at Hubert's in 1959. She must've worked for eleven years to capture him, with his parents, at that archetypal moment in 1970. The photo was not what it first seemed.

It was all ceasing to be what it seemed. Richard Charles Lucas was Charlie, was WooFoo, was Butch—so called by his wife, Virginia, Woogie, Sahloo, Wiggie, Wago. Prince WooFoo and Woogie perform "The Dance of Love" in a sideshow in the Conklin Circus. African Americans getting paid to impersonate African savages for white rubes. The endless transformations. "Charlie was always trying to get people to change their names," said Jack. "Wanted to call me Rufus." Diane's great inside talker,

he of the glittering eye, a man who, away from Hubert's, worried obsessively about his health, about money, about whether or not people liked him. Jack told Bob that Congo the Jungle Creep, "terrible as anything," according to Diane, was gay, liked to dress to the nines and stroll Times Square. Albert Alberta, half-man half-woman, and what if we couldn't always tell a trick from a miracle? Layers of the real slithered out from under him.

For a moment, when the Revelations exhibition opened at the San Francisco Museum of Modern Art, Diane Arbus was on the public's mind. There were even rumors that *Fur,* the long-awaited Arbus biopic starring Nicole Kidman, was headed for production. Jeff Rosenheim, now in frequent contact with Bob, had rearranged his position after seeing the Arbus note and the nineteen new photos. He told Bob how to get in touch with the estate and how to go about the lengthy process of getting the photos authenticated. And Bob remembered Denise Bethel from his days of consigning material to Swann Galleries. She was the head of the photography department at Sotheby's now, and in his increasingly manic state he called her, told her what he had. She was extremely interested. They had several long conversations about how such an archive might be marketed, and what it might be worth.

Bob was on fire with these facts, these connections, these coincidences. Rosenheim and the Met; the movie, *Fur;* Revelations; Denise and Sotheby's; Jack Drac; the Arbus estate; his business affairs; Jan; and the most important, essential, philosophical problem the discovery posed—that of his own identity—of his doubleness with R. C. L. and his soul communion (perhaps forged at the moment of their mutual meeting with death) with Diane.

A dizzying possibility presented itself. Could it be that he had been given these discoveries in order to reunite Charlie and Diane? Was his very being the mystical vessel in which this union was to be accomplished?

BOB AND WOOGIE

WHEN ANOTHER OF THE ARBUS PHOTOS came to life before his eyes, the intensity of the experience was almost unbearable, fraught equally with the terror of reality having come undone once again, and wonder at what the fracture revealed.

He'd been alone in the shop one night, listening disconsolately to the World Series and leafing through Charlie's papers, when he found a document referring to Woogie as Virginia Bostock. This didn't surprise him; he'd known for quite a while what her real name was. But it reminded him that Charlie had somewhere recorded her place of birth as Philadelphia. Just for a lark he consulted the Philadelphia white pages on his desk. There were several Bostocks listed. Though it was getting late in the evening, Bob, suddenly in high gear, began calling the numbers, intending to ask for information about Virginia Bostock, or Virginia Lucas. On the first call he got an elderly man.

"Virginia, she in the home now, Stephen Smith, over on Girard."

Despite the man's insistence that Woogie was out of her head, Bob arranged a visit for the two of them to the Stephen Smith Home the next day. At the appointed hour he picked up Louis Bostock, a small, furtive man smelling of alcohol, who claimed to be Virginia's brother. They drove through Philadelphia slums, the scene of some of Bob's best scores, to Belmont and Girard, and pulled into the driveway, past an old, dark Dickensian structure

that used to be the school where philanthropist Stephen Smith educated underprivileged black kids. Next to it was a 1960s-style institutional building of four or five floors. They went in and were confronted by a large, square, deeply black woman in a disconcertingly pink smock. She looked scary, but Bob announced their business and she brightened. Yes, Mrs. Lucas would love to have visitors.

Interminable wait for the elevator. Stink of institutional food and diapers. Up to the third floor. Same surprisingly friendly reception at the desk on that floor. Around to the sunroom, where Mrs. Lucas was passing her time. The room was a blare of noise from a TV, a radio, and people talking, a few of them ranting, in spasms. Three elderly black ladies were standing at a table conducting a prayer meeting, singing old-fashioned gospel songs to the accompaniment of a scratchy 78-rpm record player. Woogie was sitting in a chair in a corner, dressed entirely in white, with white socks and sneakers, all hunched down into herself, head on her chest, thinning gray hair done into a tiny knot that sat at the very top of her. Louis addressed her in a brusque manner. Bob hung back, uncertain. This was exactly the sort of sensory barrage that was so difficult for him to process. The maddening mess of sound drove everything from his head. He felt dizzy, a little nauseated. Then something impelled him toward Woogie, as if he might find safety or order there.

He knelt beside her chair. "Mrs. Lucas? Virginia?"

No response.

He grasped her hand and craned his neck around to address her face to face.

"Woogie. My name is Robert. I came to visit you. To see who you are . . ."

He realized he should've said "how you are" but before he could correct himself Woogie met his gaze. As they made eye

contact something flowed into her, and she straightened up and looked him full in the face. She smiled. Her shoulders were thrown back and there was light in her eyes. It was a gorgeous smile. Bob realized with a pang that she was still a beautiful woman. All he could think of was a desert flower opening in spring rain.

"Oh," she chuckled. "I'm doing pretty well. Taking it a day at a time."

Bob was astounded. Despite her brother's denials, she was all there. He could feel the personality, that same healthy loveliness he got from the photos and from Charlie's praise of her in the journals.

"Woogie, do you remember Charlie? Do you know where he is?"

She smiled, said nothing.

"Do you remember Hubert's, Woogie?"

She nodded. "Yes, those were some days."

"Would you like to tell me about them?"

"Well, I'm doing all right . . ."

The shadow of her personality was the only thing that survived in her. The brain had been left to molder, unstimulated. If he came and visited her every day for two hours, perhaps something would come back. But he couldn't even spare that kind of attention for himself.

"Woogie, it's been very good to see you."

"I'm doing all right," she smiled.

Later, he got hold of Jack Dracula and arranged for another visit, this time without the brother, who had hit Bob up for money after they'd left the Stephen Smith Home. Jack charged up the batteries on his motorized wheelchair and zipped through icy streets all the way from his apartment on Twenty-second Street to Belmont and Girard. Bob followed in the van, feeling too shattered to risk the sidewalk in those rough neighborhoods.

He'd drive ahead a few hundred yards, wait for Jack to catch up, then pull ahead again. Before they left he told Valerie he was going to do it that way so he could watch out for Jack. She snorted, "Are you kidding me? A three-hundred-pound, one-legged, blue-green alien in a wheelchair? Nobody's going to lay a finger on him."

Nor did they. Jack got his chair right up to Woogie, and she blossomed again, and said that she was taking it one day at a time, was doing all right. Jack asked her about Hubert's and she said those were some days.

So were these.

DECONSTRUCTING THE PALINDROME

CONTINENTS WERE SHIFTING ON PLANET BOB. Vast holes were opening, and in their depths he caught glimpses of his own destiny, which had nothing to do with mystical vessels or cosmic reunions. The model of reality he had painstakingly spent a lifetime cobbling together was failing in some fundamental way to correspond with the actual world, and it was freaking him out. The disintegration of his marriage, and the dream of family life that went with it, was breaking his heart. But he was so distracted by Charlie and Diane that he didn't understand where the pain was coming from.

Bob had done the best he could. But his version of family life had been a romance never sullied by the grinding, daily give-and-take of maintaining a relationship (a task at which Charlie had excelled), or by acknowledging the difficult choices, as Paul Grillo had done, between living like Jack Kerouac and providing a stable home for his three girls. Now Jan was seeming more and more like Mom—whose death in 1995 only hastened this process—and Mom was a force in the cosmos that was quintessentially anti-Bob. The whole thing was coming apart.

Thanksgiving 2003 was terrible, and Christmas was worse. Bob had tried to arrange a joint family get-together for Thanksgiving Day, but Jan's siblings, Meg and Ernie, backed out. That left Bob's mother, who was dying of cancer, to dine alone with Bob and Jan, Bob too resentful of Jan to muster up much

sympathy, and feeling plenty guilty about that. His suggestions for Christmas were shot down, and he wound up sitting glumly around with Ernie and Meg and Jan, who thought, rightly, that he was acting like a jerk. More of the same for New Year's. He hadn't wanted to go out at all, but allowed himself to be dragged to a club, where he nursed two light beers through the evening and watched the three of them drink, Jan chastising him for not joining in. He didn't want to drink. He knew bad things happened when he drank, and he didn't want to make a bad situation worse. In truth, Jan may have been having as much trouble as Bob. But Bob was too involved in his own troubles to grasp that.

They exhibited at the winter version of that paper show in Hartford, Connecticut, early in January 2004. Bob drank heavily, got violently sick in their hotel room, and had what he described as a "nervous breakdown." He began vomiting blood. Somehow he and Jan made it all the way from Hartford to Lancaster. Back home, they commenced a running fight that smeared across the rest of the week.

The battle reached its climax the next Sunday morning, when they woke, sick and hungover, to discover that it was snowing like hell. They needed groceries and fought about who'd go out, a dispute they settled by both going, unhappily. Walking to the car, Jan instinctively grabbed Bob's arm. Then she broke away, as if he'd grabbed her, telling him she knew he didn't want to touch her. Bob, in a terrifying flash of rage, tore the mailbox off its stand and dashed it to the ground in front of her. They dragged themselves through the supermarket, and when that ordeal was over Bob went back to bed. Jan was on the phone with Meg for most of the day.

Between phone calls she'd come up to the bedroom, flip on the lights, and start arguing with Bob about some issue that she had just finished discussing with her sister. Finally Bob accused her of being depressed. This enraged her. She started screaming

and crying. He got up to try to calm her. She pushed him away. He grabbed at her. They both fell on the bed and squirmed up immediately, shouting at each other. The fight moved downstairs to the kitchen. She blamed him once again for putting her in the middle, between him and her family.

"I feel like you'd sell me down the river for your family," he said.

"I would!"

He smashed his coffee cup on the floor and stormed out. Drove through the snow, up to a vacant Manpower office in Ephrata, where he'd been sorting a large photo collection. He had some Xanax up there, and he knew they both needed it. They had to calm down and sort this thing out.

When he got home Jan was gone.

He medicated himself and went back to bed, thinking she would call, but she did not.

He called her at work on Monday. She said she wasn't ready to talk to him and hung up.

She didn't call Tuesday.

Bob called her Wednesday morning, and she agreed to meet him for lunch to talk things through. He went out and bought a fancy spread, thinking to woo her back. Dishes of delicacies, roses, sweets, three or four bottles of expensive wine.

She stood him up. Some part of him knew she would.

if you ask what is roung I Could not say . . . sumthing is stell rong, We or good in our on way we try had to do the right thing by all, but out davil and monstrous . . . I am not a man that is likeable

That was when it all came undone—into infinite sadness, the sensation of everything receding at the speed of light, and no

will left to grab even a single piece, to try to hold on. He ate the lunch by himself—the wine part of it, anyway, and took some Xanax. Went to an early movie, took some more Xanax, rear-ended "some asshole" in a BMW. The guy wanted to make a big stink. Bob said, "Whatever . . . ," gave him his license and registration, and drove home to where the wine was. He called Valerie, crying, and later that day called her again, his voice deeply slurred now, saying things like, "I'm sorry I have to chicken out."

Valerie had married a few years before, but she was still very much involved with Book Mark and with the affairs of her erst-while business partner. Bob's calls terrified her. But what could she do? He was miles away in Lancaster and she was an agora-phobic. She called Jan at the Manpower office. Jan refused to take her call. She called her friend Mary, whose husband was a cop. Mary told her that Bob might be a danger to himself, and that she ought to call the Lancaster police. Instead, Valerie called poi-son control. They told her that Bob probably wouldn't be able to kill himself ingesting wine and Xanax all day, but that there was an excellent chance he'd strangle on his own vomit while asleep. She called the Lancaster police.

They asked her if she thought he was suicidal. She said she thought he was. They told her that if Bob wanted to sign himself into the hospital on what was known as a 201 form, they'd take him there. That way he'd be able to sign himself out again. She called Bob on his cell and told him this.

Bob called the cops and asked if they were going to cuff him when they took him in. They said yes, that was standard proce-dure. He said he couldn't abide that. They said they were sorry, but that was the policy. He said he wasn't coming in. They said if they caught him driving around, they'd haul his ass in there whether he liked it or not.

Eventually a compromise was struck in which Bob would

check himself into the hospital if Valerie could get out to Lancaster and sit with him through the difficult task of surrendering himself. Valerie's husband was a sweet-tempered artist named Larry, who owned an old car in which he drove her wherever she needed to go. Inspired by the vision of nocturnal strangulation, Valerie got Larry to start up his junker and take her to Lancaster. They met Bob at the Lancaster Brewing Co., where he was having a beer with one of his lady friends who worked at a coffee shop downtown. He'd gotten himself into a giddy mood by this time, talking about going to the hospital as if he were going to a spa, wondering if he'd get mud baths with his electroshock, joking that he might even stay an extra week if he liked it.

Valerie and Larry drove him the few miles to Lancaster General, where he checked himself in for observation. Staff people put him on a table in a cold room. He asked for a blanket and passed out. Valerie left him alone there, fairly certain that he'd still be alive when she returned. But something unexpected happened. The cops, or the examining physician, or *someone* decided he was a danger to himself, potentially a danger to others, or even just sufficiently drugged and drunk that he needed close watching for a while. They transferred him to the intensive treatment area on the top floor, to a room that was absolutely empty except for Bob's gurney. Bob woke up at six A.M. the next morning, freezing in his paper pajamas, noted the monitoring camera and the window bars, and realized that he'd been locked up in the psycho ward. It was, according to Valerie's utterly convincing testimony, the one place that "Bob had spent his whole life secretly terrified he'd wind up in."

NEW BOB

THE KISS AND THE CURSE

IN 1957 DIANE ARBUS'S CONTEMPORARY Frank O'Hara wrote about, "a poet exhausted by / the insight which comes as a kiss / and follows as a curse." O'Hara's lines honored the great mad poet John Wieners, but they will stand as an apt image of the extremes Arbus endured.

Without giving credence to the tortured-soul melodrama so often proposed for her, it is easy to imagine how exhausting her life must have been. Her energy was enormous. She accomplished the work of a lifetime in a little more than ten years, and the pages of her notebooks are crammed with enough ideas and projects to have kept her busy for several more lifetimes. Her exhaustions, especially toward the end of her life, were equally intense. The kiss of her artistry and the curse of depression coexisted at the height of her career in a terrible equilibrium.

When she died in 1971, Arbus was intestate and divorced. Management of her estate devolved on her eldest daughter, Doon, who was advised by Marvin Israel and by family friends such as Richard Avedon. They shared a fierce, protective love of Arbus and her legacy, and over the next few years they helped assemble the widely viewed 1972 retrospective at New York's Museum of Modern Art, and collaborated in publishing *Diane Arbus*, the tremendously popular collection of her photographs.

Unfortunately these successes were accompanied by an ever-increasing volume of twaddle regarding Arbus's life, work, and

death. Because of the subject matter she chose, and because of her suicide, it was easy to slide into morbid pop psychology to explain her complex persona and her difficult art. Her biographer, Patricia Bosworth, says, "It was almost as if she was determined to explore with her body and her mind every nightmare, every fantasy, she might have repressed deep in her subconscious." A reviewer for the *LA Weekly* (presumably a forensic psychologist in a prior lifetime) informs us that "Arbus fits the diagnostic criteria for a manic-depressive artist to a tee." The temptation was as great for academicians. Consider this excerpt from a scholarly article about Arbus's images of transvestites and homosexuals:

> Much of the writing and scholarship on Diane Arbus is rooted in psychoanalysis, as scholars attempt to pinpoint the images that signaled her despair, her self-loathing, and her intention to take her own life.

Remarkable words. Most of us would be hard put to identify in her photographs the "self-loathing" so casually ascribed to her, let alone "her intention to take her own life."

Doon was twenty-eight years old when Susan Sontag published *On Photography*. Sandra Phillips, a curator of the Revelations exhibition, said she thought Doon had certainly found Sontag's attack "hurtful." But the episode's implications went beyond hurt feelings. If a celebrated critic like Sontag could so spectacularly misinterpret Diane Arbus, why should the Arbus estate be complicit in further misinterpretations—or any interpretations at all? Doon became adamant in her insistence "that the photographs were eloquent enough to require no explanations, no set of instructions on how to read them, no bits of biography to prop them up."

Admittedly there is something redundant or arrogant in writing in a certain way about a photograph, which has already said what it had to say by being seen. It is perhaps even more arrogant to ascribe psychological traits to a photographer based on impressions the critic has gleaned from looking at her photographs. But Doon, in the view of many, carried such reasonable objections to an extreme. The control she exercised over Arbus's work was unequalled anywhere in the photography world.

Only prints that had been reviewed, authenticated, and signed by Doon were allowed to be sold as vintage Arbus photographs. Copies printed from Arbus's negatives were strictly limited and marketed through a few carefully chosen galleries and auction houses. Doon was also stingy about the dissemination of her mother's images in the press, and for the most part would not allow them to accompany essays and articles written about Arbus. Bosworth's biography of Arbus was published in 1984 despite the explicit disapproval of Doon, who refused to grant permission for any of Arbus's photographs to be reproduced in the book. Even Sotheby's and Christie's, which had begun to sell Arbus's photographs for increasingly grand sums, had to scramble to secure permission from the estate to reproduce the images in their sale catalogs. As Arthur Lubow said in his 2003 *New York Times Magazine* piece on Arbus, "critics and scholars fumed."

Doon's management style might have been annoying, but it turned out to be excellent marketing. Whether she intended it or not, her tight regulation of the flow of product created an aura of scarcity that, when combined with the efforts of supporters like John Szarkowski, fueled the market for Arbus photographs. The sales history of any of her iconic images—say, *Identical Twins, Roselle, NJ, 1967*—reveals an astonishing trajectory.

Twins first appeared in the New Documents show the year after it was taken. It was included, three years later, in the *Box of*

Ten Photographs. Aside from the four sets of *Box* that Arbus sold,
there are no records of a public sale of this image during her life-
time. However, judging by the few sales of her other photographs,
she might have expected to get $100–$150 for a vintage print (one
she actually produced or supervised in person) of *Twins.* In 1973,
a *Business Week* article trumpeting the growth of the photogra-
phy market stated, "In her lifetime a print signed by Diane Arbus
would have been worth $100; today, the price is closer to $750."

In 1979 a photograph collector's guide estimated that "a fine
original Arbus might go as high as $2000 or $2500." Eleven years
after her death, in 1982, a vintage print of *Twins* sold at Christie's
for $4,400. Sotheby's sold one in 1986 for $8,525; in 1987, for
$10,175; in 1990, for $44,000; in 1994, for $70,700; and in 1998,
for $101,500.

Sometime in the late 1990s, Doon decided to cooperate in
mounting Revelations—the vast, comprehensive Arbus retro-
spective—by providing a landslide of documentation and infor-
mation to accompany more than 180 photographs, some of
which had never been seen by the public. This, Doon claimed,
was a strategic adjustment rather than a reversal of policy. It was
her great hope that Revelations, with its "surfeit of information,"
would finally "render the scrim of words invisible so that anyone
encountering the photographs could meet them in the eloquence
of their silence."

That was all well and good, but anyone wishing to encounter
Arbus's photographs in the eloquence of ownership was going to
have to pay more for the privilege than ever. A vintage print of
Twins sold at Christie's in October 2000 for $270,000.

The publicity attendant on the opening of Revelations in
2003 demonstrated that something had been added to the pub-
lic perception of Diane Arbus since the 1970s. Arthur Lubow's
New York Times Magazine article portrayed Arbus as a "deeply

empathetic artist." Another piece, in *Vanity Fair,* raised the stakes, suggesting that Arbus could now be seen as an artist who "recognized the private, precious freak in everyone." Writings by scholars of sexual diversity added to Arbus's luster by identifying her as a pioneer in the fields of queer studies and gender identity. Her persona, in its new Revelations iteration, had acquired an almost saintly sheen.

None of the writing considered the effects this publicity would have on the market for Arbus's work, but dealers and collectors were keenly aware that the results—positive or negative—would eventually be reflected in the prices her photographs brought at auction. As it turned out, they didn't have long to wait. In April 2004, Sotheby's hammered down a vintage print of Arbus's *Twins* at a record price of nearly $500,000, surpassing the old record for a vintage Arbus print by more than $200,000.

The buyer, San Francisco socialite and entrepreneur Trevor Traina, told the *New York Times,* "To be able to buy one of the most important works in the entire medium for half a million dollars strikes me as the bargain of the century. I certainly can't be out there buying Vermeer, Rembrandt or Caravaggio on my budget." Coming on the heels of decades of enforced scarcity, Doon's "surfeit of information" jolted the public's awareness of Arbus and, in whatever subtle manner, made it easier for Mr. Traina to fork over half a million clams for a forty-year-old sheet of photographic paper that had been touched by genius.

There were many other auction sales of her prints, and condition and market variables were always at play, but the trend was clear. The value of *Twins* had appreciated ten times faster than the average value of the photography market, which itself had appreciated three times faster than the Dow Jones industrial average.

But the effect of all this on Bob's discovery was more complicated.

Although Doon allowed the public a peep at Arbus material that had never been displayed before, she still retained control over all the photographs and documents exhibited in Revelations. True, she permitted some images to be reproduced for publicity purposes, but these were images she had chosen, and the same few appeared over and over. Doon and her advisors had worked diligently for thirty-five years to establish the canon of Arbus's works, and to consolidate their control over the dissemination of those carefully chosen images. They were not about to surrender what they had wrought.

As far as they were concerned, images such as those Bob had discovered, while they might ultimately be of interest to scholars, had no place among the best examples of Arbus's work. The estate's lawyer compared the unsanctioned photos in the Hubert's archive to snapshots—pictures one might take of one's friends. Royce Howes of the Robert Miller Gallery, which represented Arbus in New York, likened past efforts at marketing Arbus's secondary work to going through her wastebasket. Denise Bethel at Sotheby's, or anyone involved in the photography market, would tell you that the icons were always the ones that achieved the highest prices. *Boy With a Hand Grenade, Jewish Giant,* or *Twins* would continue to escalate in value. Secondary work would fall by the wayside.

A kiss, certainly, for Doon's heartfelt management of Diane's legacy. But something of a curse for Bob. So perhaps it is fortunate that he was distracted by other matters.

PAPER PAJAMAS

VALERIE HAD IT RIGHT. The psycho ward was precisely the place Bob had spent a lifetime trying to avoid. When he awoke and saw the bars on the windows, he knew his worst nightmare had come true. His season in hell had begun.

In metaphysical terms, this territory, the country of one's deepest suffering, exists outside space and time. As Bob's guru, Muddy Waters, sang it, "Minutes seem like hours, hours seem like days." That folk-lyric fragment predates Robert Johnson, but the brokenheartedness that makes each instant endless torture has always existed. "I been mistreated and I don't mind dying," concluded Muddy. Bob, trembling on that gurney, was not far behind him.

Yet the ultimate redemption of Bob's butterfly nature and, incidentally, of his ADD, was that he had as little patience for hell as for any other aspect of his hitherto unhappy existence. Bob's Hadean sojourn was over in an eyeblink—a hard fall and a good bounce. He caught one glimpse of the psychic landscape he now inhabited, realized it was but a distillation of his life until that moment, and, with a shudder of revulsion that swept through his entire being, declared, "I don't want to *be* the person that got me here!" thus committing himself to his cure with more ardor than he'd ever poured into his pursuit of Valerie or Jan or Diane. Those adventures had been palliative; this one was for far greater

stakes. He clutched his paper pajamas tightly about him, clambered down off the gurney, and called out for help.

That morning, during his intake and indoctrination, he was tractable and calm. When the doctor interviewed him he was forthcoming, cooperative, even enthusiastic. He wanted to get *better.* Old Bob, alienated and paranoid, had been overthrown. New Bob intuited that his survival depended in some mysterious way on his connection with other people. He signed up for every therapy session and group he could get into, and he reached out in earnest to his fellow inmates, starting conversations where before he would have been too mistrustful or self-absorbed to initiate contact. After the doctors transferred him from the intensive treatment area to the general population of the behavioral health evaluation unit, he met a heavyset, miserable girl with unattractive piercings, a messed-up complexion, and slashes on her wrists. With his habitual defenses down, Bob was able to see a kind of honesty in her damaged and vulnerable state. He began to talk with her and they became friends. The next morning he met a black kid with a large misshapen head who asked him what he was in for.

"Depression," replied Bob. "How about you?"

"I see dead people."

Instead of freaking out and fleeing (not that there was anywhere to go), Bob remembered that he'd seen a copy of *Field of Dreams* in the video box. He popped it in the VCR after breakfast so he could show the kid that Kevin Costner saw dead people, too.

He met a toothless, soft-spoken redneck who'd abused his aging father and then gone mad with guilt when the old man died. In group therapy he met a teenaged schizo who got messages over his computer. *From* his computer. He met junkies and hipsters, kids and old folks; some he mentored, some he learned

from, some were too far gone for anything but compassion. In the hallways, in the lounge, at therapy, and at meals he sought out his fellow sufferers, befriended them, suffered with them, shared hopes and disappointments. Scott, the group therapy leader, told Bob that if he stopped drinking for a year he'd find out a lot about himself. This came as an invigorating shock. It had never occurred to Bob that there was anyone inside himself to find out about. Suddenly he had a new perspective. If he could reach out, why shouldn't he be able to reach in? He resolved to try.

The doctors loved him. They'd rarely seen anyone as wide open as he was. They were certain that of all of the patients they treated that dreary winter, Bob would be most likely to succeed. His new friends felt the same way. When they heard what Bob had to say about Jan, they opined that she was the one who ought to be there, not Bob.

And they heard plenty about Jan. Bob missed her terribly. At first, his primary motivation was to get himself better so that he could get out of there and repair his relationship with her. But ominous signs began to accumulate. His clothing arrived, thrown into two plastic garbage bags, with no notes attached. He tried calling her and she refused his calls. Then two letters from Jan arrived, one after the other. They were, as Bob would later characterize them, "epistle missiles of the poison pen variety; finger pointing not of the Michelangelo type."

The staff monitored Bob carefully to see how he'd react to these upsetting communications. He was certain that if he could just talk to Jan he'd be able to make her understand that he was intent on changing his ways. On Friday, after four days of treatment, he was ready to do just that.

Technically, since he'd been admitted on a 201 form, he was supposed to have been able to sign himself out at any time. But his caretakers were savvy and seasoned. They wanted to be certain

that he was developing a sense of responsibility about his mental health and that he had a support system on the outside—a treatment plan including doctors, friends, and meds—before they released him. So the nurses told him bad weather was coming, and that the necessary administrative people wouldn't be around during the weekend to process his papers.

Bob, compliant in his new mode, watched the snow fall over a gray land, and listened to the girl he'd befriended at the beginning of his stay. Despite her unending stream of god-awful stories, she'd begun to radiate a kind of beauty—demonstrating the simple truth that her essential nature emanated from a deeper place than her unhappy past. When the weekend was over the staff told him that no one was ever released on a Monday. So it wasn't until Tuesday that he was allowed to totter back into the mess he'd made of his life.

Bob and his new friends gathered in the common room to say good-bye. The mood was light, optimistic. They knew that he'd make it, and that gave them hope for themselves. While waiting for his papers to come down, they began a game of Pictionary. Bob had them all in stitches. He felt better than he'd felt in a long while. In some weird, unexpected way, it *had* been the spa he'd fantasized about. "Cooling springs for inflammation of the spirit," was how he put it.

There was a knock on the door. The nurse opened it, and instead of an orderly with Bob's release papers, Jan's brother, Ernie, walked in, looking pale and tense. Bob jumped to his feet at the sudden apparition. Ernie reached in his coat, pulled out an envelope, and thrust it forward. The nurse intercepted it.

She placed herself between the two men, absorbing the tension and turning toward Bob with a calming smile, "Do you mind if I have a look at this?"

Bob, in confused transition from the gaiety of the moment before, nodded his assent. He watched her read the paper and then he asked her what it said. He knew it wasn't going to be good news, but he still couldn't understand what Ernie was doing there instead of Jan.

"It's a temporary PFA order," she told Bob.

"What's that?"

"Protection from abuse. Your wife considers you a physical threat. She's gotten a court order forbidding you to go near her or to try to contact her."

He scanned the paper but the letters were a jumble. A wave of sadness, milky and warm, washed over him. He regarded his brother-in-law through tearing eyes. "Ernie, this is not the way to go about it . . ."

The nurse handed Bob an Ativan.

OFF THE COUCH AND INTO THE FRYING PAN

JUST AS THEY HAD EIGHT DAYS before, Valerie and Larry drove out to Lancaster General Hospital to collect Bob. The staff members were careful to explain that it would not be possible to return to Bob's home on Pinetown Road. This was a serious matter and they wanted to be sure Bob and his friends understood. There could be criminal penalties if Bob even attempted to contact Jan. Valerie was livid. Bob was incapacitated by Jan's preemptive strike. Larry took them to a Bob Evans Restaurant, where they ate a huge family-style breakfast and then, sedated by corn syrup and transfats, they returned to Philly.

There, Bob got deposited on Valerie and Larry's couch, which was tucked, womblike, beneath the stairway in the living room. It served as Bob's primary residence from the end of January until the beginning of May 2004. Zoe—Valerie's Jack Russell terrier—was his constant companion. Whenever Valerie passed through the room, Bob and Zoe would perk up and follow her. When Valerie shooed them away they'd go back to the couch. Bob would scratch Zoe's ears and mull over his problems, fortifying himself only occasionally with herb tea and peanut-buttered toast, losing about twenty pounds as a result. (Zoe might have gained a few.) In physical terms it was a fallow period; intellectually and spiritually it was one of the most active and intensively creative interludes of his life.

Valerie kept busy trying to reorganize their business, which Bob's pursuit of Diane had reduced to a shambles. By cleverly arranging their finances and maxxing out a couple of credit cards she managed to fund a cleanup and partial renovation of the Book Mark building. Trash got thrown out. The downstairs was remodeled into a modest but handsome office and meeting space. All the saleable material, including Bob's extensive photo collection, was salvaged and moved to the front half of the second floor. The rear was converted into a bedroom suite for Bob, complete with shower, toilet, television, and storage bins for his personal belongings. Valerie was highly motivated in this endeavor. The sooner she got Bob off her couch, the better it would be for them all.

Bob was motivated, too. He had the care of his soul to consider, and he put in a lot of couch hours considering it. His talks with the girl at Lancaster General had awakened something in him. Her ugly beauty enabled him to envision an unsullied version of himself deep inside the miserable creature who'd been such a failure with Jan. There was, somewhere in the wreckage of his life, an original, recoverable, redeemable Bob, a Bob he might discover for himself if, as Scott had suggested in group therapy, he quit drinking and made a few other sensible choices. The revivification of ur-Bob, he vowed, would be his masterpiece.

Books on religion, spirituality, and self-help, fetched by Valerie, began to pile up around the couch, and Bob worked them in his butterfly way—scanning, drinking deeply, moving on. He had always been interested in the Dalai Lama, and this got him into Buddhism and its contemporary practice, which led him to the world of Western adaptations of Eastern wisdom—books and tapes like Jon Kabat-Zinn's *Full Catastrophe Living* (that sticky title having been appropriated from Zorba the Greek's

highly descriptive and not entirely negative reference to his marriage as, "wife, house, kids, everything . . . the full catastrophe"). The practice of mindfulness meditation as espoused by Kabat-Zinn helped Bob, through his breathing, to meet himself in the present moment. This opened him to the droll, wise Eckhart Tolle, who suggested that the eternal Now was the portal to one's deeper self. Bob was pleased to learn that his unhappy history was an illusion of sorts, at least as it pertained to him in the present moment.

Sometimes it seemed that all the books and tapes could be reduced to a single truth, albeit one so far beyond the powers of the conscious mind that Bob could only sense its radiant presence. It was a thrilling feeling, almost dangerous in its liberating energy. It was, he telepathed to Zoe, difficult and deep. She tilted her head and cocked her ears as if to reply, "Not necessarily."

On the more mundane side of things, the doctors and therapists at Lancaster General had crafted a treatment plan for Bob, and he duly set up regular visits with a pharmacologist and a psychologist. Aside from the pills and advice they offered, these men helped Bob understand that some of his problems were physiological conditions rather than moral failings. He began to recover his dignity.

At first, Bob and Valerie thought he might have borderline personality disorder, so he made an appointment at the University of Pennsylvania School of Medicine in downtown Philly. They told him he didn't have BPD, but they suggested he might benefit from attending their cognitive therapy group. Cognitive behavioral therapy was a treatment of choice for many disorders, including depression. It aimed to show people how certain thought patterns gave them a distorted view of reality. As chance would have it, there was an opening in the group, and Bob started attending. They met once a week for two hours. Invariably it was intense.

All that winter Bob forced himself off Valerie's couch and along icy streets to his hours with doctors and fellow sufferers. Pretenses, irrational thought patterns, and stale beliefs got ripped away like mustard plasters. The membrane between him and the world was pink, proud, constantly raw.

"I felt like a burn victim," he said.

Toward the end of April, one of the women in Bob's group announced that she had found a new boyfriend, and that this one was a good guy, a real keeper. She'd met him over the Internet. Bob was intrigued. This woman was about sixty-five years old and nothing special to look at. If the Internet match service could hook her up with Mr. Right, who knew what miracles it might perform for him? He got the Web address, and he and Valerie began cruising the site every evening, fascinated and amused by the vast range of queries and responses.

Then, quite to his own surprise, Bob started corresponding, via this Web site, with a woman named Renee Russock, who seemed both smart and sincere. Valerie liked her from the get-go. The correspondence deepened, and Bob became smitten with Renee's spirit and her independence—she was a single mom whose first husband had died tragically and who had recently left her second husband. That she was an observant Jew made her seem exotic to him. They arranged a meeting at an outdoor café. Bob was happy enough with what he saw—she was pert, pretty, and blond—and they both had a good time. (Renee later admitted that she'd driven by first, and that he'd looked sufficiently interesting for her to go ahead with the lunch date.)

By May, Bob was healthy enough to move from Valerie's couch to his new apartment in the Book Mark building. But he didn't stay there for long. He moved in with Renee in October.

Of course, none of this took place in such an organized fashion. Spiritual work, clinical visits, group therapy, and romance

happened all at once, and sometimes not at all; insight jostled with the dank whiff of failure. It was indeed "the full catastrophe," but somehow he moved through those first months of 2004 with feelings of clarity and aliveness that he'd never experienced before. A good thing, too, because he needed all the clarity he could muster in his ongoing struggle to resolve things with Jan.

The PFA distressed and terrified him. It identified him publicly—and falsely, in his view—as a physical abuser of his wife. He was afraid that if he even tried to contact her about it they'd throw him in jail. Because the PFA was a temporary order, a hearing on the matter had been scheduled for early February, shortly after Bob's release from Lancaster General. Friends in Lancaster hooked him up with an attorney. There were many long telephone calls from the couch, and finally a meeting in person. Bob, by this time, had worked himself into a state of indignation. The PFA was groundless, Jan's contorted attempt to punish him. He wanted to fight it. Bob's attorney told him he didn't stand a chance. These sorts of orders were rarely overturned, and besides, his case was being heard by a particularly tough judge. The lawyer recommended surface compliance and deeper strategy. He moved successfully to have the hearing postponed.

That set Bob to work in earnest, assembling his defense and composing the long narrative of his innocence. The stacks of self-help and spirituality books on the floor around the couch got layered over with books on divorce and domestic violence, and with documents that Valerie had extracted from the files at Book Mark. Bob solicited old friends like Bill Moonie's wife as character witnesses. He was determined to prove that he'd never hit Jan and that, furthermore, Jan was not even living in their house on Pinetown Road, of which (unfairly!) she'd been granted exclusive possession.

As the court date approached, Bob became more and more confident that he would win his case. But on the day of the hearing, Jan's lawyer offered to make a deal. While Bob stewed, the two lawyers huddled in the hallway. They came to an agreement that in exchange for dropping the charge of physical abuse, the PFA would be enforced for nine months, during which time Jan would continue her tenure at the house on Pinetown Road.

When informed of this deal, Bob renounced it as a travesty and categorically refused to play along, whereupon his lawyer went ballistic, calling Bob a jerk and asking why he'd even hired a lawyer if he insisted on doing whatever the hell he wanted, regardless of how badly it damaged his case in the long run. Bob backed down. The hearing was held, and the judge gave his consent to the lawyers' deal, adding that since Bob was being deprived of his residence he should receive support from Jan in the amount of two thousand dollars per month. Whereupon Jan went ballistic, summarily firing her lawyer, hiring, then firing, a second lawyer, and finally turning, in her desperation, to the sharpest attorney she could find in Lancaster, who promptly appealed the ruling on the support payment and lost.

Bob's lawyer demonstrated his shrewdness by firing himself. The case was too complex, he said—too many houses and businesses, all those brothers and sisters and partners, and that strange archive with the blacks and freaks—it was way beyond the ken of a simple country lawyer like him. A month later his bill came in. The expenses and legal fees had eaten up almost all of the three thousand dollars Bob had given him as a retainer.

And that was only the beginning.

YES!!! FANTASTIC!!! AND FASCINATING!!!

BOB REMAINED MINDFUL OF CHARLIE and Diane, but his thoughts of them now were more complex. In quiet moments between meditations or therapy sessions, he remembered the troubled, intense, and exhilarating days and nights the three of them had shared. It was as if they'd all lived in a war-torn country and only he had gotten out alive, bringing the Hubert's archive with him as a memento of all they'd been through together. The same impulse that made him want to redeem his own life now inspired him to do right by their memory. The disposition of the Hubert's archive would be a matter of critical importance in this regard, and he was determined, for once, not to screw things up. Charlie's papers and Diane's photos needed to be thoroughly researched and cataloged. They ought to be kept together, certainly, and ideally they'd go someplace where the public would have access to them.

At the same time the archive was Bob's meal ticket. Its sale would provide enough money for him to tend to his spiritual needs, to enable any of dozens of rosy possible futures. And this was where the thinking got complex. Bob, just before his breakdown, had told Jan that Sotheby's had given him an estimate of $250,000 for the Arbus photos—without even seeing them. He'd boasted to her that they might be worth a great deal more.

Naturally Jan assumed the archive would be part of a divorce settlement. But in Bob's view, the Hubert's archive was his personal discovery. By opting out of their marriage Jan had dis-

qualified herself from sharing in its proceeds. That no judge was likely to agree with him mattered not a whit. He held the moral high ground. Unfortunately, as he soon discovered, he was stuck up there. He couldn't get divorced without selling the photos, and he couldn't sell the photos without getting divorced. It was a puzzler. He went round and round with it. Zoe couldn't help him.

So, as he'd often done in the past, he simply moved on to something else.

Remembering what Jeff Rosenheim had told him about authenticating the photographs, he contacted the lawyer for the Arbus estate, explained briefly what he had, mentioned his connection with the Metropolitan Museum, and asked for instructions on how to proceed with the authentication process. The estate's lawyer, a man named John Pelosi, responded with a request for high-quality copies of the photos and a detailed inventory. Bob sent laser scans of the images and of the note that Diane had written to Charlie, and he included a narrative of the circumstances of his acquisition of the photos. Pelosi wrote back saying that authentication was underway and might take four to six weeks.

The timing seemed just right. In February 2005, a year hence, the Revelations show would have worked its way through San Francisco, Los Angeles, and Houston, to its opening at the Metropolitan Museum of Art in New York. By then the situation with Jan would doubtless be resolved and the photos would be authenticated. The renewed wave of publicity that the retrospective would generate would help extract the maximum price for his archive—from Rosenheim or whomever.

However, the estate seemed to have little interest in Bob's sense of timing. There was no report from Pelosi in February.

There was no report in March.

There was no report in April.

On April 23, the print of *Twins* sold at Sotheby's for $478,400.
Early in May, Bob sent an e-mail to Jeff Rosenheim:

> Going on three months no word from Arbus Estate. Emailed
> the lawyer twice—nothing. What do you think? Have you
> heard anything worth repeating to me? When would a pa-
> tient person get concerned?

Rosenheim told Bob he was about to meet with Doon and
Pelosi regarding the Arbus show and promised to bring up the
matter of authentication.

A few days later Bob got a letter from Pelosi with a stern
warning that all Arbus photos were copyrighted by the estate and
that any reproduction of them without the estate's consent was
forbidden. It also said that the estate had decided nine of the
prints were by Arbus, and that they were working on the rest,
most of which were probables.

That was encouraging news, but the estate's delay had given
Bob pause for thought. Though he had no problem, in theory,
with selling his goods to the Met, he now saw that he should avoid
getting into an exclusive relationship with Rosenheim, where help
with authentication would be exchanged for an inside track when
it came to the photographs. Another aspect of respecting Char-
lie and Diane had to do with keeping his options open.

He got back to his old acquaintance Denise Bethel at
Sotheby's, and within the week Chris Mahoney, a trim, enthusi-
astic thirty-something, presented himself at Bob's door, having
been sent by Denise to examine the goods. Bob tried to probe,
but Chris was cozy as a politician. He said he liked the stronger
examples and saw an upside for the collection as a whole, but that
the real market was first for the icons, then, perhaps, for work
that was new. Bob's images were by no means iconic, but they

had a certain appeal. Chris could not possibly talk about marketing strategies at this point, but he agreed that the Arbus retrospective would help in any marketing plans for Bob's photos. What was most important was the authentication process with the estate. No sale would be possible until that had been completed. He snapped pictures of the photographs while he talked.

A few days later Bob received an enthusiastic e-mail from Denise that began, "YES!!! FANTASTIC!!!! And FASCINATING!!!" She told Bob that the photographs ought to be sold as a single lot, pending authentication by the Arbus estate, and that they'd have much more impact if presented in the context of Hubert's Museum. "It was clearly so important to her development as an artist," Denise concluded. "This is important material."

Bob got back to Jeff, telling him about Pelosi's positive ID on the nine photos.

Jeff returned his e-mail that same day. He told Bob the time was ripe for a purchase of the archive by the Metropolitan. "I suggest that you use your magic ball and come up with a sympathetic 'museum price' for the whole lot . . . I'm ready to roll if you are."

If ever there was a moment for the sale of the archive, this was it. Bob might have used the Met's stated interest as a bargaining chip to insure the best possible presentation and a solid appraisal—perhaps even a guarantee—from Sotheby's. He might then have taken the Sotheby's appraisal back to the Met as a starting point in his negotiations with Rosenheim, and as a lever to speed up authentication by the estate. But Bob was not ready to roll. He couldn't sell the photos without getting divorced, and he couldn't get divorced without selling the photos. Nothing, in that respect, had changed.

A distinctly Old-Bobbian paranoia took over. He told himself he knew *exactly* what was going on. Rosenheim was linking the

acquisition of the photos with the New York opening of the Revelations show in February 2005, and using this to generate a sense of urgency. The core of the proposition pitted Rosenheim's imagination against his own. Bob was supposed to try to imagine a price for his archive. If that number was smaller than Rosenheim's the sale would proceed. If not, Rosenheim would walk. But there was something about Rosenheim's "museum price" and his hurry-up tactics that got Bob's back up. Who did Rosy think he was dealing with? He got back to Chris and Denise, to let them know that Rosenheim was urging him to move in a hurry.

That might have put the ball in Sotheby's court. But Bob had his misgivings about them as well. He could read Denise's coded reference to presenting the photos "with much background to the whole Hubert's Museum situation." What she meant was that she was going to strip out Diane's photos and sell them as a lot. Charlie's archive would be devalued to the status of a marketing aid.

Rosenheim, having by this time figured out that Bob's magic ball was incapable of divining a museum price, suggested that Bob have the photos appraised by a West Coast photo dealer. But Bob saw through that ploy immediately. Who was this guy? One of the estate's collaborators and a friend of Rosenheim's—that was who!

Bob put him off.

Denise and Chris were having their problems, too. It took a lot of lead time to assemble an auction. The next regularly scheduled photography sale, in October, was already filled. The next one after that would take place in April 2005, coinciding with the ongoing Arbus exhibition in New York. This would be the optimum time to expose Bob's material. But no marketing or cataloging work could begin if the photos weren't authenticated. Still, they had to keep things moving with Bob. Working on Pelosi's

assumption that nine photographs were close to being authenticated, they floated a proposal for three "tiered" sales of the photos, rather than a dedicated single sale with a catalog of its own.

Bob demurred.

There was no communication from the estate or their lawyer in August.

September passed without a word.

Finally, on October 19, 2004, John Pelosi sent a message from on high instructing Bob to deposit the originals at the Robert Miller Gallery in New York. Doon, Pelosi concluded, "will need approximately three weeks thereafter to complete the work."

ROBERT MILLER

THE BIG DAY WAS UPON HIM. Bob had already housed the photos in Ultra-PRO top-loading archival sleeves. He wrapped the rigid plastic rectangles in a fluffy towel with red teddy bears on it—a nice surreal touch—and put the inventory sheet, also in see-through plastic, on top. He laid the whole into a suitcase made especially for carrying prints and packed the edges with more toweling so that the bundle fit snugly. Then he snapped the lid onto the case and fastened the two straps that went around it. The only thing missing, he mused, was a titanium chain cuffing the handle, courier style, to his wrist. He felt calm but elated, somewhere between going to an audience with the pope and dancing off to meet the Wizard of Oz. He took the train to New York and a cab to Tenth Avenue and Twenty-sixth Street.

Chelsea had changed since Diane's day. Back then, the Chelsea Piers were a place where you might get mobbed up or beaten up. Now you could go figure skating there. In 1966 the Chelsea Hotel had been the setting for Warhol's raunchy *Chelsea Girls.* Now it was on the National Register. Dozens of galleries had moved uptown from SoHo, and restaurants, much to Bob's delight, had descended on the neighborhood from every corner of the culinary world. The streets were a banquet—hip, gay, stylish, and fun.

The Robert Miller Gallery was about halfway down Twenty-sixth Street, in a row of renovated warehouses, all plate glass and

slick modernity, that lined both sides of the street. Inside, the walls were light gray and the ceilings were very high. It felt like a museum. A pretty, anorexic young lady greeted him from a desk on his left. Behind her was a glass wall, and behind that was a space that resembled the reference room of a library, with floor-to-ceiling bookshelves and people hunched over desks or pounding away at computers. It had the look of scholarship, of high-toned industry, of money.

Bob gave the girl his name and said he was there for a meeting with Royce Howes. She picked up the phone and repeated this information, then told him that Royce would be right out. Bob took a deep calming breath, undid his scarf, and looked around. In an alcove across from the desk was an automobile tire on a pedestal. It was unusual enough to see automobile tires on pedestals, but what made this one truly arresting was that it had been coated, somehow, in gleaming silver. The fucking thing was chromed, and it looked terrific. Down the hall from where he stood were two more alcoves, one on each side, in which he caught glimpses of more silver things. At the end of the hall a large doorway opened onto a brightly lit room. The floor of this room was covered with pumpkin-size silver spheres, like giant chromium ball bearings.

He'd just started to digest this visual information when Royce Howes appeared, a slight man with a friendly, rumpled aura about him. Royce led him around the corner from the desk, into a gray room whose entire ceiling was a skylight. There was a worktable in the middle of the room and a counter along the inside wall. The other walls had mural-size photographs on them that seemed to have been taken underwater, or by a camera without a lens, or by a camera without a lens underwater.

Royce, smiling, patted the counter and Bob put the suitcase down on it. Then he undid the straps, raised the lid, unfolded

the towel and took out the photos, one by one. Royce had adopted a pose of professional detachment, but Bob saw a jolt shoot through him as he scanned the array of images.

"Have you ever seen these before?" Bob asked.

"This one, maybe. This one, yes. These others, no . . . never."

They chatted in a casually enthusiastic way about the people in the pictures, and they speculated about when the photos had been taken. Standing shoulder to shoulder, they went through the inventory together, examining each photo carefully, with Bob offering commentary as required, and making a tick on the inventory sheet as each photo was examined. When this pleasurable operation had been completed, Royce signed and dated the inventory sheet in receipt, and made a copy for himself and a copy for Bob. Then he packed the photos back in their suitcase, ready for Doon's personal inspection.

From the information that John Pelosi had provided, and from some assiduous Googling, Bob knew that the Robert Miller Gallery was the estate's agent in New York, and that Royce Howes, an employee of the gallery, was their contact with the Arbus estate. Royce had worked with Doon, and with the curators, in setting up the big Arbus show, and he'd even gotten a credit in *Diane Arbus Revelations.* He was a man on the inside, and the fact that Bob's photos had elicited his "wows" and "terrifics" was a very good sign.

This emboldened Bob to ask what happened next in the authentication process. Royce explained that Doon would personally take these prints and attempt to find corresponding negatives for each one. Every print for which a corresponding negative was found would be stamped, numbered, and signed by Doon on the back. She would also issue a signed letter of authentication for that print. The entire process would take a month or more. Bob would own the prints of the authenticated photos, but the estate

would retain its copyright on the images. That meant Bob would not be able to reproduce any of the authenticated images in any form whatsoever. In the case of images for which Doon was unable to find a corresponding negative, there would be no stamp, no number, and no certificate of authentication. They would be returned to him as photos taken by someone other than Diane Arbus. He could do whatever he pleased with them.

Bob wanted to know how, exactly, this authentication process took place. How could Doon be certain that she had every one of Diane's negatives? If there were, indeed, thousands of negatives, did she look at each one? How could she be sure she hadn't missed a negative that might correspond to one of the prints? Was Doon's word final? Was there any market for unauthenticated prints? Now that he was standing in a high-end Chelsea gallery, his questions were more than theoretical. For a print that might be worth tens, or even hundreds of thousands of dollars, the question of authentication was critical.

Royce smiled, shook his head on its "no" axis, and said that he couldn't answer these questions, that he had no insights into Doon's working methods. He did know that Doon was very busy at the moment, what with the Revelations exhibition coming to New York. And he could tell Bob that Doon fielded similar authentication requests several times a year. Newly discovered Arbus photos were not unusual, and most of them didn't amount to much.

It was at this point in their meeting that Bob sensed a tightening in Royce, who had been so relaxed and friendly. The eyes that had devoured Bob's goods now became impassive, as if gray steel shutters had slid up behind them. Bob wondered if his paranoia was kicking in again, or if it was just the tug of the currents of money and power that ran beneath the surface of this amiable meeting. He figured that Royce, at the very least, was acting like

a good company man. He was protecting the interests of his client, the Arbus estate, and he was downplaying the value and importance of Bob's photos in case the gallery should be involved in any future transactions regarding them.

That was all right. That Royce seemed to clam up was perhaps an indication of just how valuable and important these photos were. The two men made a little more small talk, then Bob shook Royce's hand, thanked him for his time, took a right at the giant ball bearings, and headed into the brilliant day.

He felt great. With one troubling exception, he was making real progress. Just a year ago, in October 2003, he'd been standing in the salon of his own *Titanic,* lovesick over Diane, frustrated and confused about Jan, drinking with his imaginary soulmate Charlie, leaning stolidly into the vessel's list without a clue that the ship was going down. Now he was sitting on a yacht in the sun, clean and sober, with Sotheby's on one line and the Metropolitan Museum on the other.

And a menacing shadow in the green depths.

Like nuclear fission, the split between Jan and Bob released enormous energy, most of which was being devoted to petty, confused jostling for advantage, and to sustaining the emotional burden of all the things they'd accumulated and now were forced to slough off: two houses (three mortgages); credit-card debt; the Book Mark building (which Jan and Bob owned fifty-fifty with Valerie); a house full of books, paintings, and antiques they'd inherited or bought together; friends; mutual funds; automobiles; cats. It all had to be cared for and sorted out and counted and divided somehow. What was the value of Jan's share in her brother's Manpower Inc. franchise? What was the value of Bob's stock in Book Mark? What was the value of the Hubert's archive?

It was a hellish muddle, agony for them both. She was slow providing facts about her assets. He assaulted her with a barrage

of nonsensical settlement proposals that never once mentioned the Arbus photos. She responded with alternating waves of black withdrawal and frustrated rage. They each made shortsighted, impassioned mistakes.

Early on, Jan, Meg, and Ernie entered Bob's storage cubicle, removing ninety-six boxes of co-owned possessions, which also happened to have some Book Mark books mixed in with them, books that were technically Valerie's property. Later, when Bob had been granted visiting hours (in Jan's absence) to the house on Pinetown Road, he'd broken the padlock to her room, unable to restrain his curiosity about what she'd stashed inside. Their lawyers made complaints and countercomplaints. Depositions were taken. Hearing dates came and went.

All through 2004 and into 2005, in a rising crescendo of attacks and responses, they went at each other, to no avail. Even the judge was beginning to get fed up. But neither Jan nor Bob, despite the suffering it was causing them, could relent. Once they lost their trust in each other, it became impossible for them to cooperate in finding a way out.

A SHARK'S LUNCH

BOB SOLDIERED ON. He and Valerie began to bring Book Mark back to life. Bob would go "shopping" among the thousands of photographs and bits of ephemera on the second floor and select items for Valerie to sell on eBay. Gradually he started working eBay himself—buying, not selling—looking for lots or archives to add to his collection of African Americana, or to break up and give to Valerie to put back on eBay, or to send to Swann's Auction Galleries in New York.

He got into the habit of relaxing by surfing the Web for all things Arbus, frequently branching off into narrower searches on such related topics as "sideshows," or "Forty-second Street." The Web had become rich with swarms and eddies of odd bits of American culture. A Google search on *freaks* would yield tens of millions of hits; *Arbus,* three million; and *sideshows,* half a million. Entranced by his computer's shining screen, Bob wandered lonely as a cloud through the Times Square scene of the fifties and sixties, dense with its movie theaters, strip joints, neon lights, and zipper signs; free of danger and squalor in its sanitized electronic iteration, but still rich in alterity and alienation. The Internet was a sideshow of its own for someone with Bob's eyes.

That was how he discovered the Web site constructed by a character in Florida who called himself G. T. Boneyard. The site was an encyclopedic array of documents and images whose stated purpose was to chronicle the lost world of sideshows, medicine

shows, freak shows, and dime museums. Here Bob found a history of Hubert's and a list of performers for each decade of its existence, from the twenties to the sixties, with many names linked to other sites that detailed the performer's act and personal history. There were photographs of the exterior of the place as well as interior shots, and there were copies of illustrated newspaper and magazine articles about Woogie and her snakes, and about Professor Heckler and his fleas.

The site also featured many selections from Charlie Lucas's journals that were new to Bob, and an image of Charlie Lucas in his white shirt and turban standing on the linoleum floor at Hubert's with his arm around the diminutive shoulders of one of the midget performers. Its tone, pose, location, and detail—particularly Charlie's tie and turban—placed it in a sequence of photographs that Arbus had taken at Hubert's, several of which were in the archive Bob had scored from Okie. Some unknown person must have purchased another part of that original Hubert's lot at the warehouseman's lien sale. Or Okie himself had sold a chunk of the archive and lied to Bob about it. Either way, it amounted to the same thing.

Boneyard was holding more undiscovered Arbus.

Bob embarked on a prolonged e-mail campaign. First he wanted to determine if Boneyard really knew what he had, and then he wanted to separate him from it. To Bob's great relief it soon became apparent that although Boneyard knew about Arbus's presence at Hubert's, he seemed unaware that some of the photos in his possession might actually have been taken by her.

Once this Rubicon had been crossed, the conversation with Boneyard became a negotiation, and the negotiation eventually produced an agreement in principal that Bob would offer all the non-Hubert's sideshow material he had accumulated over the years, from which considerable stash Boneyard could select such

items as he felt would provide reasonable compensation for his letting Bob take possession of all the Hubert's items he owned, including all photographs and duplicates. Late in January 2005, Bob departed the wintry environs of Philadelphia for the Sunshine State, packing Xanax against his preflight anxiety, with all his sideshow material in a large suitcase and a portfolio.

He brought something else with him, too. This was the understanding (or, more properly, the mindfulness that he was working so hard to achieve) that all this Hubert's stuff, all the Arbus photos and Charlie journals, was just stuff. He'd do his thing because it was what he'd been put here to do, what he'd been blessed with the tools to accomplish. He'd try as hard as he could to make the deal happen, to reunite the remains of Charlie and Diane at Hubert's. But now, as he boarded his plane, he knew for the first time in his life that he didn't have to torture himself about it, about the losses and gains, about the absolutely uncertain value of it all. If Boneyard wouldn't come to terms, Bob was prepared to leave the deal on the table. Like Don Quixote donning his armor, he fortified himself with his newly acquired calm.

Which raises a final point. Bob was utterly sincere in his efforts at renewal. He took his meds, was a model member of his therapy group, considered everything his shrinks said, meditated regularly, stayed clean and sober, did yoga, offered Renee and Valerie the loyalty and respect they deserved, and worked hard to be mindful—in the moment and of the big picture all at once. He stuck to this difficult regimen with the joyous dedication of a man who has chosen life over death. But despite his considerable efforts to attain enlightenment, he did not see anything wrong with prying valuable Arbus photos from the clutches of the unwitting Boneyard.

His business, his avocation, his art—his entire life's pur-

suit—had been based on the concept of disparity of information. This was the rule by which all dealers operated, and it was the principle that democratized scouting and dealing (as well as adding to their considerable romance). Everyone had access to the same information. If one guy dug deeper and learned more, he'd have an advantage over his adversary, no matter how much more money or privilege the other fellow possessed. Bob had suffered the negative effects of this principle many times, having sold things too cheaply to smarter dealers. So he did not have a moment's doubt about the propriety of his actions when the disparity of information was working in his favor. He was using it to make whole an archive that had been cruelly and ignorantly sundered. He was, as Eckhart Tolle so eloquently put it, "playing with form." Boneyard knew Arbus had photographed at Hubert's. He could have consulted Jeff Rosenheim at the Met. But he did not, and that was his tough luck. It was one of the cleanest demonstrations, in this soiled world, of the power of knowledge, and it was as honest as a shark's lunch. New Bob, the natch'l born son of Old Bob, was staying true to his nature, thus avoiding a pitfall that has waylaid many seekers of the higher path.

The flight went fine. Bob tumbled, blinking, from the airplane onto a vast, flat savannah under billowing skies. It was warm. There were PANTHER CROSSING signs on the road and Rush Limbaugh and Jesus on the radio. Then miles of strip malls, in the heart of which his motel sprawled, bland and comfortable. Boneyard arrived at the appointed hour dressed in a standard yuppie blue shirt and khakis. He looked to be midforties, black hair slicked back on a large head, sallow skin, intense, but he moved and talked real slow. An air of suspicion hung about him. His sunglasses stayed on in the gathering dusk, and he never looked at Bob directly, just peered at him from under the corner of his shades.

Boneyard made his living reselling high-tech medical devices. Bob followed him down the mall-lined road into an industrial park composed of long, low buildings. A trapezoidal sign in front of Boneyard's warehouse announced that he and his associates were REFURBISHED DIAGNOSTIC IMAGING SPECIALISTS.

They walked through the darkened building to a brightly lit conference room whose central feature was a long wooden table. The table and the floor around it were cluttered with boxes, toys, stacks of paper, and unidentifiable pieces of diagnostic imaging equipment. Perpendicular to the table at about the middle of the room was Boneyard's cockpit, composed of a desk, more boxes, phones, intercoms, and computers. Boneyard got in there for a moment to attend to a flashing light. Then he talked on his cell phone. Bob had visions of Inspector Gadget swiveling around in his chair, punching buttons and yakking into phones.

The visuals of Boneyard's working environment jarred him. The physical disarray was shocking, morally offensive in some subliminal way. Here was a guy who ran a successful company and who, judging by his Web site, had a good sense of design and absolute intellectual control over his material. What could possibly explain this mess? It must, Bob decided, be more like a cover-up than a bad habit. There was order here, but it was coded, in heaps, in a scheme particular to Boneyard alone. It was a way to maintain control.

"The wife," Boneyard announced, plopping down in front of an almost clear spot on the table and offering Bob a seat across from him. "I've been spending too much time chasing sideshow stuff recently, and she's been on my case."

"Well . . ." Bob reckoned this was the occasion for a joke about wives. But was it? His eye went to the wall behind Boneyard and lit upon a large color photo of some kind of medical device that looked as likely to kill you as heal you.

Bob cleared more space on the table and spread out his holdings. They made an impressive heap of posters, photos, and pitch cards, as well as ring binders bulging with handbills, contracts, business cards, letters, and postcards, all filed and labeled for Boneyard's benefit. Beside them was Boneyard's much smaller stack, consisting of perhaps fifty items—miscellaneous photos, clippings, and documents relating to Hubert's Museum, a few of Charlie Lucas's whimsical drawings, some handwritten sheet music, two of Charlie's journals kept on cheap steno pads, and, oh yes, five 11 × 14 photographs. Bob glanced though them, feigning only casual interest. One—the one that had appeared on Boneyard's Web site—was of Charlie and Andy. The second one was a group portrait of Charlie, Woogie, Roy Heckler, Richard del Borgo (a magician), and a midget (not Andy) whom Bob didn't recognize. The third photo was a striking shot of the contortionist Francis Duggan, standing onstage, the image grainy in the available light, his entire torso impossibly doubled up inside a barrel with just a bit of his behind protruding from the top of it, where his head should have been, and his nose and forehead poking out the bottom end of the barrel, at about shin level. It was vintage Arbus—arresting, almost painful to look at, but wistful, too. There were two duplicate photos, of Charlie and of the group shot.

Boneyard started sorting through the huge pile Bob had brought. Each piece prompted learned Boneyardian commentary—a recollection of a similar piece and where he'd acquired it, or its similarity to another piece he'd seen, or an aside on its relative scarcity or abundance, or what it meant in the larger context of sideshow history.

There was no telling how long Boneyard could have gone on rhapsodizing over rumpled photos of pinheads. Bob, who now realized they were in for a long evening, moved to Boneyard's pile of Hubert's material. The top piece on the stack was an article

entitled "Snake Princess Wago" from the April 1953 issue of the African American periodical *Our World*. Boneyard snatched it from him and discoursed on it for several minutes. Then Boneyard picked up the next item and described it in the same deliberate manner, and then the next, and then the next, seeking by means of elaborate presentation to maximize the perceived value of each piece in his rather scrawny pile. When he finally got to the 11 × 14s, he named each person in each photo, and left it at that, thereby erasing the last sliver of doubt from Bob's mind. The guy didn't have a clue. Then they got down to haggling.

Bob had assumed that Boneyard would select the best items from his collection in exchange for the Hubert's archive, and indeed, this was what Boneyard started to do. The trouble was, he would not stop. This item looked good, but so did the next one and the one after that. He'd make a pile and glance at Bob, and Bob would indicate that sure, he'd be willing to part with that much stuff in exchange for the Hubert's archive. Then Boneyard would make another pile and push the two together. Inside of an hour he had Bob's entire stack moved over into his "keeper" pile. Bob struggled to maintain sight of the big picture. If that was what it took—his whole pile for Boneyard's little Hubert's pile— then he'd do it.

At this point a new factor entered the negotiation. Boneyard had gotten a call from his wife after dinner and had explained to her that he needed to spend a little more time with Bob. When this little bit was long past expiry, he received a series of calls, each seemingly more angry than the last. Bob surmised that Boneyard had stood his wife up, or neglected some important family obligation. Boneyard snapped his phone shut. He gazed glumly at the pile of Bob's stuff before him, then he started sorting through his Hubert's archive. He picked out some photographs and a few of Charlie's drawings, and made a tidy pile of them.

Bob was appalled. Boneyard was going to try to hold these back. The son of a bitch actually wanted to take the whole of Bob's pile, and keep some of his own stuff. As firmly as he could, Bob reminded Boneyard of his completist intent—that he was here specifically to acquire *all* of Boneyard's Hubert's archive. Boneyard responded that Bob's sideshow offering, while it admittedly contained some interesting items, was padded with secondary material and duplicates, which Bob, if it came to that, could keep. Bob said he didn't want to keep his own duplicates, that he was here to swap for or purchase the Hubert's archive in its entirety, as they had agreed weeks before. Boneyard cringed at the word "purchase," said that he had often swapped for stuff, but that he had never sold anything from his collection. Such a statement might have surprised Bob at the beginning of their negotiations. By now he was only too aware of his adversary's retentiveness.

They went back and forth, Boneyard looking for a chink in Bob's resolve or some irrefutable, logical means of demonstrating his right to take all of Bob's stuff without surrendering all of his own. At one point Bob, fuzzy with frustration and fatigue, said, "That's ridiculous. I'm offering you all this sideshow material just for the Arbus stuff and you can't see what a deal you're getting?"

"Huh?"

A gulf of ruination, bottomless and black, yawned before him. Bob closed his eyes and leapt for the other side. "I said," he intoned as if speaking to a six-year-old, "that I can't believe you don't understand what a deal you're getting—all my sideshow material for that *other* stuff."

"Oh."

Bob slumped back in his chair.

By two A.M. Bob was down to nothing but nerves. The Arbus slip had wiped him out, and he knew it had to be now or never. Sensing that Boneyard was equally tired and was teetering on the

edge of acceptance, he reached back into his Buddhist emptiness and found the mantra that welled from the core of his new understanding.

"Look," he said, surveying the table with all the authority he could muster, "Why are we making ourselves so crazy? *It's all just stuff.*"

Boneyard gazed at Bob, stunned. This, apparently, had never occurred to him. In his exhausted state, it penetrated. Then his cell phone bleeped again. Boneyard stalked out of the room. Bob could hear him behind the thin partition. When he came back he was visibly agitated.

Bob said, "I can't do this anymore. Do we have a deal or not?"

"My pile for your pile?"

"Yes."

"Okay."

"Good. You take my stuff. I'll take your stuff, and we'll go home."

Boneyard balked. "I need to sleep on it."

"What? I thought you said we had a deal."

"Look. My wife's got me very upset. I can't think clearly right now. I just need a few hours to make sure I'm doing the right thing."

"Okay. I'll take your stuff home and look it over one more time. You keep my stuff, and we'll meet in the morning."

"No. I think you'd better leave my stuff here. It'll be safer."

Bob had a teeny little flash of mindfulness then. His spiritual work was paying off. He realized that this poor man simply could not help himself. He had to keep trying to get the last word. The best of the deal. Bob saw it as more than a character flaw; it was a burden, a curse. But it didn't make him any less of a jerk.

"And we'll get together tomorrow morning and finish the deal. You'll call me when you get up, right?"

"Right," said Bob, who by now never wanted to see this guy again.

When he got back to his motel he looked at his cell phone and realized that, just like Boneyard, he'd been getting calls from his girl all night. The difference was that he'd been considerate enough to turn his phone off during their negotiations. The last call had come just an hour before, so he thought he'd better talk to her and relieve her anxiety. He assured her he was okay and gave a brief description of his evening with Boneyard. Renee's opinion was that the guy sounded like a jerk. Bob should forget about him and just get a few hours sleep. Let Boneyard make the call the next day. Bob closed the phone, fluffed up the pillow and leaned back against the headboard, trying to relax. It was good advice. She was a lovely woman. He was a lucky guy.

But then Old Bob commenced kicking in his stall, and he knew he'd get no rest until the beast had been fed. He got up, spread the contents of the suitcase and portfolio out on the bed, and went through his holdings yet again, item by item, assessing the retail value of each piece and keeping a running total. By the time he'd completed this nonspiritual self-appraisal, gray dawn was leaking into the room. He calculated that he was offering Boneyard over fifteen thousand dollars' worth of trade goods for the Hubert's stuff, which, in his opinion, was plenty. If Boneyard didn't like that deal, to hell with him.

A few hours later the phone rang. By now, under the ministrations of Old Bob, all the Bobs felt like shit. Boneyard, sounding annoyingly chipper, said that he had a window of opportunity. His daughter was at ballet class with her mother, and his son was at a Saturday session of the School for Young Geniuses. They could get together between ten thirty and noon and finish their dealings.

"It's nine thirty. Don't you ever sleep?"

"I get along fine on four hours," Boneyard boasted.

"Well," replied Bob, "I get along fine on ten." But he agreed to meet his nemesis at the warehouse at ten thirty.

This time he left all his trade goods in his car. He walked into the conference room to find that all the Hubert's material, with the exception of two photographs, had been put away. Having slept on it, Boneyard announced, he'd decided he could do the deal. Bob could have all the Hubert's material. He just wanted to retain the two duplicate 11 × 14 photos of Charlie and Andy and the group.

Bob flopped down in last night's chair and shot Boneyard a gimlet eye. "I'm giving you everything," he said. "Every time you asked for more, I gave it to you. I can't do any better than that. We can only do everything for everything. Otherwise, no deal."

Boneyard wavered. Bob got to his feet, resigned, ready to leave. Then Boneyard's phone rang. He left the room, had a muted conversation, and returned.

"Okay. Let's do it."

Bob brought his goods in from the car and put them on the table. Could this really be it? Had he finally plumbed the depths of Boneyard's gimme? Apparently not. As Bob reached across the table Boneyard said, "Umm. I'd like to keep the box."

So that was how the deal went down. They found an old cardboard box on the floor and Bob put the Hubert's archive in that.

Boneyard was probably happy to take possession of Bob's sideshow collection, and miserable that it had cost him his Hubert's material. But never in his most paranoid fantasies could he have imagined what had already happened to him—that a nervous little guy from out of town had come in and extracted the second half of the Hubert's archive, including five possible vintage Arbus prints.

CONSUMMATUM EST

RICHARD CHARLES LUCAS WAS BORN IN CHICAGO in 1909. Some time during the First World War the family moved back to the country, probably to Mississippi, where his father had come from. There, when Charlie was ten years old, his mother died. He left home soon after and was "raise by white [people] tell 1930." Presumably they were circus people, because Charlie returned to Chicago and started his act as the Immune Man in 1924. Then he moved on to Coney Island.

"In the spring of 1930 I had made up my mind that I need sum one to help me, this girl was a friend to me—I was no friend to her, I was out to us[e] her, when I find out it was to lite." It seems he had gotten her pregnant. In April 1961 he briefly and enigmatically noted, "Lucas jr. call me" inquiring about Charlie's date of birth. There is no further mention of this son in Charlie's papers, but there is a copy of a marriage license issued in the Bronx on January 11, 1930 (1/11/30—numbers that must have appealed to Charlie. What are the chances he played them?) between "Richard Lucas and Theresa Shinery" that had been sent to Charlie at his request in 1956.

Between 1932 and 1940 he worked the Sunday and Monday bit—as WooFoo the Immune Man and as "African chief of the duck bill women"—most notably at the Century of Progress in Chicago in 1934. This got him away from New York and may have provided the occasion for his parting with Theresa Shinery. He

met Virginia Bostock back in New York in the early 1940s, and in 1943 they were married. There are a few photos in the Hubert's archive of Charlie and Woogie from this time. He was lean, muscular, and handsome. She had a beautifully formed face, a direct gaze, and a full, sensual body.

Traveling circuses and carnivals, and their accompanying sideshows, were run by promoters who would book dates and venues in various cities on a more or less regular route. Charlie and Woogie found frequent employment with the Conklin Circus, a show that traveled in Canada and appeared in Toronto every year at the Canadian National Exhibition. The CNE had an African Village in the 1940s and '50s, but Charlie and Woogie

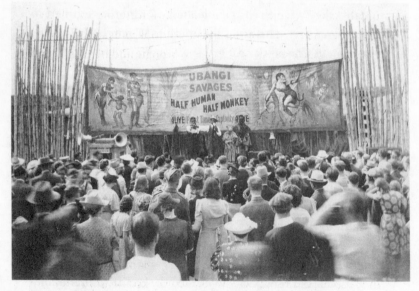

Charlie on stage, probably in Canada in the 1930s or '40s. The grotesque banner behind him plays the African savage schtick to the hilt, and the illustration on the left makes it clear why he referred to himself as "African king of the duck bill women." *African American Photography Collection of Robert C. Langmuir*

also performed "The Dance of Love"—a more titillating version of the African savage shtick. Judging by the two publicity photos that have survived, it must have been a fairly sizzling routine.

In the old days, shows like Conklin's moved by rail. But by Charlie's time many were trucked from city to city. Charlie and Woogie owned a '38 Buick, registered in Boston in the 1950s, which probably afforded them transportation on the circuit. The archive contains documents from this period from New York, Massachusetts, and Canada. They were working together and they kept on the move.

At some point in their travels, Charlie started performing more as a talker, and Woogie concentrated on her act with the snakes. By 1952 they'd gotten part-time work at Hubert's, alternating New York gigs with their sideshow tours. To supplement their income in Manhattan they both took other jobs; Charlie worked for a cleaning company and Woogie and her snakes had nightclub engagements.

Strippers, hoofers, magicians, freaks, and other low-level performers working in the Times Square area customarily lived in residential hotels that catered to show business people. Or, if they had longer-running gigs or were wintering in New York, they might find apartments in neighborhoods that suited them. Andy Potato Chips, the Russian midget, lived on One Hundredth Street with other Russian midgets. (Arbus photographed him at home with his diminutive friends in 1963.) Jack Dracula had family in Queens, and commuted to his job on West Forty-second Street. Charlie and Woogie lived in one- or two-room hotel apartments in Harlem, paid rent by the week, and cooked on hotplates.

For at least part of 1956 Charlie managed Hubert's on a percentage-plus-salary basis. Woogie began working there, too, with each of them putting in fifty to fifty-five hours a week. The show struggled, and after Roy Heckler and his flea circus departed,

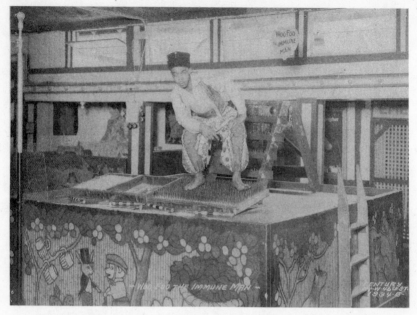

Charlie as Prince Woo Foo, the Immune Man, on his bed of nails at the Century of Progress in Chicago, 1933. The ladder of saw blades is just behind him.
African American Photography Collection of Robert C. Langmuir

Charlie's percentage was cut from 25 percent to 5 percent. In 1960 Max Schaffer, probably knowing that Hubert's would never again be a profitable enterprise, offered Charlie the opportunity to assume full management of the operation for $500. Charlie unwisely accepted. His and Woogie's income in 1959 had been about $8,500. In 1960 Hubert's grossed $33,500, of which a mere $3,350 was profit. In June 1961 Charlie wrote, "Things have ben very bad—with all of thes big bills come up and no money to pay. I am just tryingt to hung on, at times it look like I may go under at any time—I will take this road now if no can do why worry—do my best that is all I can do." Their Buick was impounded in 1962.

They had warm friendships with some of the performers such as Andy Potato Chips, Harold Smith, and DeWise Purdon and his wife, but their work schedule and tight finances afforded little opportunity for socializing. It was a difficult, often brutal, life. On March 2, 1963, Charlie recorded, "a man shooting his safe [a man shot himself] at 228 W42nd St. [Hubert's street address] at 3:30 P.M." Money troubles, alcoholism, illness, and spiritual misery predominated over the next five years, until Hubert's mercifully shut its doors forever.

It seemed to Bob that despite their generational and cultural differences, the major way in which Charlie's life during the 1960s differed from his own in 2003 was that Charlie had a strong and positive relationship with his woman. Several times Charlie recorded that when they were broke and hungry, their only pleasure was to go to bed together. "We had no food, this could not be, but it was, We cant not even go to a show so we go to bed." He considered her advice respectfully and made a concerted effort not to let their money problems intrude on their relationship— "Wiggie & I had words a bouth that show and pay roll. This is the last time I will have words abouth Hubert's Museum."

Additional documents from the Boneyard material— especially two steno notebooks containing Charlie's journal entries from the 1960s—enabled Bob to complete a rough biography of Charlie and, in a way, to finally lay his old pal to rest.

One of the latest entries Bob discovered was dated November 24, 1965, shortly after Hubert's shut down its live acts forever. Charlie wrote:

> First time since 1956 Waggie & I went down to be entert[ained] by a friend it was a treat to each other we both had a find time nothing Emportent but for this first time

Woggie & I was really human. When the evening came to
& end about 11:30 we came home by subway. It was realy
nice to be home. The nicest thing when the evening came
to & end Woggie said Butch do you know my feet don't
hurt me the answer to that question you can't beat rest.
(smile)

Rest, apparently, was what they needed. Charlie eventually
found a permanent job as a super at a Harlem apartment build-
ing or hotel. Free of the stress of Hubert's, he may have cut down
drinking and taken better care of his piles, boils, dizziness, short-
ness of breath, bleeding rectum, sore legs, and bad teeth. In any
event, he was eighty-two when he died in 1991. Woogie, eight
years younger, moved back to live with relatives in Philadelphia.
When her mind began to go and they were unable to care for her,
they sent her to the Stephen Smith Home in Philadelphia, where
she spent the rest of her life.

Presumably, when Charlie left Hubert's, his papers from that
time were put in storage. (This would explain why the record did
not continue through the seventies and eighties.) They remained
stored away until Auer's Moving & Rigging had its auction in
2002.

THE MAGIC CLOUD

ON WEDNESDAY FEBRUARY 9, 2005, just a few weeks after his contest with Boneyard, Bob returned to the Robert Miller Gallery. It had been a year, almost to the day, since he'd first contacted John Pelosi, initiating a procedure that Pelosi had told him would take four to six weeks. It had been four months since he'd deposited his photographs for authentication, a process Royce Howes had told him might take a month. John Pelosi and Royce Howes had been wrong.

Upon entering the gallery, Bob noted that the chromium tire was still on its pedestal, and that it still looked great. However, the pumpkin-size chromium ball bearings were gone. In fact, the entire room was gone, replaced by a white wall on which hung a red, orange, and green photograph of an autumn leaf that had been enlarged to the size of a bedspread. This time there were people in the gallery, two young men dressed in dark clothes, and a young woman in a long coat. It seemed odd, somehow, that "customers" should be in a place like this. But when you thought of it, how else would people buy the stuff? They had to come look at it, which the young men were doing, with great energy, their faces right up against the autumn leaf. Presently Royce emerged, wearing the same rumpled look and dark tweedy clothes, back in his friendlier mode. They went into the workroom and there was Bob's print case sitting on the shelf, right where he'd deposited

it months before. Royce took off the cover to reveal the protective red towel with the pink teddy bears. Under this were the twenty-nine examined "objects"—twenty-eight photos and the note from Diane to Charlie about seeing her first geek.

Six of these photos, Royce explained, were being returned without authentication, since Doon had been unable to find proof that they'd been taken by Diane. Those six, together with the note, made a total of seven, which, subtracted from the original twenty-nine, left twenty-two authenticated photographs. Royce removed the photos from the suitcase and separated authenticated from unauthenticated objects. Then he suggested that Bob count them to make sure the tally was correct. It was a curiously flat moment, this culmination of Bob's discovery and long struggle. Royce stood by, holding the itemized receipt-of-goods letter. Bob would sign it, strap up the print case, and be gone. If Royce had a twelve thirty lunch date, he'd make it with time to spare.

Twenty-nine is not a large number. Most four-year-olds can count that high. But it quickly became apparent how complicated things could get with twenty-nine "objects," each demanding close scrutiny because of its potentially great monetary value. The situation was complicated by the fact that the documentation accompanying the authentication was tripartite. Each of the twenty-two authenticated prints was stamped on the back with a pro-forma statement attesting that this was an authentic Arbus photo. Next to the stamp, Doon had filled in the corresponding negative number from the estate's files, and signed it. Additionally, each validated photo was accompanied by a letter giving the working title of the photo, attesting to its authenticity, and giving the corresponding negative number again.

Royce might have been thinking about lunch, or about Diane, or Doon, or about the possible intrinsic worth or mone-

tary value of the photos, or about any of a thousand things as he stood there, receipt in hand. But Bob was thinking about nothing. He was all eyes, scanning those familiar images, front and back. He was, in fact, at the top of his game, tranquil and alert, calm and excited, playing totally within himself. He went through the authenticated photos the first time and counted to twenty two. Royce said, "And the six photos with no authentication, and the note from Diane make a total of twenty-nine objects, right?"

"Right."

"Well, then, I guess that's it."

"Um, wait a minute. Let's count the letters. There's got to be a letter for each authenticated photo, right?"

"Right."

There were twenty-one letters.

Bob then collated the letters with the photos. He discovered that there were two letters authenticating the same photograph, another photo that had not been authenticated by Doon, and one of the letters, correct in every other respect, that had not been signed. The authentication process, which had taken a year to complete, was flawed.

There were a lot of things the Old Bob might have done. It must have been tempting to wonder aloud at the smallness of the number twenty-nine and length of time twelve months represented. It certainly would have been within his rights to inquire how it was that the estate could insist on maintaining such total control while doing their own work so sloppily. But Bob just took a deep breath and arranged the photos in categorical piles, where he could *see* each of them, exploring patiently with Royce Howes the types of deficiencies.

What to do next? Eventually they agreed that the missing and unsigned letters would be supplied by Doon, and the only photo that would have to stay at the gallery was the one that Doon had

forgotten to number and sign. Upon which, with mutual sighs of relief, they bundled up the goods. This culmination of Bob's dreams had devolved into two sweaty hours of intense sorting and scrutiny, and Bob still had doubts they'd gotten it exactly right.

He told Royce about the Boneyard haul and gave him the surprising news that it contained five more Arbus photos taken at Hubert's. They agreed that when Bob returned to retrieve the print that Doon had forgotten to sign, he'd drop off the new batch for authentication.

And even then there was something unresolved, something that was potentially more troubling because there was no explanation for it. Two of the unvalidated photos, *Charlie with Two Women* and *Dancing Girl in her Dressing Room* were strikingly similar to *Charlie with Two Attractive Latino Women* and *Exotic Dancer,* both of which Doon had authenticated. From details of clothing and background, it was apparent that each of the authenticated photos had been taken within minutes of its unauthenticated twin. How, Bob asked Royce, could this be? The shutters went up again, with an almost audible clunk. Royce replied that he did not know. Could it be, Bob wondered, that Doon had simply been unable to find corresponding negatives for the unauthenticated photographs? Royce replied again that he did not know and left the room to make the necessary changes to the receipt-of-goods letter.

Bob chatted up the perky intern who came in to make a copy of the photograph for which more documentation was required. She was on her work semester and she *loved* New York and she especially loved working at the gallery. Yes, she'd met Doon, who she described as the most fantastic person, with really great energy and long flowing dresses and a huge puff of frizzy black hair, who swirled in and out as if on a magic cloud. The intern's word

portrait was intended to communicate the excitement of working with such a fascinating person but, considering what he'd just been through, Bob found the image disconcerting.

Well, there was nothing he could do about it now. Besides, he'd been hoping to get back to Renee in Philly by four and it was already two. He decided he'd simply resubmit the unauthenticated Charlie and dancing girl photos. If he was lucky, the corresponding negatives might emerge from the cloud the second time around. He strapped up his print case, said good-bye to Royce, and exited the gallery, rather missing the startling view of the room full of chromium ball bearings. How in the world did one dispose of such a thing? Had a customer bought the entire room and installed it in his East Side apartment? Did the balls get recycled? Painted red and sent to a circus for seals to juggle? Crushed up by one of those car smashers and sold for scrap?

The whole place, now that he thought of it, was pretty mysterious.

BOB AND STEVE

BY THE SAME SUBTLE PRINCIPLE that enabled *Star Wars* characters to detect disruptions in the Force, the gravity of twenty-one newly authenticated Arbus photographs altered the fabric of the universe. What had formerly been no more than a collection of sideshow pictures now existed as a coherent body of work executed by a great American artist. Resplendent in the context of Charlie's journals and the business papers of Hubert's Dime Museum, they documented an arcane and exotic aspect of American culture. And just as surely as Darth Vader felt a twitch when Luke Skywalker entered his galaxy, the sensitive antennae of Jan's lawyer responded to the recently enhanced status of Bob's holdings.

On April 7, 2005, in the normal course of divorce proceedings, Bob was deposed on matters relevant to the case. He was extremely reluctant to provide any information about the Hubert's archive, which he considered none of Jan's business, but her lawyer patiently teased out the facts behind the acquisitions from Okie and Boneyard. Further questioning extracted the information that some of the prints had been authenticated by the Arbus estate.

Bob argued that he'd paid for the photos with Book Mark checks, and that they were Book Mark property, rather than his personal (hence common marital) property. Furthermore, because the photos were part of a much larger archive, they had a

low per-item acquisition price when prorated with the rest of the objects in the archive, and therefore weren't necessarily worth a lot of money. Jan's lawyer deftly cast that interpretation aside and got Bob to admit for the record what they both knew already—that Sotheby's had told him they might be worth $250,000 or more. The only solace Bob could take was that the lawyer was using a guess concocted by Chris and Denise before they'd even laid eyes on the Hubert's archive.

As unpleasant as the deposition process must have been, it forced Bob to see his holdings in a new light. Previously he had regarded Charlie's journals and Diane's photos almost as personal mementos. Whenever he thought of selling the photos, it was in a dreamy, theoretical kind of way that had them, like dutiful children, providing for him for the rest of his life. Now the Arbus photographs stood discrete, identified by the lawyer's probing and defined by the estate's authentication. Bob was faced with the fact that he would ultimately have to deal with them as commodities—things that had commercial value and that existed apart from his private life.

The commodification of the Arbus photos was another benchmark in the emerging meaning of the Hubert's archive; eventually an accurate dollar valuation would be useful to all concerned. But in the short term the thought of it only increased Jan's frustration at Bob for holding out on her. A week after the deposition, in the course of an already difficult telephone call, she wound up screaming at him, *"Tell me how much those photos are worth!"*—as if *he* knew.

In a burst of paranoia, Bob and Valerie removed all traces of Arbus-related correspondence from Book Mark's computers, and all the Hubert's ephemera relating to Arbus from the physical premises. (This was a move Bob would later regret, when he

went about rounding it up, only to realize he'd forgotten where he stashed various bits of Charlie's worldly remains.) When Jeff Rosenheim called, attempting to restart negotiations, Bob cut him off, requesting that all copies of their correspondence be destroyed or returned to him. Then, just to keep the paranoia evenly distributed, he made the same request of Chris Mahoney and Sotheby's. Bob moved the photos from a safe-deposit box at his bank in Bryn Mawr to a high-security storage facility in Jenkintown.

It was as if the Arbus photographs had become evidence of some unspecified crime committed against Jan. More than once Bob considered donating them to a charity, or even burning them. They had become weighty indeed.

Desperate for a convincing way of fending off Jan's claim to the photos, he called Chris Mahoney, who remained solicitous despite Bob's recent unseemly behavior. What, he asked, accounted for the value of an Arbus photograph? Was it the authentication? Was there such a thing as an unauthenticated Arbus photo? Had Sotheby's ever sold one? Chris replied that such a thing was out of the question. Not only was there no market for unauthenticated Arbus photos, Sotheby's and all the high-end auction houses were more or less restricted to selling just the icons—the famous images that had previously appeared in print. In all the photography world, he added, the Arbus estate was unique in how tightly they controlled their material.

Bob thought there might be something useful in this. He turned to John Pelosi, the estate's lawyer. What was it that made an Arbus photo an Arbus photo? Was it, as Chris Mahoney implied, the authentication process? If that was the case, could it be said that prior to authentication (during the time Bob and Jan were married) they had no value? And if they only acquired value

as of their authentication date (which, in this case, happened *after* Jan instituted divorce proceedings), would they, in their authenticated state, be outside the realm of common marital property?

John Pelosi replied that Bob had ventured into an area of "cutting-edge law."

Bob asked if Mr. Pelosi would be interested in explaining the intricacies of the matter to Jan's lawyer.

Mr. Pelosi said he would not be able to take Bob's case.

What he could do, however, was make it clear to Bob, in the most forceful language at his command, that Bob's photos were not up to the highest level of Arbus's work. They were more like snapshots she'd given to her friends. Though he did not say so explicitly, he left little doubt in Bob's mind that the estate had no interest in helping him market the Hubert's archive.

So Bob's obsessive scrambling had accomplished the following: Chris Mahoney was telling him the photos would be a tough sell because they weren't on the level of *Twins*. And John Pelosi, who considered them no better than snapshots, could not be induced to explain the situation to Jan's lawyer, who was certain they were worth at least a quarter of a million dollars.

This state of affairs would have sent Old Bob into a tailspin, but Bob had resources now, and he used them in a way that would have made his doctors at Lancaster General Hospital proud. He consulted with his therapy group and they very sensibly suggested that he find a lawyer who specialized in the sort of cutting-edge art law Pelosi had talked about. Eventually Bob located a man in Boston who sounded quite familiar with such matters. He told Bob that the photos were not, at the time of their acquisition, Arbus photos. They were *attributed* Arbus photos. He said he'd be happy to examine the question of whether Jan had rights to the "attribution value" of the photographs—an

undetermined amount, but one much different than their value before they'd been authenticated by the estate.

Bob began to relax. And in a moment of calm, fortified by all the work he'd been doing on himself, he found the means to thread his own needle and commence a conversation that, in the long run, would be more beneficial than any he'd had with John Pelosi or Chris Mahoney.

Instead of hiring the Boston lawyer, he called Steve Turner and asked for advice.

Steve and Bob had known each other since the early nineties, when Bob was first getting seriously into his Afro phase. Like Bob, Steve was a dealer and collector with an abiding interest in African Americana. He knew about photography and he knew about the law, having opted for the art business over sports agency after passing the California Bar. He owned and operated the Steve Turner Gallery, and was partners with his wife in California Curio Company, a firm specializing in historical photography and western ephemera. In his younger days he'd been a basketball junkie with sufficient physical gifts and mental toughness to get him, as a white boy, into some of the great ghetto games of his era. He had excellent social skills, was adept at networking, and had long before identified Bob as someone who was good at finding things, someone to keep in the Rolodex.

For his part, Bob respected Steve because he was a smart guy, and because he possessed qualities Bob lacked. Which is to say he was optimistic and self-confident, with an open, forthright disposition and a solid, realistic outlook. When, for example, an early deal with Bob exploded because of Bob's squirrelly nature, Steve understood that Bob had a gift—albeit one weighed down by certain personality issues—and let the matter slide. That made an impression on Bob, who now saw Steve as a bridge between his own lone-wolf dealer mentality and the daunting institutional

fronts put up by Robert Miller, the estate, Sotheby's, the Met, and Jan's lawyer.

In an unprecedented act of trust, Bob told Steve all about the Hubert's acquisitions and showed him copies of the Arbus photographs. Steve tried to help with the simple organizational aspects that he knew would be problematic for his friend. He questioned Bob about matters of provenance and title. He counseled Bob to sort his material, describe it carefully, and then evaluate it as if he were appraising someone else's collection. He should, above all, be sober, factual, and unromantic. Forget about the divorce. Forget about Sotheby's and the Met. The Hubert's archive, no matter how good Bob thought it might be, was just another buy, and at some point he'd have to sell it and move on. That, said Steve, had to be the mind-set.

OTHER FACES

AS BOB WAS DIGESTING THIS INFORMATION, the Robert Miller Gallery called to tell him he could collect the rest of his property. He hastened back to the Big Apple.

The tire was gone. The supersized color photograph of the leaf that had replaced the chromium ball bearings had itself been replaced by a huge shiny black rectangle. There were other, smaller shiny black rectangles hung throughout the gallery. The surface of each rectangle had channels running across it, as if someone had dragged their fingertips through a tray of molten licorice and let it harden. Some of the black rectangles were relieved by a stripe of dark blue or white. They were all the work of an important French artist named Pierre Soulages, and they were paintings in a series he called *Outrenoir*—beyond black. Soulages' show was opening at the gallery that very evening, and Royce was wearing a black suit and a dark blue shirt that perfectly matched the paintings. He explained to Bob that Soulages' work didn't just represent the effects of light; each work was an actual demonstration of what light *does* to it. Bob stood slack-jawed. It was as if one of the paintings had extruded Royce Howes in order to begin explaining itself.

The business with Bob's photos was straightforward. Doon had gotten everything right this time. They went around back to the workroom and Bob received the 11 × 14 print of Charlie with the pointer in front of the electric chair, stamped and signed, and

the letters of authentication, signed by Doon, that had been lacking. While he was signing the receipt, Bob asked Royce, in as offhand a manner as he could muster, what it was that made an Arbus photo an Arbus photo? He'd had, he told Royce, a group of images that were valueless until authorized by the estate. Now that they were stamped and signed, they were worth money. Was it the stamp that created value, or the image?

Perhaps inspired by the energy of what the Solages press release referred to as "revelatory works—light-filled, scintillating black abstractions," Royce himself was more revelatory than usual. He reiterated what Pelosi had said about the estate's mission being the promulgation of the highest level of Arbus's work, and what Chris Mahoney had said about the primary market, and hence the greatest values, being in the iconic images. By way of illustration he cited the example of another recently discovered Arbus photo that had been authenticated, but had failed to sell at auction. Would Bob say the estate stamp had created value in that case? Finally, it wound up at the Robert Miller Gallery, where it sold. Royce looked at Bob and shrugged, implying but not actually articulating the obvious—that it was the *gallery* that conferred value on that photograph.

In answer to the related question of how an Arbus photo could go from $150 in her lifetime to $478,400 thirty-five years later, Royce sketched the schematic of a divergence in photography from just about the time of Diane's death, when museums began collecting photography and galleries began selling it. Photography was for the first time regarded as its own *art form*. Then artists seized this idea and ran with it. People like Warhol or Andreas Gursky began doing large color photos that were more like paintings. (Bob thought immediately of the giant leaf.) These *extensions* of photography brought more money than any Arbuses ever had, presumably because they entered the market as fine art

rather than as photography. Meanwhile Diane's work, for all its startling subject matter, was very conventional in the photographic sense. She took portraits. So while this other experimental branch of photography was soaring, her work, because of its intrinsic cultural value, appreciated slowly but steadily. Then in the late eighties or early nineties the fine-arts branch more or less collapsed. People began realizing that it was *all* photography, regardless of technique. The experimental and the traditional were reunited. That was when Arbus's work and the work of other greats was recognized as being undervalued. In fact his friend Joshua Holdeman, who used to work at Robert Miller and was now the head of photography at Christie's, thought Arbus still had a way to go—that higher values would come. But the point was that the marketplace is complex. No single factor confers value, and nothing guarantees it. The only generalization one could make is that her signature images, like *Twins*, tended to bring the highest prices. In the case of Bob's photographs, they were certainly not at the level of Arbus's established canon, but they showed something unique—the manner in which she engaged her subjects. On that note, Royce departed to attend to some last-minute preopening detail, leaving his auditor in a state of enhanced confusion. It was complex, all right.

But Bob was resilient in his new mode. By the time he'd gotten back to Tenth Avenue he'd managed to parse Royce's discourse to his satisfaction. Higher values would come. He now had twenty-two photos signed, sealed, and delivered. The five from Boneyard were in the pipeline, which made twenty-seven. And the two that Doon had incorrectly, in his view, refused to validate, which might pass on a later go-round, would make twenty-nine. Twenty-nine times what? It might grow up to be a big number. Would Royce be standing there explaining it to a customer some day?

Bob received a final tutorial, courtesy of the Robert Miller Gallery, when he returned to New York a few months later. A new show had opened at the gallery, and he came up on opening day expressly to see it. The show was called Other Faces, Other Rooms, and according to the press release it presented "rarely seen photographs by Diane Arbus." Royce told him that the intent of the exhibition was to break down the distinction between the thirty-five-millimeter and the square format, and to expose lesser-known works that stood on their own—on an equal footing with her more famous images.

Bob counted forty-nine images on the walls. Of these, only three had been printed by Arbus herself. The others had been done after Arbus's death by Neil Selkirk, the only man allowed by the estate to print from Arbus negatives. He'd been her student when she was alive, and after her death he'd devoted himself to recreating her printing techniques. The Selkirk prints in this show were being offered at $10,000–$18,000. The three vintage Arbus prints—Bob recalled a stripper, a lady in funny glasses, and a little black kid—were priced in the $50,000 range. He knew to a certainty that several of his own Arbus photos were as good as, or better than, what was being offered for sale at Other Faces, Other Rooms. This raised questions.

For example, what accounted for this exposition of Arbus's "rarely seen photographs," and how did that square with the estate's avowed intention to promulgate only her highest level of work? Why were the images rarely seen? Did that reflect Doon's judgment that they were not worthy of being seen? After all, the estate exercised nearly complete control over what was seen or not seen. Was Doon thus complicit in the exhibition of second-tier material? Or was this stuff suddenly included in the canon of her greatest work and hence worthy of being shown in a reputable New York gallery? How had that happened? Was it because

the estate and the gallery, on the back of the groundbreaking Rev-
elations show, saw an opening for a new category of iconic ma-
terial? Why would they do that? For educational purposes? Then
why were the three vintage Arbuses for sale at fifty-K a pop?

On page 269 of *Diane Arbus Revelations*, Neil Selkirk wrote
the following:

> At the time of her death, prints of several hundred of
> Diane's images were found . . . The existing prints were
> gathered together and one example of each different
> image that had been found was re-photographed. I was
> presented with the results: fifty-two twelve-exposure
> proof sheets of all the images then known to have been
> printed by Diane. . . . Subsequently, prints of another
> five hundred, mostly early photographs, were found.

That meant the estate was holding over a thousand vintage
Arbus prints. Bob could imagine how they might let a few of these
prints out each year, to Sotheby's or Christie's, or to the Robert
Miller Gallery. It would provide a steady source of income that far
outpaced inflation. But those thousand photographs couldn't all
be icons like *Twins* or *Jewish Giant*. Some of them were probably
flawed prints or in poor physical condition. That still left a lot of
lesser known and rarely seen material that, if the whole thing were
properly orchestrated, might be sent quietly into the marketplace.

All this was no more than a guess; Bob would never get Royce
Howes or anyone connected with the estate to confirm it. Indeed,
he had no way of knowing if the estate thought in those terms at
all. But for the moment, it was a reasonable enough hypothesis,
and it served the valuable function of explaining the estate's ap-
parent reluctance to embrace his discovery. They'd cleaned out
Diane's wastebasket thirty-five years before.

WOOGIE'S BOXES

IN THE AUTUMN OF 2005 THE JUDGE presiding over Bob and Jan's divorce case held a hearing related to the ninety-six boxes of books and papers that Jan and her brother and sister had removed from Bob's storage cubicle when he was in the hospital. It had been an impulsive gesture, and it proved unwise. Although there could be no such thing as theft of common marital property, some of the items removed belonged to Book Mark, Bob's business. This meant that Valerie, Bob's business partner, could file charges against Jan if she wished.

This did Jan's side no good in court. The judge ruled that Bob be allowed access to the ninety-six boxes. Ernie was to meet Bob at Bob's storage facility in Lancaster and lead him to the place where they'd stashed the goods. It was a small victory for Bob, but it made him nervous. At this point in their relationship, he didn't want to be alone with his brother-in-law. His lawyer told him to bring a friend. Bob asked me if I wanted to come along, and I said sure.

The boxes were in a storage facility in Smoketown, stuffed into a 9 × 12-foot economy-size unit, stacked in layers around the side and back walls. In the face of Ernie's glowering presence, Bob attempted a brisk, businesslike attitude. He'd brought a clipboard and a magic marker, and he numbered the accessible boxes and wrote corresponding numbers on his clipboard. Then he made a work surface out of boxes stacked three high and opened the first

box for inspection. Ernie retired to the hallway, where he began leafing through *Fodor's 2005 Guide to Spain,* no doubt planning his next vacation.

Bob inspected the contents of the first few boxes, marking a *0* on the clipboard next to each corresponding number, signifying that there was nothing of value in the box. He wanted to make a tally of the value of Book Mark property in case Valerie ever decided to press charges. Soon he gave up making any marks at all. The boxes he'd numbered were obviously the overflow from the house he and Jan had shared. It was yard-sale fodder, books on gardening, travel, literature, spirituality, health, and cookery, nothing of any great value. Then he got into boxes full of older stuff. They contained a few personal possessions, but mostly illustrated books, fairy tales, a book of pressed seaweed, and classic literature in leather bindings. His bustling efficiency melted away. He began breathing heavily, sighing frequently. It seemed as if the books got heavier, harder to haul up from the depths of his demolished marriage. He lingered longer over each one, making an appraisal of emotional rather than monetary value. These were books he'd given Jan, books they'd collected together, books that reflected their common interests and dreams. He began to weep, in strangled wet snuffles, then gathered himself and wiped his eyes.

"I'm done. I can't do this any more."

We locked up, climbed back in the van, and drove off. Bob was pale and trembling.

The plan was to head back to the Book Mark building in Philly, where I would inspect yet another batch of divorce documents. But as soon as we were a few miles down the turnpike, Bob took the exit onto Route 322 and commenced what seemed like a long, meandering tour through Mennonite Pennsylvania— past signs for Intercourse and Ephrata, through Blue Ball, New

Holland, and Leola; past fields harvested in sere Brueghel rows
hard by acres of tall stalks waiting their turn; past black-clad
ladies on bicycles and black horse-drawn buggies with directional
signals; past promising farmsteads and white churches; through
town after pleasant town of squat, heavily signed storefronts of-
fering goods and services to satisfy a farmer's every need. Bob's
primary need was just to drive, to settle down to the hurt he was
feeling. Finally we arrived at Tri-Town Storage on the outskirts of
Leola. This was the place from which Jan and her siblings had taken
the ninety-six boxes. Bob was returning to the scene of the crime.

It had smelled of cow shit at City Storage in Lancaster, and it
had smelled of cow shit out at the Smoketown storage facility.
When we got to Leola, it smelled of cow shit there, too. The day
had gotten muggy, and the smell sat on me like a derelict's over-
coat. I asked Bob about it.

"Bob, is that cow shit I'm smelling?"

"It's manure. For the fields. They mix it with water and spray
it on."

"Like slurry, huh?"

"Slurry, yeah."

The perimeter of Tri-Town Storage was lined with empty
RVs on flattening tires—Eagles, Hurricanes, Gulfstreams, Holi-
day Ramblers, along with some smaller truck campers under
dead Dodge front-ends, and even a couple of lonely automobiles.
It was a melancholy prospect. Bob walked around his ransacked
cubicle, hefting bookends and planters, putting a few things in
his van to take to the flea market next week and sell. He was
weeping again.

"This is purgatory," he said.

Where was your life when the wife took the kids and went
back to Mom, and all the stuff that defined your existence got
put in a storage cubicle and your car was stored there too? Add in

GREGORY GIBSON 210

the people who'd died, and the people who'd gotten old or broke
and had been forced to downsize, and the people who'd been
fired or transferred or called to active duty or sent to jail, and you
probably had half the country working out of storage cubicles. It
had happened to Charlie, who'd stored all his sideshow stuff and
then never gone back to the sideshow, and then it had happened
to Bob.

Things weren't any better back in Philly. Valerie was sitting at
her computer putting photos on eBay. Zoe the pooch did circles
and figure eights when we came in, leaving little doubt that she
could've executed triple axels given proper training. This display
was lost on Bob. He walked over to his desk, extracted a fistful of
folders from a plastic file box, and handed them to me. Then he
began telling Valerie about his morning in the cubes. The more
he talked the bluer he got.

I turned my attention to the documents. The files Bob had
given me were full of lawyers' petitions—some ruled on and
some not—and it took a while to sort them out. Eventually I
grasped that Judge Henry S. Kenderdine had made a key deci-
sion about the valuation and disposition of the Arbus photos.
Judge Kenderdine ordered that *either* the photos be professionally
appraised and made common marital property at the appraised
value, *or* that the collection be sold and the profits split (depen-
dent on Valerie Francis, partner in Book Mark and therefore part-
owner of the photos, agreeing to such a sale), *or* that the two sides
agree to a stipulated value for the photos and enter them as com-
mon marital property at that figure.

This ruling had been followed by a meeting in the judge's
chambers in which a deal was struck between the two parties.
They agreed to go with option three. A stipulated value of
$250,000 was placed on the Arbus photos. This figure was based
not on an official appraisal but on an earlier estimate that

Sotheby's had given Bob. Jan's lawyer, apparently not wishing to risk an appraisal, had proposed this figure to Bob's lawyer as the stipulated value, and Bob's lawyer had accepted. The way was free for divorce proceedings to move ahead.

The rest of the documents left a paper trail that was complex, tedious, and appallingly trivial. I watched Zoe crawl contentedly into her box and I thought of all the energy Bob and Jan had expended inflicting punishment on each other, searching through records, tapping out wild, accusatory e-mails, making nasty phone calls, strategizing, lying. I thought of their mutual bewilderment, of plain old hurt and loss, not to mention thousands of dollars' worth of shrink time and lawyer nonsense. They were not bad people, either of them. And yet it had come to this.

Then I had a happy inspiration. A few weeks before, while scrabbling through my records, I recalled that Bob had made contact with Charlie Lucas's wife, Woogie, in 2003 by finding her brother, Louis Bostock, in the Philadelphia phone book. He'd called the old man and visited him. Then they'd gone to visit Woogie in the nursing home. She and Jack Dracula were, as far as we knew, the only surviving members of the old Hubert's Museum troupe of freaks. Woogie's mind was gone, but the brother might still have something to tell us. Now here we were, right in Philly, where the old man lived, with an afternoon on our hands. We needed to have another talk with him, and we needed to do it immediately. Bob was nearly frantic with relief at being rescued from his dark thoughts.

A few minutes later I had a man on the line. I asked if he was Mr. Louis Bostock, and he asked what I wanted in a manner that indicated he was indeed Mr. Louis Bostock. I told him I was researching Hubert's Museum and was looking for information about his sister, Virginia Bostock. I asked if I might possibly conduct a brief interview with him regarding these topics. He asked

me what I meant by "researching," and I told him I was writing a book about Robert Langmuir, the person he'd met in 2003, and an archive Robert had discovered pertaining to Hubert's Museum in New York, and to his sister, Virginia Bostock.

"Well I'm not Bostock," the man said. "My name is Brown, and I'm Louis's personal best friend. What did you say you want to talk to him about?"

I told Mr. Brown, more slowly, that I wanted to talk to Mr. Bostock about Hubert's Museum and about his sister, Virginia, and that I was calling to find out if I could visit him for a brief interview.

At length Mr. Bostock got on the phone, and I went through the whole thing again. He said, "uh-huh" once, somewhere in the middle of it, and was silent when I finished.

After a few uncomfortable seconds I asked, "Would it be possible to come over and talk with you?"

"When?"

"Right now."

"I'm busy right now."

"Oh. That's too bad. I'm only going to be here today. I have to go back to New York tomorrow."

Silence on the other end of the line. I glanced over at Bob to roll my eyes in a show of frustration and I saw that he was jumping around like Zoe. It was apparent that he'd been trying to get my attention for quite a while. He had his arm pointed at me and he was rubbing his thumb over his index and middle fingers indicating that I should offer this guy some money.

"Of course," I told Mr. Bostock, "I'd be paying you for your time during the interview. Hiring you as a sort of consultant, if you know what I mean."

Mr. Bostock informed me that he'd soon be finished with what he was working on. I pictured a half pint of gin.

"When did you say?"

"I could get there in fifteen minutes."

He gave me directions.

It was actually only ten minutes from the Book Mark building on Rittenhouse Square to the 1700 block on Fifty-fifth Street—ten minutes, and about $200,000 per year income. White folks drove through that neighborhood with their doors locked, or saw it on FOX Murder News, or gentrified the edges of it. Mr. Bostock's place had a white rose of Sharon growing over the sidewalk in front, and concrete steps leading sharply up to a torn screen door. A lady inside was yelling at someone with the repetitive, jagged cadence of a person on the front end of a long, nasty fight. I knocked on the aluminum part at the bottom half of the screen door, which resounded like a drum into the apartment. Shushing imprecations, then a slender, forty-five-year-old lady came to the door and apologized for the ruckus. I stated my business, she nodded a surly acknowledgment and let us in. Maybe she was twenty-five. It was hard to tell.

Her hair was a purplish tint of orange. She was wearing a black beret and a brown tank top under a black open shirt and tight skirt. She led us through a cluttered entryway into the living room. There were two easy chairs against the left-hand wall, a stairway leading up, a passage to the kitchen, a noisy color TV sitting atop a huge, dead maple console TV, and a couch along the right wall with a coffee-table in front of it. The woodwork, the stairs, and the floors were finished with the orange shellac they'd used in the twenties when the place had been built. The wallpaper looked original, too. All the shades were drawn against the heat and it was difficult to see much more. There was a fan on the floor.

The lady folded herself into the first chair, just inside the entry. A slender man dressed in dark colors rose from the couch.

On the other chair was an old man in a red jersey with an emphysema oxygen rig coiled around him. The man from the couch intercepted us in the middle of the room and introduced himself as Brown. The lady was Esther. Bob and I started to introduce ourselves but were interrupted by Mr. Brown, who thought it important that we understand he was NILES K. Brown. The first. He had a son who was Niles K. Brown the second. And that over there in that chair, that was Louis, his personal best friend. Mr. Brown was holding a half-quart bottle of Lionheart Malt Liquor. It was still frosty, dewed with condensation in the humid afternoon, but it was better than half empty. I assumed that it was not his first bottle.

Esther had a bottle beside her chair. "Brownie, we got people. Turn that damned noise off."

Mr. Brown ignored her, to Mr. Bostock's obvious relief. Mr. Bostock was looking intently at *The Jerry Springer Show.* A woman with a five-o'clock shadow and a man's voice was telling another woman she'd always love her. Bob and I took seats on the couch beside Mr. Brown and made our greetings to Mr. Bostock. He sat erect and dignified, sucking oxygen, looking more like a bantamweight James Earl Jones than the drunk Bob had described. In fact, being just out of the hospital and unable to drink, he appeared to be the only sober one in the room. Bob and I were juiced on the adrenaline rush of finding ourselves in this strange place, and Esther and Mr. Brown were sauced on Lionheart.

There was a momentary lull and, being unable to think of anything better, I stated the purpose of our visit to Mr. Bostock. He nodded his understanding. I interpreted this as a sign that I should go ahead, so I took out my notebook and asked him when Charlie had died. He told me it'd been ten, fifteen years ago. Then Virginia'd moved in with her aunt in New Jersey.

At this point Mr. Brown leapt to his feet and stood between me and Mr. Bostock. Not another word was to be said until I stated my purpose here more clearly. This was when, as Bob would later explain, I made several errors. I used the phrase "writing a book." I mentioned New York and Boston, and I did not spend an initial fifteen minutes talking shit and circling the matter at hand with grace and humor. My direct approach marked me as a barbarian, made us no better than cops, who were the only white guys ever seen in the ghetto and who, Bob had assured me, we'd be mistaken for anyway—two middle-age honkies pounding on a door in the middle of the afternoon. Mr. Brown got his face up against mine and informed me that he was not stupid. He knew about "writing a book." He knew it meant the movies. He smelled money and he told me so. Nothing was going to happen until we cut Mr. Bostock in, and Mr. Brown was there to see that it got done right.

Mr. Bostock objected. Esther shushed him. Mr. Brown told her to be quiet herself and she yelled at him that she would not, either. He turned on me. I was going to go and take everything they had, all this information of Louis's, about his beautiful sister, then I was going to split and leave them nothing. He knew what the deal was. I was going to write my book and I was going to get all the profit from it. They'd be left with nothing. He squinted at Bob.

"And you. What're you doing here, Dave?"

"My name's Robert. I'm a collector. I'm interested in Hubert's Museum."

"He's the one who got me started on this story," I interjected. "He owns a lot of Hubert's material already."

Mr. Brown ignored me. "Well, I'm sorry I called you Dave. You know all you white folks look the same."

Esther started in on him. Rude drunk that he was, he didn't even know how to behave when there was people in the house.

Mr. Bostock said, "Show 'em what you got, girl!" He was talking to the TV, not Esther. A large-breasted woman on the Springer show had just lifted her shirt at another woman, but her breasts were fuzzed out.

A kid called down from upstairs, "I'm hungry." Esther shushed him.

The ruckus stoked Mr. Brown up. We would not get a word from Mr. Bostock, he announced, unless they were cut in on the deal. They wanted 1 percent of the profits from the book. I told him the book wasn't finished. Might never get finished at this rate. He gave me a moisty look and took a slug of his Lionheart. I was the Writer, he said. I knew how to play the game. But he wasn't stupid. It had to be 1 percent plus payment by the hour for talking. Prepayment. Take it or leave it. He seemed on the verge of getting pugnacious. Leaving it sounded like a sensible idea to me. I looked around at all of them, smiled, nodded at each, and stood up to depart. Bob, Esther, Mr. Bostock, and Mr. Brown stared at me with wide, white, horror-struck eyes. I realized then that the whole conversation had drifted dangerously off course.

Bob, seeing how poorly I'd navigated these shoal waters, took the wheel. He looked around me, or through me somehow, to Mr. Brown.

"Hey, Brown," he said, "Hey, Niles! How can you be standing there talking all this shit drinking a beer in front of us and not even offer us a taste?"

That was more like it! Mr. Brown disappeared into the kitchen. I sat back down. He reappeared with two cold half quarts of Lionheart, made a show of looking us both over, put one bottle down beside him, and handed the other one past me to Bob. Here, at last, was something I could do correctly. Knowing that

Bob was still going light on the booze, I intercepted the bottle, drank a long sociable swig, and set it down on the coffee-table. Bob picked the bottle up, wet his lips, and talked shit for a while, circling the matter at hand. He rounded up all the themes, stated and unstated—Dave, white folks, cops, Virginia, Jerry Springer, Mr. Bostock, Niles's bad manners, Hubert's Museum, the Writer's bad manners, the millions we were going to steal from them— shook them up and rolled them out like he was shooting craps. Niles K. Brown took a whack, then Esther, then Bob again. There was much knee-slapping and cackling. The Lionheart juiced my adrenaline rush and the room closed down till it was just a circle of faces. The banter wasn't combative, as it had first seemed. It was an entertainment, a way of passing time, or of spicing time's dreary passage. Maybe the argument I'd heard when we first came in hadn't been an argument at all. It was improvisational, and it was raw, edgy, and booze-fueled, but no worse for that. There certainly must've been limits to it, but we returned to business matters before I quite grasped them. The room opened back up and everyone was looking at me again, in anticipation rather than horror. If Mr. Bostock had time to talk, I told them, we'd pay him for it.

Mr. Brown went off again, in a rather more poetical vein, I thought. Virginia was a beautiful woman. A *very* beautiful woman. Many men were after her. White men. White men were after her. We thought we'd just come in here and get her for noth- ing. But we were wrong. Did Robert say something about a snake? Well, he didn't know nothing. He didn't know about the stuff in Virginia's boxes in the cellar. What about all of that, the letters and costumes and such? He didn't even know it was there when he walked in here, and now . . .

"What about it, Brown?" said Bob. "Show us what you got."

"Not if all this Writer has to show us is his damn notebook."

I placed two twenties on the far corner of the coffee-table. Esther headed for the bills but Mr. Brown got there first.

"This don't get you nothing," he said, snapping the crispy green as he handed the money to Mr. Bostock. "We know what that book is worth."

"Mr. Brown," I said, "you've got no idea how much this is costing me. You really want a cut of that?" Something about the look in my eye, I guess. The man knew a healthy deficit when he saw one.

Bob, with his peculiar roving vision, saw a photograph on the wall. It was one of those boot-camp pictures of dozens of men in uniform. He slid into the opening, asking Mr. Bostock if he'd been in the army.

"That was my son. Military man. Died last year."

"I'm sorry."

This was another story Mr. Bostock wanted to tell, along with the ones about Charlie and Virginia. He had two interested listeners and not much time left. But Mr. Brown silenced him again. It wouldn't be possible, he told us, to plumb the true depths of Louis's connections with certain powerful figures in the south of Philadelphia, nor the worldwide breadth of his adventures. And anyway, not so much as a sigh would escape Louis's lips until we had a deal in writing. Mr. Bostock regarded him in a bemused sort of way.

"What you laughing at?" demanded Esther.

"I'm just smiling," said Mr. Bostock, "not laughing."

But Mr. Brown had given me my entree. He'd said "writing."

"Okay," I told them all, flipping to a blank page in my notebook. "You want it in writing? I'm the Writer. I'll write it down. But you've got to tell me what you want." More shit was talked. The kid upstairs called down again. Another lady on TV had her shirt up, flashing the first lady. Eventually Bob and I agreed to

come back and retain the services of Mr. Bostock as an informant at the rate of eighty dollars an hour. There was no more mention of a cut of the profits. The interview was only to take place in the presence of Mr. Brown and Esther. (They wouldn't have missed it for anything.) Furthermore the interview would be supplemented by a viewing of the personal papers and possessions of Virginia Bostock, contained in boxes on the premises. Bob and I signed that document, and I gave it to Mr. Brown, who handed it to Esther, who comprehended it in an instant and handed it to Mr. Bostock, who studied it at length, folded it, and put it in his shirt pocket, pushing the oxygen tube aside. In the course of hashing this agreement out, it was also agreed that Mr. Brown would extract said boxes from the basement in time for Bob's return at eleven o'clock Friday morning, two days hence, and that we would call Esther on Thursday. ("You're not talking to him, you're talking to *me!*" said Esther when I suggested calling Mr. Brown.) Twice, delicately, in the course of this conversation, Bob inserted the possibility of purchasing the contents of Virginia's boxes. They were ghostly insertions, almost like subliminal advertising, grasped at the deepest level but not overtly acknowledged. They were punctuated by Bob giving Mr. Brown shit for holding back that other bottle of Lionheart. Mr. Brown put it on the coffee-table and, to his delight, we declined it. Somehow, by the time the arbitration was completed, Esther and the Messrs. Bostock and Brown understood that if there was any money coming out of this deal it would be coming from the jive ass, well-heeled collector, not the flimflam Writer in the honkey Hawaiian shirt.

As we made for the door, Mr. Brown, who'd become increasingly oracular on Lionheart, posed a sphinxlike riddle to the two ofay pilgrims in his dark land.

"Virginia was a beautiful woman," he said. "Men went crazy

for her. But if you had to choose between her and Louis, who would it be?"

I stood there stumped, waiting to be strangled.

"Louis," lisped Bob. Knee-slapping and cackling ensued.

Mr. Brown leaned his face close to mine. "When you're done with Louis's story, you come back. I've got a *real* story for you."

In the car Bob instructed me, gently, on my errors and hashed out the moral difficulties inherent in this buy. It was a long shot that there'd actually be anything there when—and if—he returned. The Bostocks were too socially and financially stressed to identify and preserve those kinds of artifacts. But supposing there were more Arbus photos? It was one thing to deal with Boneyard, but what was he to do with these people, who needed every cent they could get? He almost didn't want to get into it. But if he didn't, and Louis died, who knew what might happen to Woogie's boxes? Probably wind up in the trash. He had to try to get them, if they brought them out. Niles K. Brown was right to want a percentage, it was only fair. If there were photos and if they sold, Bob would come back to them with money. But you could never offer that up-front. It would screw everything up.

That night I slept alone in the Book Mark building, up on the second floor where Bob had lived during the dark days of his exile from Jan. It had been my romantic notion that I might soak up some of the vibes from that troubled time, when Bob's mad obsession with Charlie Lucas and Diane Arbus was becoming a dominant force in his life. I hoped for troubled dreams, but they didn't come.

Instead my waking mind teemed with images of those desolate Smoketown and Leola cubes; and of Charlie Lucas's storage cube, from whence this whole saga had come; and of that cellar in Louis Bostock's house, where there might be still more of it; and of Bob, weeping in the morning and dancing through his

dicey ghetto deal the same afternoon. I thought for a long while about the strangeness and intensity of such a life. I wondered if that was how Charlie and Woogie had lived, or Jack Dracula, or Andy Potato Chips, or Diane Arbus, for that matter. I had a deep vision of Bob, sitting in that living room with Esther and Mr. Brown and Mr. Bostock, talking shit and drawing a bead on Woogie's boxes with the absolute concentration and thoughtless joy of a man doing what he'd been born to do. Then I rolled over and slept like a baby.

THE OLD, WEIRD BOB

THE REASON BOB DIDN'T COME BACK to the Bostocks the very next day was that he had an appointment with Elisabeth Sussman, the curator of photography at the Whitney Museum in New York. She, along with Doon Arbus and Sandra Phillips, had curated the Revelations show and edited the magnificent catalog that accompanied it. She'd gotten wind of Bob's discovery, and she wanted to meet him and see his photographs. Bob, of course, was equally interested in meeting her. The Whitney, with its specialization in American art, might turn out to be the ideal repository for his archive. At the very least, their stated interest would give him leverage in his dealings with Sotheby's and the Met. He reckoned Louis Bostock wasn't going anywhere. Someone as important as Elisabeth Sussman had better be attended to at once.

She was a petite, fine-boned, bespectacled woman, dressed in standard stylish New York dark. She looked scholarly enough, surrounded by her books and piles of paper, and she had a kind of steely energy that Bob found not at all unattractive. She told him right off the bat that the whole Revelations project had been her idea in the first place. She'd spent fourteen years enlisting Doon Arbus's cooperation, getting rebuffed, and coming back, over and over again. When Bob complimented her on her tenacity in dealing with the refractory mistress of the estate, Sussman intoned, looking at him dead-on, "I was sincerely interested in

the project," in a way that suggested she'd have walked through brick walls to get the job done.

She'd proposed the idea of an Arbus show to her boss at the Whitney, David Ross, and they'd gotten Avedon, who liked it, in on it, and he in turn got Doon involved. But then Ross moved to the San Francisco Museum of Modern Art, and his successor at the Whitney, Max Anderson, got interested in other projects. So she pitched the Arbus idea to SFMOMA and they took her up on it, which was when Sandy Phillips got involved.

Ultimately, the Arbus exhibition came to be part of a two-show deal with SFMOMA. Both Ross and Sussman were interested in leading with an exhibition of the work of the artist Eva Hesse. Like Arbus, Hesse had packed a lifetime of work into a single decade, and then had died young—of brain cancer in 1970. It was in the course of researching Hesse's papers at Oberlin that Sussman first discovered Hesse's appointment books. Unlike Hesse's papers, which the scholars had thoroughly combed, and which dealt with "how hard it was to be a woman artist," the appointment books turned out to be a gold mine. They showed whom Hesse had been talking to and working with. She'd even made brief notes in them that gave hints about what her thinking was.

When Sussman got back to the Arbus project, she remembered how fruitful this line of investigation had been. She asked Doon if Arbus had kept any appointment books and, "Out they came!" (The recollection of this breakthrough still made her smile.) More and more documentary material kept coming from the estate and, as had been the case with Hesse, they showed to whom Arbus had spoken and what she'd been thinking about. That, more than anything, accounted for the form of the Revelations show and catalog. Forget about the feminist angle, or whatever else was trendy in academia at the time. The particulars

that poured down from the estate were used to construct a chronology illustrating Arbus's evolution as an artist. "I made it clear to Doon I was interested in process, not theory." After a couple of years, so much revelatory material had accumulated that Elisabeth and Doon agreed they *had* to go public with it.

Once the idea for an Arbus show got rolling at SFMOMA, they realized that they were going to need a New York venue as well. The Whitney and Max Anderson were occupied with their own projects, and, in terms of scheduling and the appropriateness of the site, the Metropolitan Museum of Art came to seem like the logical place. This was the point at which Jeff Rosenheim and the Met came to be identified with the Revelations exhibition, at least in its New York appearance. So it was natural that Sussman would want to meet Bob, see the photos, and find out if his archive might be a fit for the Whitney, particularly since she knew that he'd already had some conversations with the Met.

Bob sensed a morass of politics, egos, and scholarly infighting beneath Sussman's distinguished gloss, but that hardly mattered. She'd already won him over. He felt a keen appreciation for the things she was telling him about the Revelations exhibition because they reminded him of his own piece-by-piece approach to Charlie and Diane. His whole relationship with those two characters had been built on the accumulation and gradual understanding of date books, photos, journal entries, and other documents, just as Sussman's chronology had grown out of the wealth of particulars that Doon released. He perceived that the formidable Whitney Museum scholar went about her business in much the same way he went about his, and this made him feel as if he were in the company of a kindred spirit.

Sussman may have believed that Bob's native genius replicated her own intellectual rigor in coming to terms with Arbus's challenging oeuvre. Or she may just have been humoring her

strange visitor, waiting to get a look at his Arbus photos. For whatever reason, Bob was feeling relaxed in her presence.

So that when it was his turn to talk he was able bring all his talent as a raconteur to bear. He told her of the various stages of acquisition and discovery; of those remarkable characters, Okie and Boneyard; of the long process with the lawyer and the estate and the Robert Miller Gallery; of his fascination with the strange Times Square world of sideshows and freaks, of snakes and midgets and alligator-skinned ladies. He told her of Charlie's rambles, of his gambling and drinking, of his philosophical musings and dream journals, and of his quest for the mystical Number that would set him free. He told her about Charlie's precious relationship with Woogie, and about the other Hubert's performers, and about how some of the "documents" he'd discovered—namely, Jack Drac and Woogie herself—were of the human kind. If he'd aroused Elisabeth Sussman's condescending interest at the beginning of his talk, he had her complete attention by the time they got around to looking at the photographs.

It was a fascinating lot, no question. She had her doubts about some of the unauthenticated photos, and a few of the authenticated ones weren't much more than snapshots. But others, like the portrait of the lady sword swallower, which prefigured Arbus's later masterpiece, were of considerable interest. The photo of Andy Potato Chips was "sweet." The freaks onstage had a vintage Arbus feel, and the portrait of the three Puerto Rican women in the dressing room was "as good as anything she's ever done. They could sell this in a minute!"

Bob was discreet enough to realize that Sussman's enthusiasm for the material had momentarily gotten the better of her. He managed to refrain from asking *who* could sell it in a minute? Or who would buy it? Or for how much? But after a decent interval he did inquire whether or not he ought to consider the Whitney

as a repository for his archive. She told him, "I might buy some—a few." It was a halfhearted offer on her part, seeing as he had already made it clear that he would not break up the archive, but it allowed her to convey, without completely discouraging him, that the Whitney would not be purchasing his archive en bloc. That took care of the supposed purpose of the interview, yet their talk went on for quite a while, and in a surprisingly animated fashion.

Engrossed in the particularity of those images, those "objects," those "documents," they discussed the history and sequence of the writings, the provenance of the photos, the identities of the people they portrayed, and, most important, the manner in which this peculiar lot of material might be presented to its best advantage. They agreed that Charlie's writings enhanced the photographs, and that the photographs illuminated all the other documents—that somehow they were of a piece and should be considered as an organic whole. Sussman asked Bob if he'd seen the Revelations exhibition at the Met.

Back in May, he and Renee had taken the train up to New York to see the show. Although a few of the mounted photographs had caught his eye (particularly one of the *Untitled* series taken at that home for retarded people in New Jersey), what had really impressed him were the three darkened rooms—the one in particular, with Arbus's journal entries, and manic lists of future projects, and torn-out newspaper articles, and pitch cards of freaks, and snatches of letters, and even her notes of the interview she'd done with Jack Dracula, spread over the walls and pinned like butterfly specimens under the lit glass counter. Now Bob understood how and why Elisabeth employed such materials in her chronology. When you stepped into that mysterious space, the wealth of hitherto unseen images and documents added depth and meaning to the Arbus icons displayed on the walls surrounding the room, even as those icons referred back to

the contact photos and hastily scribbled notes inside it. Talk about process! That Arbus mind-cave was its carefully calibrated equivalent.

And *that*, Sussman and Bob agreed, would be how you'd present the Hubert's archive. With Charlie's grind tape (his uncanny Lord Buckley voice spieling over Charlie Parker's alto) running on an eternal loop as a sound track, and his drawings and his charts of numbers and his anguished journal entries providing a context for Arbus's photographs of him and Woogie and DeWise Purdon, the sharpshooter with no hands, and Bill Durks with that hideous hole in his forehead, and the dancing girls, and the snake swallowing the rat in the backward Garden of Eden. That was the sort of presentation, Sussman told him, that informed *The Old, Weird America,* an important book written by her friend Greil Marcus. That was the coming thing, the way in which people were beginning to understand this sort of material. That was exactly the spirit in which Bob's archive should be exhibited. Bob agreed wholeheartedly, and for a wonderful instant they were—at least as far as he was concerned—cocurators.

The Old, Weird America—that phrase, enhanced by Elisabeth Sussman's backhanded encouragement, resounded in Bob's imagination. It would be a while before he got around to actually reading the book, but in many ways (which his ultimate perusal of the text proved more or less correct) he felt he hardly needed to. The information it contained was alive in the air, and in the course of his adventures he had absorbed it into his bloodstream. His underdog outlook, his blues mind-set, his instinctive grasp of negrology, his deep affinity for outsider art and vernacular photography, his obsessive accumulation of the artifacts of African American culture—verily, his many rabbit hole dives and his

drive to get *inside the real*—had all been propelled by a vision that he immediately understood to be central to Greil Marcus's account.

The Old, Weird America, while ostensibly a treatise on Bob Dylan's celebrated *Basement Tapes* and their sources in American folk music, in fact proposed as Dylan's true source a metaphorical version of America, contained, mystically, *inside* our contemporary nation. This alternative America at once inspires and explains the strangeness of our daily lives.

> Here both murder and suicide are rituals, acts instantly transformed into legend, facts that in all their specificity transform everyday life into myth . . . There is a constant war between the messengers of god and ghosts and demons, dancers and drinkers . . . Here is a mystical body of the Republic . . . a declaration of what sort of wishes and fears lie behind any public act.

The first and primary expositor of this hidden place was a polymath genius named Harry Smith who, in 1952, released *The Anthology of American Folk Music.* This consisted of Smith's selection of eighty-four tunes that had been issued on commercial recordings made between 1927 and 1933 (when the Depression put an end to such marginal items as blues and hillbilly records). The music had roots in medieval Europe, African slavery, and the Wild West, and its themes were love, death, and transformation, the classic subjects of folklore and myth. It was performed by bootleggers, mountain people, jug bands, itinerant street musicians, and ragged gospel groups, all of whom sounded inconceivably ancient and immeasurably far away, yet as uncannily familiar as Narcissus or Oedipus. These artists, and the subjects of their songs, made up the population and the topography of

the old, weird America, and their music delivered the tremendous power latent in that mystical alternative republic. Harry Smith's *Anthology of American Folk Music*, issued "at the height of the McCarthyist witch hunt," became the primary source for the folk revival of the 1950s, which, in its turn, was the voice and moral authority of the civil rights movement of the 1960s. Smith was presented with a Grammy for his work in 1991 and on receiving the award said simply, "I've lived to see . . . America changed by music and music change America."

At Sussman's first mention of her friend Greil Marcus's book, Bob grasped that there was a continuum between the old, weird America and the familiar, yet unattainable world of Charlie and Woogie and Hubert's and all the rest, up to and including the Bostocks of West Philadelphia.

Charlie's archive was at least as profound, recognizable, and impenetrable as the music on Harry Smith's *Anthology* or, for that matter, the photos of Diane Arbus. And the America of the archive's origin was equally old and weird. "Facts that in all their specificity transform everyday life into myth . . . a constant war between the messengers of god and ghosts and demons, dancers and drinkers." Could there be a more perfect description of the material that Bob had been working with for the past few years? And weren't those ineffable "facts" exactly what Diane Arbus, in all her "photographic studies of American rites, manners and customs," had sought to portray?

Elisabeth Sussman had nailed it. Bob's archive was the same kind of evidence Harry Smith's recordings had been. Just as Greil Marcus had presented Dylan's work in the context of the "mystical body of the Republic" conjured up by Smith's recordings, so the old, weird America of Hubert's, and Charlie, and the Bostocks would be the context for the presentation of the Arbus photos.

Bob wasn't sure what that entailed, or how he would get it done, but thanks to Elisabeth Sussman and, indirectly, to Greil Marcus, Bob Dylan, and Harry Smith, he had discovered a new way to think about his archive, a way that liberated it from being his private obsession, or something-to-be-kept-from-Jan, or even just a commodity to be sold. His toil in the Hubert's vineyard amounted to no more or less than the continuing archaeology of the old, weird America. This was, he now understood, an activity in which he'd been engaged prior to his Arbus haul, and it was an interest that would continue to occupy his attention long after the Arbus material had passed through his hands.

Everything was different after that.

THE BOSTOCKS OF WEST PHILADELPHIA

FRIDAY MORNING IN WEST PHILADELPHIA, Esther, Niles K. Brown, and Louis Bostock were sober and subdued, but not a bit abashed by the fact that there were no boxes of Virginia's. It had all been part of the entertainment. Mr. Bostock was still in his chair, but he was off the oxygen today and when asked how he felt, said, "Good." This was saying a lot, because it turned out that he was an intensely taciturn man. His sentences were never more than a few words long, and were delivered at five-minute intervals. He may have been thoughtful—he certainly looked it—but there was no sure way of telling if he was thinking deeply or not at all. Bob had made copies of photographs of Charlie and Woogie, and of Woogie with her snake, and Mr. Bostock looked at them long and hard, shuffled them, and looked at them again.

Mr. Brown was eating vanilla ice cream from a plastic container. He offered Bob some and Bob declined. Esther came downstairs, greeted her guest briefly, and then went into the kitchen, where she spent most of the interview pounding pieces of meat to tenderize them. Mr. Brown sat in the chair that Esther had occupied two days before. He facilitated Bob's interview with Mr. Bostock by asking Bob questions that led, by comparison, to him, and then to Mr. Bostock, who would be tricked by the momentum of the conversation into saying something. Bob noticed that Mr. Brown, when sober, used his large and graceful hands like a fan dancer's fans.

He'd say, laying his left palm over toward Bob and covering one side of his face with his right, "I don't mean to get too personal, but where did you say you was from?" Bob would give his answer, and Mr. Brown would respond with his own. Then he'd look at Mr. Bostock, who'd say, "Philadelphia. Born and raised." And Bob would say, "What part of Philly were your people from, Louis?" And Mr. Bostock would grunt. "South Philly. Cabot Street."

So it went for half an hour. Bob learned a few things about Charlie Lucas, and a little more about Virginia Bostock. Charlie had been a damn good man and Virginia had been a smart girl, a good student in school. Never left home till she went to New York to stay with her aunt on 115th Street and met Charlie, her first and only. Mr. Brown and Mr. Bostock, in turn, learned things about Woogie, aka Princess Sahloo, aka Wago, that they hadn't heard before. It turned out Mr. Brown had never even met Virginia. Mr. Bostock listened hard, nodding his head slowly and shuffling through those photographs Bob had given him.

Presently they ran out of questions. Mr. Brown had done his best, but he'd apparently sounded the bottom of Mr. Bostock. Bob was invited to call back in a couple of weeks, after Mr. Bostock had telephoned his sister in New Jersey to find out if she'd kept any of Virginia's belongings, although it was clear this would be a futile quest. Bob put five twenties on the coffee-table and this time the money just sat there. They made their good-byes, Esther shouting hers from the kitchen. It had been a sweet visit, tinged with a kind of melancholy, a sadness perhaps more felt by Esther, Niles K. Brown, and Louis Bostock, that there were no boxes in the basement, never had been.

DEEP LEO

IN THE DAYS THAT FOLLOWED, Bob had several conversations with Steve Turner about the estate's control of the Arbus material, and about his endeavors as chief archaeologist of the Times Square division of the old, weird America. While not directly validating Bob's views, Turner strengthened his friend's confidence in them.

This bit of psychological commerce was predicated on a more mundane piece of business. Steve had told Bob early on that he had no interest in acquiring the Arbus photos or in selling them in his gallery. He was, he said, interested in the photographic documentation of blacks in the West and—as Bob well knew—he wanted badly to purchase the portion of Bob's extensive collection that pertained to those interests. Bob understood from the start that it was going to be a quid pro quo relationship, and that was fine with him. If Turner could help him figure out how to deal with the Arbus stuff, it'd be worth parting with a portion of his stock. Besides, he could use the cash. So, in November, Bob traveled to L.A., much as he'd gone off to Florida, with his goods in a suitcase. Only this time, instead of freaks, he brought rare photographs of black cowboys and African American pioneers.

When they hammered out their deal, Bob was consistent, tough, and fair. It was the first time he'd been able to make a big sale without driving himself nuts. Steve considered their smooth transaction a breakthrough for Bob.

That set the tone for the rest of the visit, which was a success on all fronts. They did the flaneur thing on the streets of Los Angeles, visiting flea markets and galleries, sitting in cafés and watching life parade past. They even had drinks at the revolving bar in the Bonaventure. Bob developed a crush on Steve's wife, Victoria ("She smelled good"). Victoria thought Bob was a lively person with an accurate and unusual way of seeing the world. She did his chart and noted a conjunction of the Sun and Pluto in Leo—"a deep Leo"—with his Moon, Saturn, and Mercury in Virgo, and Venus and Uranus in Cancer, all of which went a long way toward explaining Bob's intensity, his loner quality, and his winning combination of charm and retreating sensitivity.

They also continued their discussion of the Arbus situation. Steve, as Victoria said, was "like a good basketball coach," correcting flaws while emphasizing the positive attributes of his players. According to Steve, Bob was a fantastic buyer—daring, aggressive, and creative. But as a seller he had problems that were mostly of his own making. He lacked self-confidence. He tended to be paranoid. That was why he hid behind the auction rooms. He was reluctant to confront power head-on, and he couldn't stop second-guessing himself. Those traits played right into the hands of the people with whom he was now dealing.

Steve told Bob it sounded as if he was allowing the estate and the Met to intimidate him. It was ridiculous that the authentication process should take so long. Doon's totalitarian control over the images probably ought to be challenged. At the very least, he doubted that she'd have the legal right to prevent Bob from reproducing the photos for the purpose of selling them—in a carefully crafted prospectus, for example, that would serve as Bob's primary marketing tool. Denise Bethel's excited response to the photographs elicited a yawn from Coach Turner. She just wanted the listing for Sotheby's. And as for Sussman's helpful input, the

Whitney was in the same league as the rest of them. There were no nefarious intentions. It was just business. But Bob should be aware of the manner in which such business proceeded.

It was crucial that he not get romantic, as he was prone to do. He should analyze his archive in a professional manner, produce an appropriate descriptive document, and let the market—not Elisabeth Sussman, Royce Howes, or Jeff Rosenheim—decide if his price was reasonable. It was, Steve said, simple but not easy. The description had to be complete, but he couldn't oversell his goods. Something had to be left to the customer's imagination. In the end, the buyer was the one who would sell it to himself.

In this way, over decaf cappuccinos and gelati in the Southern California sun, the old, weird America, Other Faces, Other Rooms, and the Hubert's archive came into conjunction with the gentle urging of Steve and Victoria. The means by which he would assert his own mastery over the Hubert's archive would be the prospectus, or marketing tool, about which Steve had so patiently counseled him. Then the market would decide if his assessment was correct, and the buyer would sell it to himself.

IN WHICH BOB PROVES TO HAVE BEEN
MORE STUBBORN THAN JAN WAS ANGRY

BOB SPENT THE WINTER OF 2005 planning his prospectus and laying out in his mind a Sussmanesque Arbus at Hubert's exhibition to be held at the Steve Turner Gallery, attended by deep-pocketed collectors, equally well-funded curators, and photo-mad movie stars. It was all fantasy, of course, exactly the sort of planning at which he excelled. But that was all right. He was learning to understand the Hubert's archive in a new way, and he really couldn't do much more than fantasize until he resolved his still-pending divorce. Despite the lawyers' comforting pronouncements, progress in this area remained excruciatingly slow.

Then in the spring of 2006, Jan fired her third lawyer and hired as her fourth a woman who specialized in divorce cases. Perhaps realizing that her new client was approaching the limits of her financial and spiritual resources, she contacted Bob's second lawyer and laid out a deal whereby Jan would give up her interest in Book Mark (the business and the building) in return for which Bob would give up the house on Pinetown Road and the mutual funds. He'd also pay Jan $36,000. The proposal said nothing about the Arbus photos or about Jan's interest in Manpower Inc. Presumably the lawyers decided not to drag these two most disputed and inflammatory assets back into the fray, but simply to let them offset each other.

In that it offered both sides a way out of a stalemate that had lasted two years and consumed tens of thousands of dollars, it

was a pretty good compromise. At least it was a place to start. Bob might make a counteroffer on the amount of cash just to see how much bargaining room was built into the deal, or he might simply accept it as a chance to put the whole mess behind him and be done with the divorce. Any reasonable man would have gone for it.

However on hearing the particulars of the proposed settlement, Bob read his lawyer the riot act. There was no way in God's creation he was going to pay Jan a single nickel, let alone $36,000. He would not hear another word about it. The lawyer, a patient and wily man, told Bob it was his call. He could fight this thing all the way if he wished, probably for another two years, at the cost of an additional $25,000 and untold anguish.

Bob went back through every scrap of paper documenting his fiscal relationship with Jan since the beginning of 2004, looking for monies he'd paid out to her, funds she'd borrowed and never repaid, and house-related expenses that she'd failed to pay and he'd been forced to cover. On top of this he factored in the increase in value of the antiques that had remained in Mom's house all these years, the rise of Jan's equity in Manpower Inc. (an unknown but surely large amount) and, finally, a mysteriously calculated and not inconsiderable sum that he reckoned she owed him for his own "pain and suffering."

When this twisted computation was complete he put his pencil down and noted with satisfaction that the $36,000 she wanted as a divorce settlement was more than offset by the $70,000 he reckoned she owed him. He reported his findings to his attorney, who raised an eyebrow and decided that Bob ought to get points for creativity, if nothing else. He then began to peck away at his client. "Offer her $30,000," he'd urge. Bob would reply, "Not a penny!" "Consider the time-value of money," the lawyer told him. Bob wasn't quite sure what that was, but it sounded like it

would cost him. Not to mention that all the time he was spending on his divorce was time he could not work. So not only was he paying all this money out, he was losing earnings. He began to waver. The lawyer recalculated Bob's cockamamie figures. "Offer her $8,000," he counseled. "I don't think she'll go for it, but it's worth a try." Bob gave in.

Yet another hearing was scheduled, this one for early June. Bob began sending Jan flowers, little tokens and sweets, and trinkets of sentimental value that he'd unearthed in his storage unit. Preparatory to their hearing they planned to meet again at the storage unit in Smoketown, to try to arrive at a settlement regarding the ninety-six boxes of disputed property, and Bob was working hard to get her in a receptive mood. However just as he was driving out to this meeting, Jan called him on his cell and told him she had to cancel their appointment. She was sick with the flu. She just wasn't up to it.

Some cosmic vibration or subtle signal from Jan resonated in the cathedral of Bob's marvelously honed but sometimes erratic intuition. On a hunch, he changed course and swung past the house on Pinetown Road. He hadn't been there in quite a while and it shocked him to see how overgrown the yard had become.

He walked to the front door and knocked.

She answered, looking as drained and sick with the flu as she'd sounded on the phone. She invited him in, offered him a seat. They made awkward small talk at first. As Bob recalled it, "We ironed out the wrinkles of being in each other's company." Neither of them had known this meeting would take place, and yet, somehow, they both felt it was time.

Finally Bob asked her, "What do you want? What's the bottom line?"

She told him she was mentally and physically worn out. Even

worse, in a way, was the fact that she'd long since exhausted her fiscal resources. She was running a $1,500 monthly deficit.

He told her he was happy in his life now, but *not* because he was free of her. He wanted to talk about personal things, spiritual things. She kept bringing it back to money. He began to weep. This was the woman he'd been married to all these years. He could feel how heartsick she was. Tears were harder for her. There was so much frustration and anger.

Bob agreed to let her have the house and the mutual funds, and to stop receiving the monthly support payments the judge was making her pay him. He offered $8,000 cash, but only if she repaid him the $2,500 loan he'd given her last year. She agreed.

Then Bob had an inspiration about the disputed ninety-six boxes. He proposed they drive over to the storage unit together sometime and bring the boxes back to Pinetown Road and sort through them there, in the house, together. He knew it would be the best thing to do, a healing thing. He told her, "Trust me, Jan."

She did, and that made her feel so much better that she insisted they drive to the storage unit right then. On the way over they were able to share a beginning of that deeper conversation they'd been needing to have all these years. Bob told her he thought she'd lost her faith, and that was when everything went bad for her, and that she then started blaming others and demonizing him. She agreed that she'd lost her faith. She told him that her heart had been broken because of his violence. He'd lashed out at her for flaws in their relationship that only he could fix. He just *yelled* so much. She told him she regretted filing for the divorce, but she did not regret the PFA. She told him he deserved it.

"But you never committed yourself to me. Your family always took precedence."

"You always were so *angry*."

"I went over the line sometimes . . ."

There was more talk, then a long silence. She told him, "You've really changed."

They wept and hugged.

"I hope you can forgive me," she said.

"I hope you can forgive me, too."

They were so exhausted by all of this that they couldn't go through the boxes. He took her back to Pinetown Road and left her there. She waved after him as he drove away. Bob felt like he was leaving his own funeral.

Because the principals were who they were, their deal nearly blew up several times. Ernie and Meg appeared at one meeting and Bob freaked out. Later, it so happened that the ninety-six boxes, when efficiently repacked and compacted, yielded only about forty boxes total, and Jan, thinking that Bob had stolen the rest, freaked out. Then the sticky details and legal confusion involved in transferring jointly held properties caused Bob and Jan to freak out in unison. But the cooler heads of the lawyers prevailed.

Bob and Jan Langmuir signed their divorce agreement on July 5, 2006.

HEISENBERG JR.

AS SOON AS IT BECAME CLEAR that his legal business with Jan was about to be resolved, Bob went to work in earnest. He called Royce Howes and asked for Royce's opinion of the value of his discovery "within a range, a realistic value." Predictably, because he was a specialist in photography rather than an archivist, Royce ignored the association value of the Hubert's archive and concentrated on the photos themselves. Any appraisal, he told Bob, whether it was real estate or fine arts, depended on comparable values. And what were the comparables in this case? Royce could think of only one instance, in recent years, in which Arbus's secondary material had appeared at auction. These were pictures of Doon and Amy that Arbus had taken and printed herself. They were offered at two different sales, and on neither occasion made their reserves. Royce, in his thoroughgoing professional manner, was careful to keep the conversation theoretical and not discuss actual figures, since he was not performing a formal appraisal of Bob's photos. However his overall thesis was sufficiently discouraging. If one looked at the photos themselves, the comparables did not suggest a particularly high valuation.

Bob researched the auctions to which Royce had referred and did the math. The photos of Doon and Amy had been estimated in the $8,000 range. If they hadn't made their reserves, which were typically a fraction of the estimate, you could say they were worth, what? Less than $4,000 each? That, multiplied by his

twenty-nine photos, was a disappointingly small number. It re-
minded him of what he and Steve had discussed—how "it was
always me being dependent on someone else for the value of this
stuff and what I should feel about it." Bob resolved not to do that.

Besides, he was certain that Royce had it wrong on two
counts.

In the first place there was no way a real appraisal could ig-
nore the archival aspect of the Hubert's material—of which the
photos were only a part. Secondly, Royce's choice of comparables
was all wet. The comparables in this case were not unsellable im-
ages of Diane's daughters. The comparables were the three vin-
tage photos offered for sale at Other Faces, Other Rooms for
$50,000 each. Strippers, strange ladies, and black kids had a lot
more in common with the Hubert's crowd than pictures of Doon
and Amy.

Bob then subscribed to artprice.com and downloaded im-
ages, descriptions, estimates, and selling prices of every Arbus
photo that had appeared at auction over the past three years. He
weeded out all the limited-edition reprints produced by Neil
Selkirk, and combed through what was left of Arbus's vintage
prints, seeking images of freaks, sideshow performers, and other
similarly strange persons. He wound up with a sampling of prints
resembling those in the Hubert's archive. Each of them had sold
in the $20,000–$50,000 range. Further Web searches turned up
an even more intriguing prospect. A company in New York called
the Silverstein Gallery was offering an authenticated vintage
Arbus photo of a teenage girl with a baseball bat. The image was
a little goofy, a little edgy, and pure Arbus in spirit. Best of all, it
was virtually unknown, having never been published in *Diane
Arbus* or in *Diane Arbus Revelations*. The asking price was
$60,000, which corresponded nicely with the price of the three
vintage prints in Other Faces, Other Rooms.

Having established an array of comparables—from $20,000 for a circus fat lady to $60,000 for the best Arbus image not included in the canon—Bob set about grading his own collection. He spread his twenty-nine photos out before him and ranked them by aesthetic merit, also taking into account size and physical condition, on a scale of one to five. Then he did it again and again and again. He did it when he was depressed, when he was elated, when he was tired, when he was sick of the photos, and when he was in love with them. When I came to visit, he had me repeat the experiment. Then he asked Valerie and Renee to do the same. He compiled these many values to generate an average grade for each photo. Then he returned to the comparables and used their established values to compute a hypothetical value for his twenty-nine photos, where a grade of one equaled less than $20,000, and five equaled $50,000.

It's easy to describe the process in a few paragraphs. In actuality it was a convoluted business demanding patience, organization, and abstract analysis—skills that were not exactly dominant in Bob's makeup. For example, the problem of converting his graded photos into dollar values was easy enough when a grade of one equaled $10,000 and five equaled $50,000, but did the facts of the market support this assumption? What was the dollar value if $4,000 (portraits of Doon and Amy) was the low end and $60,000 (girl with the baseball bat) the high end? How about $20,000 (circus fat lady), or $50,000 (vintage photos in Other Faces)? Or $4,000–$20,000? The possibilities were many, but only a few of them made sense in real terms. The photo of the three Puerto Rican women, about which Elisabeth Sussman had raved, was manifestly better than the girl with the baseball bat at the Silverstein Gallery. The question was, how much better? And how "bad" were the most snapshotlike of the photos in Bob's archive? Then there was the larger question of the archive itself.

By now it was clear that the photos explained and were at the same time enhanced by the documentary material that surrounded them—but how did one place a dollar value on that? The total value of the documents and photos came to seem like a range or field whose variables arrayed themselves with the classic indeterminacy of quantum mechanics.

Bob gritted his teeth and put himself to it for hours at a time. He'd get confused. The data would rise up around him like a swarm of gnats. He'd calm himself and go back to work. Doubts would sneak in; impish, perverse doubts of every sort. He'd quash them and forge ahead. Distractions were legion. He specialized in distractions. For Steve Turner or Royce Howes it might have been a few days of grunt work. For Bob Langmuir it was torture.

When he'd taken the process as far as he could, he sought a second opinion from a professional dealer in photography. This man, Alex Novak, also published the *E-Photo Newsletter,* the largest circulation newsletter in the photography collecting field. Novak was well known as a competent professional, but was probably not on Jeff Rosenheim's short list of designated experts, which was a good thing in Bob's view. He also happened to live in Chalfont, Pennsylvania, just a stone's throw from where Bob and Renee lived. Bob was happy to learn that Novak's range, or field, was in the same realm as his own.

The final impetus for creating the vaunted marketing tool came from an unexpected source (though the more Bob thought about it, the more expectable it came to seem). A few weeks after his nonappraisal conversation with Royce, Bob received a call from Jeff Rosenheim, "out of the blue." There was to be an acquisitions meeting in a few months, and Jeff, with some urgency, suggested that Bob submit a proposal for the sale of the Hubert's archive to the Metropolitan Museum.

Bob could imagine Royce Howes telephoning Jeff Rosenheim and telling him, "Hey, Langmuir just called me all in a sweat, and I lowballed his Arbus photos. Now's the time to make your move." In the past, he would have poked and prodded such a paranoid imagining until it bloated and filled his entire field of vision. Now he considered it and cast it aside. Such a conversation was possible but not very likely, and if a communication even remotely similar to it had taken place between Royce and Jeff, it didn't matter. Rosy had asked for a proposal for the sale of the Hubert's archive, and by god, he was going to get it. Borrowing a page from Steve Turner's playbook, Bob took Jeff's phone call in a positive light, as a challenge.

He just needed to let things settle out a bit before committing himself to a final price for the entire archive. Given all that he'd been through, specifying such a figure felt absurd, almost painful to him. Whenever a likely number came into his mind, he found himself unable to say it out loud, as if naming it would violate the integral uncertainty of the entire process.

UNTITLED

AS THE MARKETING TOOL APPROACHED completion there were delays in arranging the meeting at the Met. Jeff wasn't ready. Then Bob was leaving on vacation and didn't have a chance to call Jeff back. Then Jeff was out of the office and unable to return Bob's call. Then Jeff got busy with an artist from Eastern Europe and had to postpone.

These delays didn't bother Bob. He felt healthy and strong, with a renewed sense of his own mission in life and the self-assurance to undertake it. Now when his cell phone rang it gave out the happy, raucous noise of a jungle full of birds. He'd deepened his friendships with people like Steve and Victoria, and he'd moved his relationship with Valerie to a whole new level of trust and mutual respect. Hell, he'd even met Renee! It wasn't as if he had to be in a hurry to sell the photos. They were already doing enough for him.

Then it was time.

Bob forwarded copies of every scrap of paper in the Hubert's archive, each one in its own protective plastic sleeve, the lot organized by category (letters, performer contracts, financial information, etc.) in five large, serious black binders. He also sent an understated description of the contents of the archive and a carefully worded essay explaining the archive, giving its historical context and demonstrating the two-way relationship between Arbus and Hubert's. The whole package, in Bob's opinion, was

quite effective. Apparently Jeff Rosenheim agreed. He and Bob scheduled a meeting at the Met for the afternoon of July 21. Bob was to deliver the real photographs for Jeff's inspection, make his pitch, and name his price. As of July 20, he was still working on the price.

On the morning of the twenty-first, Bob and Renee drove through the sultry remnants of a tropical storm, but made New York in good time. He had slept well. His only problem was a lingering fuzziness, as if anxiety were gumming up his brain, so he took a Xanax. The fuzziness remained, but the Xanax enabled him to convince himself that he wouldn't need his brain at this meeting. Everything he had to say was already in the proposal.

He and Renee ate a pleasant lunch in the Met's recently renovated cafeteria and strategized about the forthcoming meeting. Bob had a friend who worked at a museum in Philadelphia, and she had explained to him how intensely political a job like Jeff Rosenheim's was. The acquisition of the Hubert's archive was sure to be a complicated process, and might be decided by factors having little to do with the artistic or historical merit of the material. Bob and Renee agreed that he might be making his presentation in front of a committee, and they told each other that having to address a group would be better than a one-on-one meeting. With several people wanting to talk, Bob would be required to say less.

After lunch Renee wandered off through the galleries and Bob presented himself at the reception desk. He cooled his heels for an increasingly nervous ten minutes before Jeff appeared, bouncy and welcoming, in a summer beige suit that contrasted nicely with his dark hair. He led Bob to the offices of the photography department on the mezzanine level, making small talk all the way.

There, the binders containing copies of the documentary

material had already been spread across a worktable. Bob handed Jeff the suitcase full of Arbus photographs, still in their Ultra-PRO top-loading protective sleeves, now each with the addition of an estate stamp and letter of authentication, but minus the protective teddy bear towel, Bob having substituted a more sedate red one at the last minute. Jeff stacked the photos in front of him, offered Bob a seat across the table, and making a sweeping gesture at the Hubert's materials arrayed around them, told Bob, "It's your meeting. I'm here to listen to what you have to say."

Bob was terrified to see that there was no committee awaiting him. He'd be alone with Jeff Rosenheim. The tension ratcheted his fuzziness up to an almost audible buzz of white noise. He said, "Umm . . ."

Jeff couldn't have been expected to fully understand how climactic an event this was, but Bob's half-strangled gurgle gave him the sense he might be rushing things. So he added a conditional, "in response to my questions, of course," then launched into a long and genial preamble in which he praised Bob for his remarkable work in assembling and describing the material, and reminded him that he, Jeff, had been responsible for the critically important authentication of the Arbus photos. He was the one who'd explained the procedure to Bob at the very beginning. And he was the one who'd facilitated the authentication every step of the way. All Bob could remember was how the supposed six-week process had stretched into thirteen months, and had been botched up even then. Fortunately, he was still incapable of speech.

Jeff picked up Diane's note to Charlie, which was on top of the pile, and said, "What can you tell me about these pictures?"

Bob marshaled his resources. He was as familiar with that note as if he'd written it himself. He told Jeff who Dingo was, and how Charlie had facilitated Diane's forays into sideshows

outside Manhattan. Jeff asked about a possible date. They consulted the chronology in *Diane Arbus Revelations* and found an entry under the year 1960 to the effect that Charlie Lucas had sent Diane to other sideshows in Maryland and New Jersey. Jeff made a note on the legal pad in front of him and picked up the first photo, asking Bob again to tell him whatever he could.

Bob offered information about the people and the places in the pictures. His presentation was lame and halt, but it came. Jeff continued to try to get him in a more relaxed frame of mind, making his own comments about the photos as he sorted through them, and inviting Bob to play off what he'd said. Jeff found it interesting that several prints, especially those of Andy Potato Chips, Jack Dracula, and the contortionist Francis Duggan, had pinholes in the corners and showed other signs of wear. When Bob explained that they had probably come right off the walls at Hubert's, Jeff made a long note on his legal pad. Those objects had been in a real place in real life, handled by real people. He referred to this as "tribal" use. Bob was encouraged by the word "tribal." It sounded as if Jeff might be edging, unknowingly, right up to the old, weird America. When Bob told him about G. T. Boneyard he made another long note.

As Jeff looked through the photos, he discoursed on the ones he liked, ones that documented the moment but had another, deeper, artistic quality. He held up the photos of Charlie at the blade box and Charlie with the pointer in front of the electric chair, explaining to Bob how they were portraits of an interesting character, but how they possessed something else, a special richness that Diane Arbus's art had given them. The same held for those photos showing tribal usage. There was something about them, a mood or an ambiance, that went beyond mere documentation. He contrasted these to a group shot of Charlie and

his colleagues in the basement at Hubert's. It was perfectly descriptive, Jeff said, perfectly adequate as a document, but it was not imbued with that same magic. Bob, figuring he couldn't go wrong by agreeing with what Jeff said, nodded vigorously.

After inspecting each photo, Jeff stacked it on one of three piles. The first pile contained the good stuff, a second was for the "perfectly adequate as a document" category, and the third was for those of the mere snapshot variety. Bob noted that Jeff's "keeper" pile was larger than the other two stacks. It included the three Puerto Rican women, the snake eating the rat, the tribal photos, Charlie with the pointer in front of the electric chair, handless DeWise Purdon standing menacingly on the stage, and many of his other favorites. He thought he counted sixteen photos in this pile, and another half dozen in the "interesting" pile.

When Jeff had finished with the photos he reiterated his praise of the job Bob had done describing and presenting the collection. However, he continued, the appraisal and the price were still lacking, and they might as well get down to that bit of business sooner rather than later. By what process had Bob arrived at a price for this collection, and what was the price?

Bob muttered some timid sentences about his assemblage of comparables and the grading of his own photographs, but he ran out of steam on that topic pretty quickly. Then, casting around for something else to say, he mentioned his conversation with the professional photo dealer whose evaluation of the archive had agreed with his own.

Jeff stared at him, eyebrows arched, as if to ask, "So, what's the number?"

This was the moment. And Bob had prepared for it. Knowing he'd be incapable of actually uttering the price of his goods, he'd printed it out ahead of time at the bottom of a single sheet of paper on which was also printed a concise and sober summary

of the contents of the Hubert's archive. This document, the cul-
mination of the marketing tool, was housed in a protective plas-
tic sleeve, as if it, too, were a precious artifact. He took it from his
briefcase and slid it across the table to Jeff. He was wearing the
poker face of a man whose full house was about to be called, but
inside everything was black and red and roaring.

Jeff leaned forward to receive the document and asked if this
appraiser might have been Royce Howes of the Robert Miller
Gallery? Bob paused for a heartbeat, sensing some shift in the dy-
namic of the conversation, and then said no, he'd wanted to find
a qualified professional who was somewhat out of the Manhat-
tan loop, and had chosen an "expert in photography, a dealer who
knows you and who you know very well." This individual, Bob
continued, spent several hours with the archive. Jeff was now on
the edge of his seat. "His name," said Bob, as if he were pulling a
rabbit out of a hat, "is Alex Novak."

Jeff sat back and nodded. Novak was indeed known to him.
"Did he just look at the photographs, or the entire archive?"

In the course of Bob's visit, Novak had looked at a represen-
tative portion of the photographs, plus copies of some of the
documentary material. He made it clear to Bob that his general
estimate of the range of value was definitely not an appraisal.
However, he did say he thought the collection was an "important
find" whose value was heavily dependent on authentication of
the images by the Arbus estate. Bob told Jeff that Alex Novak had
grasped the "gestalt" of the Hubert's archive.

"Well," said Jeff, scanning the paper, "This figure doesn't sur-
prise me. It's pretty much in line with what I was expecting. But
I'm going to need your help with it."

Bob braced himself for the inevitable cheap shot, the ritual
downgrading of his material and the accompanying request for
a better price, a "museum price." But that didn't come. Jeff asked

him something else instead. Unfortunately Bob was still reeling from having laid his cards on the table, and could not understand the question. He cocked his head, straining to hear through his own defenses.

"So," Jeff was saying, "We have to justify this acquisition to the people who will actually fund it."

Days earlier, after he'd spoken with his friend from the Philadelphia museum, Bob had composed a speech about how he was just a humble bookseller, unversed in the complexities of museum politics. He got a few sentences into it and then stopped. Wrong speech, somehow.

Jeff forged ahead undeterred. "Supposing the Arbus photographs had never been authenticated, or that you didn't know they were Arbus photographs. What would the price for the archive have been in that case?"

Bob stayed silent for a long while. The idea of separating Arbus from Hubert's was so *not* what this archive was about. Rosenheim had to be trying to trick him. Finally he said, "That's a difficult question. I'd have to think about it longer."

"Let me put it another way. How would you evaluate the Arbus component? What proportion of the total are the photographs?"

Bob stared fixedly at the table, certain that their whole meeting was headed for disaster. Couldn't Jeff understand that the Hubert's archive was an integral whole? Why would he keep trying to pry the thing apart? It didn't make any sense. Then he had his first constructive thought of the day. Maybe it didn't make any sense because he was misunderstanding it. Maybe Jeff was getting at something else. "These components you're talking about. I'm not sure I . . ."

"An acquisition of this level, while not unusual for us, is beyond our normal budgeting process. That means we'd have to

find a donor to help us, as we often do, or another institution. Someone we could partner with."

"So you'd be splitting the collection up in a certain sense, but . . ."

"Sure. We don't normally handle documentary materials of this sort, whereas the New York Historical Society, or the Museum of the City of New York, where I used to work, would be perfect venues for the exhibition of the material."

"The Arbus photos?"

Jeff smiled. "We've already done an Arbus show. I want to do a Hubert's show."

Bob realized that their meeting was headed in the right direction after all. Jeff Rosenheim might not have read *The Old, Weird America,* or been pals with Greil Marcus, but Bob now saw that he was as hip as Sussman to the possibilities of Hubert's from a museum point of view. This vernacular stuff, this tribal stuff, these layered exhibitions *had* to be the coming thing for people in their world.

Their meeting, when all was said and done, lasted an hour and a half. Toward the end of it, Jeff sent Bob upstairs to a small exhibition of photographs illustrating the critical writings of Susan Sontag, so that he could spend a little time alone with the photos then show them to his director. Twenty minutes later they got back together and Jeff told him that the director had liked the material. All they had to do now was find a way to raise the money. He had a couple of ideas, but Bob would have to work at finding a donor or brokering the deal with another institution. Jeff must have intuited that the asking price printed at the bottom of that sheet of paper was a large, difficult, and life-altering number. Never once in the course of their ninety minutes together did he say it out loud. Neither did Bob.

HEALING WATERS

IT TOOK THREE WEEKS FOR THE CRASH to come, but when it came it was horrible. Jeff Rosenheim did not call and did not call, and Bob, afraid of upsetting the tenuous harmony between the two of them (now that Jeff had replaced him in the difficult and dangerous job of serving as the mystical vessel for the reunion of Charlie and Diane), could not bring himself to drop a dime and get a report about the Met's progress in funding the acquisition. Instead, he slid into a natural letdown after the excitement of his New York visit and fretted himself into a funk that meshed perfectly with his long-suppressed and now unavoidable grieving over the death of his marriage. As if that weren't bad enough, Valerie was being stalked by some chat-room nut case, and Zoe the pooch had lost her vigor and seemed to be failing physically. Then Renee left for a few days to attend a conference, and the funk turned into a full-blown depression. He began waking at four A.M. with nightmares and old ruminations, ideations. Floors caving in on him. Buildings exploding. Being pursued. He hallucinated Renee's presence, even though she was hundreds of miles to the north. Then he realized that his first thought each day for the past two-and-a-half years had been about Jan and their relationship. He envisioned moving back to Pinetown Road and taking care of Jan's every need, donning overalls and letting his beard grow, and raising goats and sheep and miniature ponies, just like

he'd always wanted to do. He was, in short, as bereft of reason as he'd ever been.

When Renee came home on Saturday, she found him in the swimming pool.

He was sitting in his sea chair, submerged up to his chin in the warm water, steeping in a light broth of painkillers and anti-anxiety medication. He'd diagnosed his condition and figured out that the only thing to be done, for the moment, was exactly what he was doing.

He told her, "I'm taking the healing waters."

She laughed.

He was ferociously glad to see Renee. Her touch was like a meal to a starving man. They drank a very cold bottle of sauvignon blanc and went to the Russian baths for salt-honey scrubs at high temps alternating with cold pool plunges. They rested and talked about how it was August in New York, after all, and how *nobody* did *anything* in New York in August. Anyway, if Rosy didn't come through, he'd take the archive to Weston Naef at the Getty when he went out to go hiking with Steve Turner in October. They enjoyed tuna tartare, broccoli rabe, and antipasto with a bottle of good red wine, outdoors in comfortable chairs in the backyard, in the late afternoon sun. That evening they planned their trip to Jacob's Pillow, the dance center in the Berkshires, to whom Bob was hoping to sell his incredible archive of one thousand Hans Knopf photographs and negatives documenting Ruth St. Denis, Ted Shawn, and the golden age of American modern dance.

There followed a period in which things seemed to improve with each passing day. On a springlike afternoon in January 2007, Bob and Renee sat on a stone wall overlooking a rolling Pennsylvania field and married themselves, holding hands and

exchanging vows of lifelong commitment. A few days later they hosted a celebratory brunch attended by a few relatives and close friends. Renee, in her happiness, radiated beauty. Bob was bursting with emotion, on the verge of joyous tears. Exactly three years had elapsed since his visit to the psycho ward at Lancaster General Hospital.

Then he sold the Hubert's archive for that life-altering sum and rode off into the sunset, having secured his position as the Indiana Jones of the old, weird America.

THE SUNSET KID

OR HE SHOULD HAVE. In a novel he would have. In real life, alas, a difficulty emerged. It turned out that Bob and Jeff Rosenheim had completely misread each other.

From Jeff's curatorial point of view, the Arbus photos were an interesting but not critically important part of the offering. If he needed prints of the images in the Hubert's archive, he could obtain them from the estate via Neil Selkirk at a reasonable cost. For him, the true value of the archive was in Charlie's journals, poems, letters, and drawings, and in the contracts and financial statements that documented daily affairs at Hubert's. Though he was fairly well grounded in the history of dime museums and New York's sideshow subcultures, the African American component was new to him, and quite exciting. The Hubert's archive, he felt, would be the core of a wonderful exhibition—one he very much wanted to curate. Still, despite their exhibition worthiness and their inherent fascination, these materials—even in the most charitable evaluation—were worth only a fraction of what Bob was asking for the entire archive. Jeff had assumed that a tacit understanding existed between Bob and him, whereby his help in getting the Arbus photos authenticated would be exchanged for the study and use of the rest of the Hubert's materials. This proved not to be the case.

In Bob's dealer mind-set the Arbus photos were an inseparable part of the entire archive, and the archive as a whole had a charisma

that transcended museum exhibitions and scholarly studies. Arbus herself had worked with each of those two dozen pieces of photographic paper. She had coaxed from them the remarkable images that shed light on Charlie's pained journal entries and crabbed business records. Those prints had commercial value because they'd been crafted by one of the great geniuses of the twentieth century; they had even more value because each print was enhanced—*illuminated*—by the mass of documentation in which it was embedded. There was no "Arbus component," no "Hubert's component." There was just the Hubert's archive, and Bob felt he owed it to Charlie and Diane—and to himself—to sell the archive on his own terms, for what he thought it was worth.

Jeff didn't necessarily disagree with this; he just had something else in mind. When he said, "This figure doesn't surprise me," he was merely acknowledging that the marketplace was complex, and that Bob was entitled to value the archive at any figure he could justify. It did not mean that the Met was going to write a check for such an amount. When Jeff then said, "But I'll need your help," it was by way of suggesting that Bob would have to take the lead in raising the money or brokering an agreement with another institution. As far as Jeff was concerned, he'd done his part by helping to get the photos authenticated and by convincing his boss that the Hubert's archive would be a worthwhile acquisition. Now it was up to Bob to find the money. Bob missed this entirely.

Both men, to some degree, took the miscommunication personally. Though Jeff claimed that he understood Bob's viewpoint, he was obviously dismayed by it. Bob, despite all the work he'd been doing on himself, couldn't help but feel that Jeff was jerking him around. In fact, their problem went beyond personalities. It was a clash of cultures. The curator and the dealer saw the same things with different eyes. Always had and always would. Each held his view with passion and commitment, which was why each

of them was so good at what he did, and why neither of them could understand the other.

It took weeks of baffling telephone conversations, but gradually the situation normalized. Jeff, with his innate optimism and can-do spirit, remained hopeful that something could be worked out. Bob decided that for the time being he'd rather not get involved in raising funds for the Met.

He settled in to his life with Renee and became ever more active in business, prowling the East Coast as he had in days of yore. On one of his forays he discovered a very early photo of renowned bluesman Howlin' Wolf that had been taken at Parchman Farm, and that more or less settled the controversy over whether Wolf had murdered a man in his youth. Occasionally he'd meet old colleagues and be touchingly surprised to discover that after a hiatus of three years, most of them were glad to see him. Bob began having fun again.

In the canny Zen of his ADD, he was perpetually in a dither, but lying in wait, also, for the perfect opportunity to sell the Hubert's archive, knowing that when the time came it would be *the* time, and that however much he got for the archive, it would be more than he had, and pretty much what he was willing to take.

And this is exactly the point at which the story escapes back into the wild, leaving us with the marvelous afterimage of Bob and his courageous rabbit hole plunge, somehow rescuing himself in the course of retrieving the Hubert's archive, but also leaving us wondering about that mass of paper that so eloquently documents life in a Times Square freak show in the middle of the twentieth century.

★ ★ ★

Just for a moment, let us return to one of the origin points of this narrative—"Darkest Africa"—the trope of the savage and

the pseudosavage, and the complex effect this imagery has on the white imagination. Somewhere in Graham and Beard's wonderful *Eyelids of Morning,* Alistair Graham talks about how civilized man is disposed to conquer what is wild and dangerous in nature, but that once he has conquered it, he develops a kind of nostalgia for the very things he has just destroyed—"seeking in them qualities to cherish." Of course Graham was talking about crocodiles on Lake Rudolph in Africa, but the mechanism is quite the same when we consider the Disneyfication of Times Square and the displacement, by proud city fathers, of freaks, faggots, drug addicts, and other threatening species.

We now find many such "qualities to cherish" in Charlie's woes, Woogie's snakes, Hubert's freaks, and Diane's photographs. However, none of this lode of noir glamour would be available to us had it not been for Bob's involvement—seemingly accidental, but in fact highly specialized and tremendously disciplined. The spiritual benefits of the work were paramount. But in terms of the fate of the Hubert's archive, the payday aspect is just as important.

Bob's researches were aimed at proving that the archive was significant—that it should be valued. By the lengthy and difficult process already described, he assembled a disparate group of materials, gave them a coherent identity, and showed where they fit in our past. His work of discovery and valuation brought that collection of documents into being as a unique entity with cultural significance. Because it is now valued as such, because it now *exists* in this way, the Hubert's archive will never be lost. It doesn't really matter who writes the check, what the number is, or how many zeroes follow it. Sooner or later—whether by purchase, donation, or some radical and sophisticated swapping of goods and tax advantages—the archive will land in a museum or an institutional collection, where people who care about such

things can access its riches. Then they will curate their shows and launch their Web sites and write their books and make their movies. And we will read and see, and speculate and be enthralled. We will note the manifold ways in which that vanished world informs our own.

This may sound mystical, but it's simply part of an age-old transaction in which scholarly treasure hunters like Bob return to us the valuable things we've inadvertently discarded. Such specialists help gather the materials of our history, but they provide something else as well: the replenishment of a potency or possibility that most of us experience as an imagination of the past, and a rare few transform into art. Diane Arbus speaks of the process thus:

> These are our symptoms and our monuments. I want simply to save them, for what is ceremonious and curious and commonplace will be legendary.

AND THAT'S NOT ALL

ONE MIGHT ASSUME that the sale of the Hubert's material would be as twisted and difficult as the events leading to its discovery. In actuality, the process by which the archive came to market proceeded in such a straightforward and timely manner that it almost seems out of character with the rest of the story.

Bob went back to his life as a rare-book scout, working eBay every day, buying and selling, scouting country auctions with the same mania as ever, leavened now with a hard-won sense of the arbitrary nature of his calling—that it was *all just stuff*. He had his usual share of great finds narrowly missed, of sure-fire prospects that turned out to be duds and the occasional long shot that came through. When time and money allowed, he indulged his love of travel. He went to Mexico on his own and vacationed with Renee in Canada. Simply stated, his new life kept him so busy that he didn't have the time or energy to devote to marketing the archive.

So, in the summer of 2007 he retained his old friend Steve Turner to act as his agent in the sale of the Hubert's material. Steve had been uninterested at first, but then he realized that an exhibition of the Arbus photos would be a perfect event for the new gallery he was opening. Bob went back to his business, preparing for the winter sale of African Americana at Swann Galleries, and hardly gave the archive a second thought.

Not so for Steve, who pursued the matter with characteristic vigor. That fall he showed the archive to photography experts at

Phillips de Pury & Company, a prestigious international auction house specializing in photography and contemporary art. The presentation was a sort of reprise of the one Bob had made to Jeff Rosenheim, but this time Steve was making it, and the end result was quite different. Phillips was more than intrigued. They flew representatives to Los Angeles to view the originals of photographs in Steve's gallery and shortly thereafter inked a deal to sell the Arbus photos at a public auction.

The auction was scheduled to take place in New York in April 2008, and the sale was to be preceded by exhibitions of the material in Los Angeles and New York, providing a potentially large number of people the chance to see the fruits of the collaboration between Diane Arbus and Charlie Lucas. The estimate by the experts at Phillips de Pury of the selling price of the photos was well in advance of the "life altering sum" Bob had floated to Jeff Rosenheim.

The last time I saw him, Bob was elated but calm, counting his chickens but not walking on eggshells, planning modest vacation homes in Laguna Bacalar, Mexico, and Mahone Bay, Nova Scotia, and otherwise full of fantasies about how the money would change his life. But to me all of that just sounded like Bob being Bob. The money wouldn't change him. He'd already changed.

AFTERWORD

Bob traveled to Manhattan on April 7, 2008, with a light heart and high hopes, fully expecting to come home a millionaire. He woke on April 8 to learn that Phillips de Pury & Company had canceled their auction of the Hubert's archive, overnight and without warning.

He called me that morning, distraught. I immediately called Phillips Gallery. The woman with whom I spoke told me the auction had been canceled. She said a buyer for the entire archive had come forward and, because of their obligation to keep the archive intact, Phillips de Pury had accepted his offer. I asked her, if that were the case, why they had gone to the trouble to issue an auction catalog with each photograph offered for sale individually? She regretted she could not comment on that. I asked who the buyer was. She told me she was not at liberty to disclose the buyer's identity, thanked me for my call, and bid me adieu.

In the afternoon I went down to Phillips de Pury to look at the photos one last time. Then I met Bob around the corner at a bar called Son Cubano. We drank outside in the watery April sunlight, feeling like Zero Mostel and Gene Wilder in *The Producers* after the laughter and cheers reached them across the street. In the evening a documentary film crew recorded Bob in his room at the Hotel Roger Williams on Madison Avenue, lounging against the blue satin headboard of his sumptuous bed like an odalisque or Janis Joplin, still drinking, telling the filmmakers

how he'd come to this strange pass. I could not imagine how Bob felt in that awful moment, if he felt anything at all. Finally Renee shooed everyone out of the room, and Bob began his long crawl through days, weeks, and months, waiting to see how the situation would resolve.

The lawyers clamped down almost immediately and, though I had access to Bob on a personal level, he was under strict orders not to speak about legal matters. "I don't have any news," he'd say, "and I'm doing my best not to make any." I was left to theorize about the causes behind the shocking cancellation of the auction.

In the spring of 2007 Steve Turner, acting as Bob's agent in the sale of the Hubert's archive, struck a deal for its auction with Phillips de Pury. As part of their agreement, Steve had gotten the auctioneers to *guarantee* Bob a certain amount from the proceeds of the sale. Bob never told me exactly how much the guarantee from Phillips was, but each lot in the auction was assigned high and low estimated values, and the total of even the low estimates added up to well over a million dollars. In making their financial commitment to Bob, Phillips had, in essence, "bought" the archive. They acknowledge as much on the first page of their catalog for the auction—as legally required—stating that they have a financial interest in the Hubert's archive. To seal the deal, they gave Bob an advance on his projected earnings.

Then, in December 2007, Steve Turner scored a publicity coup. Somehow he got the *New York Times* to write the whole story of Bob's discovery and the forthcoming auction. The article was illustrated with one of the photographs from the archive—Arbus's portrait of DeWise Purdon, looming handless and menacing on the stage at Hubert's Museum in the 1960s—and it even mentioned my book, whose publication was timed to correspond with the auction. Steve and Bob were ecstatic.

My publishers groaned. The article had come out far too early—
four months before the auction and the book's release. In the
world of publicity, four months is an eternity. Events proved
them correct, but that wasn't the worst of it.

One of the people who read the *Times* article was Bayo
Ogunsanya, the dealer who appears in this book (at Bob and Val-
erie's request) as "Okie." Bayo saw that the goods he'd sold Bob
for a few thousand dollars were about to bring millions. He ini-
tiated a lawsuit against Bob, and in the ensuing publicity, suc-
cessfully cast himself as an innocent Nigerian scholar, a collector
of African-Americana, who had been victimized by a greedy
white professional from Philadelphia. Bob had solid grounds for
disputing Bayo's claims, but Bayo's version seized the day in the
press. In the public discussion that followed, it was widely as-
sumed that Bayo's lawsuit was the reason Phillips had halted the
sale of the Hubert's archive.

Phillips did nothing to dispel this rumor, but I thought there
were other, deeper reasons for the cancellation. Phillips de Pury
& Company had all along been marketing themselves as a
younger, hipper version of Sotheby's and Christie's. The Hubert's
archive was fascinating stuff, but commercially Phillips was tak-
ing a risk. They knew, as did everyone else, that it was the Arbus
"icons" that brought the big money. As it happened, their
planned April 8 sale of off-brand Arbus images was flanked by
two high-end photography sales at Christie's and Sotheby's. On
April 7, Sotheby's auctioned the Quillan collection, which fea-
tured a strong selection of nineteenth- and twentieth-century
images and which brought nearly $9 million in sales. A few days
after the proposed Phillips sale, Christie's was holding two strong
photography sales, including a collection of fifty Arbus icons. As
it turned out, those sales yielded a total of more than $5.5 mil-
lion.

It seemed to me that Phillips de Pury got caught between these two stronger auctions, which drew attention away from the Hubert's archive, and sucked the oxygen out of the room as far as buyers were concerned. I became convinced that they canceled their auction because, in competition with the two bigger auctions, they got little or no presale interest in their Arbus offerings. If they'd been unable to sell the photos at auction, it could have been fatal to the investment they'd made in the Hubert's archive. So they concocted their single buyer story and decided to take their chances renegotiating a contract with Bob. This is only my speculation, but I believe the evidence points convincingly to such a scenario. (I have blogged extensively about the causes and ramifications of the matter on the book's website, hubertsfreaks .com.)

Bayo's lawsuit and the disappearing auction were followed by more bad news. An enthusiastic producer who'd been trying to line up Phillip Seymour Hoffman to play Bob in a movie version of *Hubert's Freaks* informed us, regretfully, that Phil simply did not have time to take the project on. Bob was philosophical. "How can we expect Phil to want to play me when I don't even want to play me?" Then, in a surprising turn of events, Phillips de Pury & Company was purchased by Mercury Group, Russia's largest luxury retail company. Mercury owns high-end department stores in downtown Moscow, dispensing such brands as Gucci, Prada, Giorgio Armani, Rolex, Ferrari, Maserati, and Bentley.

It is perhaps emblematic of the situation that Bob burned through his advance from Phillips de Pury hiring Park Avenue lawyers to protect his interests against their claims, as well as the claims of Bayo Ogunsanya. In essence, Phillips was paying Bob to take them to court. Thus things proceed in the world of high art.

As this paperback edition of *Hubert's Freaks* goes to press, there have been no further developments. Bayo is still suing Bob, the white knight buyer of the archive has not appeared, and Bob faces negotiations with the Russians. The Hubert's archive languishes in a vault somewhere, and I remain stupidly hopeful that the story will yet have a happy ending. Bob, thanks to the work he'd previously done on himself, goes forward with surprising equanimity, though he does seem to be spending quite a bit of his time in Mexico these days.

I can't say I blame him.

ACKNOWLEDGEMENTS
SELECTED BIBLIOGRAPHY

ACKNOWLEDGMENTS

Thanks to my editor, Andrea Schulz; my agent, Neeti Madan; and to readers Louie Howland, Anthony Weller, John Brown, Deb Baker, Kathy Rich, Sue Chady, Lou Schneider, Barry Feldman, Mick O'Connor, Kathy O'Connor, Orv Haberman, Charlotte Gordon, Jack Baker, Bob Langmuir, Valerie Francis, Alen MacWeeney, Joe Burns, Gay Walley, John Hellebrand, and Joe DeGrazia.

David Smith, research librarian at the New York Public Library, was a tremendous help and support throughout the research phase of this project, as were Don Marritz, on property law issues; Renée Watson, Watson Library at the Metropolitan Museum; Jenn Hathaway, Franklin Institute; Dierdre Donohue, librarian at the International Center of Photography, NYC; Fred Cohen, Jazz Record Center, NYC; Elisabeth Sussman, Whitney Museum; Sandra Phillips, SFMOMA; Jeff Rosenheim, Metropolitan Museum; staff at the Boston Public Library; Katie Latona, MoMA, NYC; Kathleen Tunney, MoMA Archives, Queens; Elena Rossi-Snook, Donnell Media Center, NYC; Royce Howes, Robert Miller Gallery, NYC; Mack Lee, Lee Galleries, Winchester, MA; Chris Mahoney, Sotheby's, NYC; Valerie Hoyt, Christie's, NYC; Wyatt Day, Swann's, NYC; the staff at Billy Rose Library, Lincoln Center, NYC; and David Hough at Harcourt.

Also: Elizabeth Biondi, Tony Lee, Richard Flint, Rob Lewine,

Connie and Richard Harrier, Nancy Crampton, Carmella Bran-
cleone, John Keegan, Robert Stevens, Oakie, Karin Bleeker, Niles
K. Brown, Esther, Louis Bostock, Gerrit Lansing, Renee Russock,
Bobby Reynolds, Ward Hall, Gene and Rosalie Schaffer; and of
course Bob, Val, and the other exasperating, generous, slippery,
lovely characters who appear in this book. They wrote the story
with their lives; I just copied down what happened.

SELECTED BIBLIOGRAPHY

Abbott, Berenice, introduction. *Lisette Model*. NY. Aperture. 1979. Model was Arbus's early teacher. The book was designed by Marvin Israel.

Adams, Rachel. *Sideshow U.S.A.* Chicago. U. of Chicago Press. 2001. Good source on history of freakdom. Interesting section on pp. 120–122 titled "From Hubert's to MOMA: Freak in the Museum."

Allen, Donald (editor).*The Collected Poems of Frank O'Hara*. Berkeley. UC Press. 1995. "A Young Poet," pp. 278–9.

Anon. *Aunt Sally's Policy Players Dream Book.* no publisher, date. Gives number equivalent for dream subjects. "Policy" was a numbers game.

Arbus, Doon and Marvin Israel (editors). *Diane Arbus: Monograph*. NY. Aperture. 1972. This book defined the Arbus canon.

Bahr, Mary (editor). *Diane Arbus: The Libraries*. San Francisco. Fraenkel Gallery. 2004. Foldout photo of Arbus's library installation at Revelations, with booklet containing a bibliography.

Ballantine, Bill. *Wild Tigers & Tame Fleas*. NY. Rinehart & Company. 1958. Much on Hubert's. Charlie's lecture on Heckler's fleas, p. 232.

Berman, S. N. *Duveen*. NY. Random House. 1952. Classic work on one of the first modern purveyors of fine art.

Bianco, Anthony. *Ghosts of 42nd Street*. NY. William Morrow. 2004. Much on the history of the Times Square neighborhood. Vintage photo of Hubert's Museum, 1939.

Blodgett, Richard. *Photographs: A Collector's Guide*. NY. Ballantine Books. 1979. General information from the early years of the photo boom. Cites a high of $2,500 for an Arbus photo, p. 108.

Bogdan, Robert. *Freak Show*. Chicago. U. of Chicago Press. 1988. Scholarly study of this form of entertainment, 1840–1940. Material on Darkest Africa and Charlie Lucas.

Bosworth, Patricia. *Diane Arbus: A Biography*. NY. Alfred Knopf. 1984. The only full-length biography. Unauthorized. A source of some biographical material about Arbus used in this account.

Crimp, Douglas. *On the Museum's Ruins*. Cambridge, MA. MIT Press. 2000. pp. 67–81 have Szarkowski information.

Davidson, Bruce. *Brooklyn Gang*. Santa Fe, NM. Twin Palms Publishers. 1998. Davidson's photos of gang kids in Hubert's with recollection of gang member of visit there.

Dennett, Andrea Stulman. *Weird and Wonderful: The Dime Museum in America*. NY. NYU Press. 1997. Early dime museums and Barnum.

Drimmer, Frederick. *Very Special People*. NY. Bell Publishing Co. 1973. Brief biographies of the most notable freaks, mostly nineteenth century.

Dufour, Lou and Irwin Kirby. *Fabulous Years*. NY. Vantage. 1977. Original source for exploits of Charlie Lucas and Darkest Africa.

Dylan, Bob. *Chronicles: Volume I*. NY. Simon & Schuster. 2004. Lenny Bruce, p. 11. Also mentions Dylan's visits to Hubert's.

Eliot, Marc. *Down 42nd Street*. NY. Warner Books. 2001. History of the Times Square neighborhood up to the early days of its rehabilitation.

Fiedler, Leslie. *Freaks*. NY. Simon and Schuster. 1978. Lenny Bruce at Hubert's, pp. 329–30.

Frizot, Michel (editor). *A New History of Photography*. Koln. Konemann. 1998. Articles by Bunnell, pp. 291 and 313; Ducros, 351–353; Gunther, 555–557; Alexander, 597; Frizot, 581; and Benjamin, 733.

Gee, Helen. *Limelight*. Albuquerque, NM. U. New Mexico Press. 1997. Much on the café-gallery in Manhattan and photographers on the scene.

Green, Jonathan. *American Photography*. NY. Harry Abrams. 1984. Source of Trainer quote on Arbus's "overdose of evil," though it has been altered somewhat in Trainer's use, which appeared originally in *Athanor* XVIII as "The Missing Photographs: An Examination of Diane Arbus's Images of Transvestites and Homosexuals from 1957 to 1965."

Herlihy, James Leo. *Midnight Cowboy*. NY. Simon & Schuster. 1965.

Hyde, Stephen and Geno Zanetti. *Players*. NY. Thunder's Mouth. 2002. Selection from Nick Tosches' "Cut Numbers," p. 285, gives origin and basis of various types of numbers games.

Igliori, Paola. *American Magus: Harry Smith*. NY. Inanout Press. 1996. Rambling account of Smith's life and career.

Jackson, Kenneth T. *The Encyclopedia of New York City*. New Haven. Yale U. Press. 1995.

Jay, Ricky. *Jay's Journal of Anomalies*. NY. Quantuck Lane Press. 2003. Conveys an excellent sense of the whimsical side of freakdom.

Jenkins, Reese V. *Image and Enterprise: Technology and the American Photographic Industry, 1839–1925*. Baltimore. Johns Hopkins U. Press. 1975. Role of technology in the development of photojournalism.

Kabat-Zinn, John. *Full Catastrophe Living: Using the Wisdom of Your Body and Mind to Face Stress, Pain, and Illness*. NY. Dell. 1990. One of Bob's resources.

Keller, Ulrich and Gunther Sander. *August Sander*. Menschen des 20. Jahrhunderts. Munchen. Schirmer/Mosel. 1980. Major collection of the work of Sander, a major influence on Arbus.

Koster, Piet and Dick M. Bakker. *Charlie Parker, 1940–1947.* Vol. 1, "Parker Discography." Alphen aan Rijn, Holland. Micrography. 1974. Source for information on background music for the grind tape.

Lee, Anthony W. and John Pultz. *Diane Arbus: Family Albums.* New Haven. Yale University Press. 2003. Book about an archive that came to light after Arbus's death.

Lenz, Wiliam E. *The Poetics of the Antarctic.* NY. Garland Publishing, Inc. 1995. Morrell, Woodworth, and Poe.

Malcolm, Janet. *Diana & Nikon.* NY. Aperture. 1997. For some reason, she has been given permission to reproduce some of Arbus's iconic images.

Mannix, Daniel. *Freaks: We Who Are Not as Others.* NY. Juno Books. 1999. Photos and information on some twentieth-century freaks, such as Sealo the Seal Boy and William Durks.

Marcus, Greil. *The Old, Weird America.* NY. Picador. 1997. The book to which Elisabeth Sussman referred. Harry Smith's *American Anthology* and Bob Dylan's *Basement Tapes.* Originally published as *Invisible Republic: Bob Dylan's Basement Tapes.*

Meriwether, Louise. *Daddy Was a Number Runner.* NY. Feminist Press. 2002. Dreams and numbers in African American daily life.

Mitchell, Joseph. *Up in the Old Hotel.* NY. Pantheon Books. 1992. Lady Olga at Hubert's, pp. 89–105.

Mooney, Kempton. Essay titled "The Chiaroscuro Market: Art Theft and the Art World" found at www.geocities.com/fkmooney/TheChiaroscuroMarket.pdf. In its defense against being sued by the DeShong Museum for selling fourteen stolen paintings, Sotheby's Holdings Inc. claimed that it was "impossible to check the titles to all items."

Morrell, Abby Jane. *Narrative of a Voyage.* NY. J. & J. Harper. 1835. Narrative by the wife of "the biggest liar in the Pacific."

Morrell, Benjamin. *A Narrative of Four Voyages.* NY. Harper & Brothers. 1853. Reprints Morrell's 1832 Narrative.

Nickell, Joe. *Secrets of the Sideshows.* Lexington, KY. U. Press of Kentucky. 2005. Good source for mid-twentieth-century sideshows. Information on Charlie Lucas.

Palmer, Robert. *Deep Blues.* NY. Viking Press. 1981. Information on Muddy Waters and "Rollin' Stone."

Parr, Martin and Gerry Badger (editors). *Photobook: Vol. I.* NY. Phaidon. 2004. Source of Stieglitz information in "Collectors" chapter.

Atlantic Monthly. Portfolio of ten prints.

BusinessWeek. February 10, 1973. Rising values of Arbus photos.

Harper's Magazine. November 2003. Francine Prose's perceptive review of the Revelations catalog.

LA Weekly. February 27–March 4, 2004. Article by Doug Harvey stating, "Arbus fits the diagnostic criteria for a manic depressive to a tee."

Ms. Magazine. October 1972. Doon Arbus's article on her mother mentions "small, black, spiral-bound notebooks" beginning in 1959. Presumably these were the ones so ably utilized by Elisabeth Sussman. Also, "She had begun as a huntress and it seemed that the more she discovered, the more she became her own prey."

Newsweek. February 20, 1967. Review of New Documents and Arbus.

New York Magazine. February 27, 1972. Arbus and cult of dead female stars.

Shocked and Amazed. Baltimore. Dolphin-MoonPress. 2005. Volume 8, pp. 72–82 contains Denholz article on Heckler flea circus at Hubert's.

New Yorker. April 19 and 26, 1958. "Talker," by Robert Taylor.

New York Times Magazine. September 14, 2003. "Arbus Reconsidered." Long article, beginning on p. 28, by Arthur Lubow as prelude to the October opening of Revelations.

New Yorker. October 14, 2003. Judith Thurman's review of the Revelations catalog.

New Yorker. September 12, 2005. Memorial article on Sontag by David Denby, p. 90.

New Yorker. March 13, 2006. Calvin Tomkins's article on the Whitney Museum begins on p. 46.

New Yorker. March 20, 2006. Profile of Tobias Meyer, chief auctioneer at Sotheby's, p. 88.

Photograph Collector. NY. Photograph collector's newsletter. 1983–2004. Consulted vols. 4–25 for market trends.

Time. November 1972. Arbus as much a cult figure as Plath.

Vanity Fair. August 2006. Patricia Bosworth's saga of the optioning of her Arbus biography, p. 152. This eventually became the movie *Fur*.

Vanity Fair. November 2003. Article beginning on p. 238 by Vicki Goldberg, as prelude to October opening of Revelations. Source of "private, precious freak in everyone" quote.

Women's Review of Books cited as the source of the Elsa Dorfman piece in which she questioned the fact that Diane's parents apparently never assisted Diane financially. Available at elsa.photo.net.

Russell, Ross. *Bird Lives.* NY. Charter House. 1973. Information on session that was the background music for the grind tape.

Sante, Luc. *Low Life.* NY. Farrar, Straus, Giroux. 1991. Old "Huber's" museum, p. 98.

Smith, Harry (editor). *A Booklet of Essays, Appreciations, and Annotations Pertaining to the Anthology of American Folk Music.* Washington, DC. Smithsonian Folkways Recordings. 1997, 1967. The written document to accompany Smith's seminal collection of American roots music. It was reprinted by the Smithsonian in 1997 when the set was issued in CD format.

Sokolov, Raymond. *Wayward Reporter: The Life of A. J. Liebling.* San Francisco. Creative Arts Book Company. 1984. Liebling and Albert/Alberta, p. 124.

Sontag, Susan. *Against Interpretation.* NY. Farrar, Straus & Giroux. 1966.

Sontag, Susan. *On Photography.* NY. Farrar, Straus & Giroux. 1977. Particularly pages 3–82.

Sontag, Susan. *Regarding the Pain of Others.* NY. Farrar, Straus & Giroux. 2003. Mature Sontag's further thoughts on photography, p. 29: "Whether the photograph is understood as a naive object or the work of an experienced artificer, its meaning—and the viewer's response—depends on how the picture is identified or misidentified; that is, on words."

Sontag, Susan. *The Volcano Lover.* London. Vintage. 1993. This novel explores aspects of collecting psychology, i.e., pp. 25, 27, and 137, and of freakishness, p. 247.

Southhall, Thomas W. and Diane Arbus. Doon Arbus and Marvin Israel, editors. *Magazine Work.* NY. Aperture. 1984. Devoted to Arbus's magazine career. First publication of her article "Hubert's Obituary," written in 1966, pp. 80–81.

Strausbaugh, John. *Black Like You.* NY. Penguin Group. 2006. Blacks as savages, pp. 45, 48. Sideshow evolution, p. 129.

Sussman, Elisabeth, Sandra Phillips, curators. *Diane Arbus Revelations.* NY. Random House. 2003. Catalog to accompany Revelations exhibition. Articles by Phillips, Neil Selkirk, and Jeff Rosenheim. Chronology by Sussman and Doon Arbus. My source for most of the biographical information and Arbus quotes.

Szarkowski, John. *Photography Until Now.* NY. MoMA. 1989. Quote about introduction of photography into art schools, p. 272.

Szarkowski, John. *Looking at Photographs.* NY. MoMA. 1973. Szarkowski quote on silence, p. 186.

Szarkowski, John. *Mirrors and Windows: American Photography since 1960.* NY. MoMA. 1978. This catalog of a 1978 traveling exhibition is typical of Szarkowski's broad range and graceful touch. Features four Arbus photos, with *Man at Parade on Fifth Avenue* as cover illustration.

Szarkowski, John. *The Photographer's Eye.* NY. Doubleday & Co. 1966. A 1966 MoMA catalog. Szarkowski advances his theories by presenting some anonymous photographs as being on a plane with recognized masters.

Szarkowski, John (editor). *From the Picture Press.* NY. MoMA. 1973. This was the MoMA project on which Arbus worked before her death. She's credited by Szarkowski.

Szarkowski, John (editor). *The Photographer and the American Landscape.* NY. MoMA. 1963. Quote on p. 4 about picture revealing photographer.

Talese, Gay. *New York.* NY. Harper & Brothers. 1961. Eddie Carmel and Jack Dracula.

Tolle, Eckhart. *The Power of Now.* Novato, CA. New World Library. 1997. Also audiotape. Another of Bob's resources.

Vail, R. W. G. *Early American Circus.* Barre, MA. Barre Gazette. 1956. Eighteenth-century origins of freaks in America.

Wald, Elijah. *Escaping the Delta.* NY. Harper Collins. 2004. Best contemporary study of blues and modern America.

Ward, Geoffrey C. *Unforgivable Blackness: The Rise and Fall of Jack Johnson.* NY. Alfred Knopf. 2004. Jack Johnson at Hubert's, pp. 442–3.

Watson, Peter. *From Manet to Manhattan: The Rise of the Modern Art Market.* NY. Random House. 1992. Growth of collecting trends and the rise of auction houses.

Witkin, Lee and Barbara London. *The Photograph Collector's Guide.* Boston. New York Graphic Soc. 1979. In his bibliography for Arbus, Witkin cites Bunnell article in *Print Coll. Newsletter* 4 (Jan–Feb 1974, pp. 128–30) and Robert B. Stevens "The Diane Arbus Bibliography," *Exposure,* 15 September 1977, pp. 10–19.

SELECTED NEWSPAPER ARTICLES

Dallas Morning News
May 18, 1986. Deshong art theft.

New York Daily Mirror
August 21, 1956. Roy Heckler.

New York Daily News
January 17, 1939. "Schork and Schaffer Largest Pinball Owners."

New York Recorder
July 17, 1910. Closing of old Huber's downtown, which becomes Luchow's.

New York Review of Books
November 11, 1973 and April 18, 1974. Original Sontag articles on photography.

New York Sunday Mirror
March 23, 1952. Forty-second Street.

New York Sunday News
May 17, 1964. "The Street that Went to the Fleas."

New York Telegraph
July 17, 1910. Closing of Huber's.

New York Times
September 2, 1925. Hubert's building leased.
April 29, 1928. Death of Zip.
March 7, 1928. Theaters on Forty-second Street.
July 5, 1928. Classified help wanted for young girl at Hubert's.
August 30, 1931. Heywood Broun on Hubert's at Coney Island.
February 10, 1932. Court case on Hubert's as "museum" or entertainment.

February 14, 1932. Ditto.

April 28, 1932. Loitering on Forty-second Street.

May 6, 1932. Brooks Atkinson's favorable review of Hubert's.

June 24, 1932. Rattlesnakes at Hubert's.

May 26, 1935. Help wanted at Hubert's.

September 1, 1935. Ditto.

February 2, 1936. Hubert's closed.

January 24, 1937. Freaks at Hubert's.

July 24, 1938. Roy Heckler Sr.

October 9, 1939. Flea lost in mail.

October 17, 1939. Manager of Hubert's dies.

June 28, 1944. Description of wartime Hubert's.

October 3, 1944. $5000 alteration. (Hubert's moves downstairs?)

April 30, 1945. Building sold.

June 11, 1946. Jack Johnson obit.

June 11, 1947. Max Schaffer buying material for Hubert's.

February 5, 1958. Brooklyn Strong Boy's obit.

March 14, 1960. Forty-second Street decay.

March 14, 1960. Life on Forty-second Street.

March 26, 1966. Forty-second Street cleanup.

August 22, 1971. "Diane Arbus: The Subject was Freaks."

November 5, 1972. "From Fashion to Freaks."

November 8, 1972. Review of Arbus retrospective.

February 15, 1974. Max Schaffer obit.

February 15, 1974. Red Smith on Hubert's.

June 23, 1977. Article on Playland post-Hubert's iteration.

July 11, 1977. Smut shop in Playland.

March 8, 1979. "42nd St. You Ain't No Sodom."

October 15, 1980. George Segal remembers Hubert's.

June 25, 1985. Maureen Dowd on growing up in Times Square.

October 15, 1996. "The New Times Square."

October 17, 1994. Long letter on history of Hubert's building prior to its demolition.

June 16, 1996. Hubert's building torn down.

October 24, 1997. Self-storage auctions.

July 14, 2002. Auer's advertises auction at which Hubert's archive was sold.

March 14, 2004. "Common of Earthly Delights." Century of change on Times Square.

January 10, 2006. Trevor Traina and *Twins*.

Variety

January 27, 1959. "Penguins that Write Underwater." Hubert's nuttiness.

January 8, 1975. Hubert's obit.

OTHER MEDIA

An unexpected and marvelous source is a seven-minute film made at Hubert's in its last days. A copy is at the Donnell Media Center, NYC. Videotapes *John Szarkowski: A Life in Photography* produced by Checkerboard, and *Diane Arbus* produced by Creative Arts Television. NPR did a sound documentary on Eddie Carmel. There are thousands of Web sites pertaining to Arbus and Hubert's. One of the most interesting can be found at showhistory.com.

INTERVIEWS

Most of the material pertaining to Bob's adventures, the growth of the photography market and Arbus's place in it, and much pertaining to Hubert's Museum in the day was gleaned in the course of hundreds of hours of interviews with: Bob, Renee, Val, Okie, Royce Howes, Frank Russell, Jack Baker, Paul Grillo, Mo, Andrew Hawley, Wyatt Day, Sandra Phillips, Chris Mahoney, Elisabeth Sussman, Alen MacWeeney, Patricia Bosworth, Fred Cohen, Mack Lee, Anthony Lee, Steve Turner, Victoria Dailey, John Lynes, Bobby Reynolds, Ward Hall, Jeff Rosenheim, and Robert Stevens. My sincere thanks to them all.